GEORGE BAXTER
and the Baxter Prints

Max E Mitzman

GEORGE BAXTER
and the Baxter Prints

DAVID & CHARLES
Newton Abbot London North Pomfret (Vt)

British Library Cataloguing in Publication Data

Mitzman, Max E
 George Baxter and the Baxter prints.
 1. Baxter, George 2. Color prints, English –
Biography
 I. Title II. Baxter, George
769'.92'4 NE1860.B2

ISBN 0–7153–7629–2

Library of Congress Catalog Card Number 78-52165

Typeset by Tradespools Ltd., Frome.
and printed in Great Britain
by Biddles Limited, Guildford
for David & Charles (Publishers) Limited
Brunel House Newton Abbot Devon

Published in the United States of America
by David & Charles Inc
North Pomfret Vermont 05053 USA

Contents

Foreword

George Baxter—Touchstone of the Victorian Middle Class

Every Sunday morning, three colour supplements are available at newsagents all over the country. Colour reproductions of old master paintings, colour photographs of remote and romantic countries, of the Royal Family, of battle scenes, religious ceremonies, beautiful women, and scenes of general interest, jostle for our attention for the price of a Sunday newspaper. On every hoarding, large colour advertisements clamour for our attention, while our coffee tables groan under the weight of lavishly illustrated books on the arts—the 'museum without walls' of André Malraux. A turn of a knob brings colour television into the home. In our colour-saturated day, it requires a great effort of visual imagination to conceive a consumer society without colour—the black-and-white world of pre-Victorian England.

This stark description is to some extent an over-simplification. Just as the great improvements in road surfaces brought about by Macadam led to the swift passage of the mail coaches that presaged the coming of the railway age, so the natural human appetite for colour showed itself in the early nineteenth century in differing ways at different social levels. Wealthy gentlemen could subscribe to expensive quarterly publications, illustrated with carefully hand-coloured plates on ornithological, geographical and botanical subjects, which, when the set was complete and sumptuously bound, embellished their libraries. Lower down the social scale, the demand for colour can be gauged by the vigorous brush strokes of the toy-theatre sheets sold for '1d plain, 2d coloured', and the bold hues of the hand-coloured caricatures of Gilray, Cruikshank, William Heath and 'Paul Pry', which could be purchased for 1s at print sellers.

All methods of hand-colouring had one great disadvantage—the inevitable slowness of the process, and, even with the low wages of the time, high costs. While whole families could dash their way with verve, at the rate of 4d an hour, through a pile of toy-theatre sheets, one child painting in the reds, another the blues, and so on, the process was much slower and costlier with the careful hand-colouring of acquatint and lithographic plates in books. In the 1820s a skilled colourist, working for the best publishers like Ackermann's or Mclean's, could earn as much as £12.10s per week tinting landscapes or colouring botanical plates. Thus, though the public craved for colour, they were denied it, until a relatively cheap method of colour printing could be discovered. While earlier attempts to do this had been made, full credit for the first widely distributed and successful colour prints must go to George Baxter, whose new method of printing in oil colours radically altered the process of printing, and made colour available to the people. For over a quarter of a century he was to produce a range of prints which, in their

variety of subject, match the publications of the Sunday supplements today, and in the quality of their printing reveal technical ability of extraordinary virtuosity. In the prints recorded by Courtney Lewis and Max Mitzman, the tastes and interests of the High Victorian age are reflected, not in the sombre black and white of engravings, but in the chromatic colour of prints in oil colours. After Baxter's invention the excitement of colour would never be lacking from the humblest wall in the land.

Like so many great Victorians, Baxter's career really begins during the reign of William IV, whose short reign of seven years had its own individual character, differing from both the flamboyance of the Regency, and the proprieties of the Victorian, era. The first known Baxter print of three butterflies—an illustration for an unrecorded book—has something of the high colouring of the finest ceramic productions of the Rockingham and Coalport factories during the reign of William IV. Much of Baxter's early work was produced as book illustrations, and the titles of the volumes in which the prints appeared are immensely evocative of the interests of the age: Mudie's *Feathered Tribes of the British Isles*, Fisher's *Drawing Room Scrap Book for 1834*; *Social Tales for the Young*; *The Artist: or Ladies Instructor in Painting*; and *Garland of Love: or Wreaths of Pleasant Flowers gathered in the Field of England's Poesy*. The topographical impulse is a recurrent phenomena in English art. The desire to possess a specific visual record of a picturesque beauty spot or city, both in this country and abroad, led in the 1830s and '40s to the publication of numerous keep-sake albums and pocket books embellished with engraved vignettes after Turner and other well known artists. This demand provided Baxter with a fine opportunity, for colour added an alluring extra dimension to the appeal of such books. Topographical views of Tintern Abbey, Welsh landscapes, Warwick and Windsor castles, the Lovers' Seat and Dripping Well at Hastings, alternated with views of the cathedral cities of France and the Italian lakes. A charming view of 'Isola Bella, Lago Maggiore', was used as the frontispiece for Mudie's *Summer: or the Causes, Appearances and Effects of the Grand Nuptials of Nature in all its Departments*, 1837. A note in the book states: 'As it would have been impossible to find any subject emblematic of the whole summer, a scene in Italy has been chosen which shows both land and water under a sunny sky'. It says much for Baxter's versatility that he could turn with equal facility in the same year from the depiction of sunny Italy to produce the alarming hinged illustration to Sir Edwin Saunder's *Advice on the Care of the Teeth*, an unconsciously surrealist premonition of one of Max Ernst's collages.

With the accession of Queen Victoria, Baxter's work began to reflect the growing moral awareness of the new reign. Between 1837 and 1857, twenty-nine prints on themes relating to missionary work in the Far East and Pacific were produced. These prints, which included his first portrait work, were undertaken principally as illustrations to such works as the *Wesleyan Juvenile Offering* and Mudie's *Missionary Labours*, but also included

Baxter's first print to appear with a mount designed not as an illustration but as a picture in its own right—'The Departure of the Camden Missionary Ship for the South Seas', produced in 1838 for the London Missionary Society.

The coronation of the young queen led Baxter to embark on one of his largest and most ambitious prints of Queen Victoria receiving the Sacrament, sketched at the actual ceremony. The *Patriot* of 17 May 1841 noted: 'Mr Baxter has taken no less than 200 likenesses from life, which will have the advantage over all other representations of the imposing scene of being literally accurate down to the minutest details'. Unfortunately, such scrupulous attention to detail resulted in a three-year interval between event and publication, during which time public interest had waned, and the print failed to sell in large numbers. But Baxter's work was not entirely fruitless, since his attendance at Buckingham Palace to sketch royal portraits attracted continuing interesting from the royal family, particularly Prince Albert. A decade later in 1851, Baxter had a stand at the Prince Consort's cherished Crystal Palace, and his records of the building published in *Gems of the Great Exhibition* provided one of the most widely circulated souvenirs of that event. This series of views is particularly interesting as it provides striking evidence of the contemporary enthusiasm for large sculptural groups. Hiram Power's 'Greek Slave', was one of the great attractions of the exhibition, and Baxter's print shows the chaste canopy which draped the ample posterior charms of the figure from sensitive puritan gaze. The statue was, however, thoughtfully provided with a revolving pedestal, which, by the insertion of an umbrella or walking stick, could rotate the figure to reveal all. Other sculptures depicted included Raffael Monti's *tour de force* of illusionist drapery carving, 'The Veiled Vestal', and Mary Thorneycroft's 'Alfred the Great Receiving from his Mother the Book of Saxon Poetry', retitled by Baxter, possibly with an eye to his evangelical patrons, 'Mother Presenting her Son with a Bible'.

Although the Great Exhibition remains the most well known of the enthusiasms of the Prince Consort, he had many other intellectual pursuits, notably a passionate interest in the work of Raphael, whose famous cartoons, then at Hampton Court, were some of the most important treasures of the royal collection. He formed an archive of photographs, still preserved at Windsor Castle, of every recognized work by the artist—one of the first attempts to use the new discovery of photography in the services of art history. In a very different way, George Baxter was also aware of the power of the new discovery to record works of art, and issued in 1854 a series of sepia reproductions of the Raphael cartoons, giving them the title 'baxterotypes', in a conscious attempt to rival the new photographic processes of the daguerreotype and calotype.

The immense success of the Great Exhibition, which attracted six million visitors in the short space of six months, led to the rebuilding of the Crystal Palace at Sydenham. This also is commemorated in Baxter's work in a fine

view of the interior of the Pompeian Court, and a spirited panorama of the whole site dominated by the group of vast pre-historic creatures modelled in cement by Waterhouse Hawkins under the direction of Sir Richard Owen, first Director of the Natural History Museum, and inventor of the term 'Dinosaur' from the Greek words for 'terrible lizards'. Baxter was also alert to the possibilities for new markets afforded by the foreign exhibitions which emulated the success of the Crystal Palace, producing a print of the New York building of the same name erected in 1853, and the print 'Me Warm Now' which was sold at the stall Baxter held in the New York show.

'Me Warm Now' (Plate 1) depicting a Negro boy warming himself by a fire, was one of a group of prints which illustrate the varying moods and behaviour of children. Such child genre subjects were immensely popular in High Victorian England, an age which responded with morbid enthusiasm to the death-bed scenes of Little Nell in *The Old Curiosity Shop* (1839) and Paul Dombey in *Dombey and Son* (1848), and the powerful evocation of the joys and sorrows of childhood in *David Copperfield* (1850). Pictorially, such subjects provided themes for the artists of the well known Cranbrook Colony of artists, which included Thomas Webster, F. D. Hardy and William Mulready. Surprisingly, Baxter's prints include no examples of the Cranbrook Colony's work, but interestingly one print is after a pre-Raphaelite artist, James Collinson's 'Short Change'. Works of this type include 'Prayer' after Sir Joshua Reynolds, 'Little Red Riding Hood' after Sir Edwin Landseer, and 'So Tired' (Plate 2) after Winterhalter's portrait of the Princess Royal. Other popular titles were 'So Nice' with its pendant 'So Nasty—I don't like it', 'The First Lesson' and 'See-Saw Margery Daw'. All these works had in common a calculated reliance on the innocence and senti-mental appeal of infancy which guaranteed success. It is intriguing to con-trast the sentiment of 'Copper Your Honour' by Baxter with Henry May-hew's description of the actual life of a crossing sweeper, and the stark realities of such an existence as recorded in the engraving after a daguerrotype used to illustrate *London Labour and the London Poor*.

Purchasers of Baxter prints would, it may be surmised, have come principally from a slightly higher social group than the public for another extremely popular Victorian artefact, the Staffordshire figure, which also acts as a barometer of popular taste. This can be clearly seen when the portraits of famous personalities represented in both mediums are con-trasted. Baxter's portrait range is strictly confined to the royal families of England, France, and Prussia, to Nelson, Wellington, Sir Robert Peel, John Wesley, to the heroes of India (two needle-box series, produced just after the Mutiny), and to the allied sovereigns (produced during the Crimean War). The range lacks the wider sweep of the Staffordshire figure, which includes such extremes as famous murderers, sportsmen, and a crowded Green Room of theatrical notabilities. The only theatrical personalities portrayed by Baxter, in what are perhaps his most delightful portraits, are the popular singers, Jetty Treffz and Jenny Lind. The latter is portrayed in 'The Daughter

of the Regiment', and has great romantic appeal.

These likenesses have the same consciously pretty and engaging charm, so evocative of the High Victorian era, that can be found in the celebrated 'Four Ladies' of the 1850s: 'The Lovers' Letter Box', 'The Day before Marriage', 'The Bridesmaid', and 'The Fruit Girl of the Alps'. The type of female beauty portrayed in such works can almost be defined as the 'Baxter girl', demure in expression, decolletée and crinolined in dress, posed against an attractive and appropriate floral or sylvan background, the quintessence of the High Victorian heroine. Other examples of this type include 'The Parting Look' after E. H. Corbould, one of Baxter's largest prints; 'Summer Time'; 'Flora', also known as 'Flora, the Gypsy Girl', and said to be a portrait of Baxter's daughter; 'The Belle of the Village', and 'Shall I Succeed?' also known as 'The Coquette'. Such titles have the period charm of pressed flowers in a long closed keep-sake book, or the titles of long forgotten tinkling melodies on musical boxes by Auber or Balfe. Even in the more voluptuous beauties depicted in 'The Andalusians' of 1848, and the chastely draped limbs of 'The Circassian Lady at the Bath' of 1850, 'there is nothing calculated to bring a blush to the face of a young person' (the unctuous words of Dickens' Mr Chadband).

The embellishment of trays, boxes, screens and furniture with coloured pictures which were then varnished, was a popular Victorian pastime, dignified with the portentous name of 'découpage'. Baxter's needle-case prints were eminently suitable for use in this way, and some of the most delightful of his productions are the series of tiny prints designed to decorate individual boxes of different sized needles, microcosms of such Terpsichorean delights as La Tarantella, The Greek Dance, Fairy Scenes and the Pas des Trois, reminiscent of R. Brandard's popular hand-tinted lithographs of the great stars of the romantic ballet, Taglioni, Grisi, Cerritto and Grähn. Produced throughout the 1850s, these engaging trifles were emulated by the enterprising German and French chromolithographic printing firms whose coloured decorative scraps, imported in large quantities, were to be an important contributory factor in Baxter's financial eclipse.

Seen in retrospect, perhaps the most surprising aspect of Baxter's career is his failure to make the fortune that would have entitled him to a place in the most famous collection of Victorian success stories—Samuel Smiles' *Self Help*. This failure cannot be attributed to lack of enterprise for, from his earliest ventures as a book illustrator in such publications as *The Order of Knighthood*, Baxter had enlarged his activities by ingenious trail blazing in new and varied publishing ventures. Nor can the blame for his lack of financial success be attributed to the contesting claims of his desire for topicality and his sense of perfectionism; although topicality was always to prove an elusive subject, Baxter learnt from his early expensive lesson over his print of the coronation of Queen Victoria and brought out views of such events as the royal tour of Ireland, the Siege of Sebastopol, and the ascent of Mont Blanc in reasonable proximity to the event. In such prints as the

'Soldier's Farewell', showing a guardsman departing for the Crimean War and his father presenting him with a Bible, Baxter produced a work which, while topical, also possessed a long-term sales appeal. This was also true of his two gold-rush subjects, 'Australia: News from Home' and 'News from Australia', produced in 1853 and 1854. These prints share a common theme with Abraham Solomon's 'Third Class—the Parting', exhibited at the Royal Academy in 1854 and Ford Madox Brown's 'The Last of England' exhibited at the Liverpool Academy in 1856. Between 1851 and 1861, more than two million people emigrated from Great Britain, the total population then being approximately thirty million, or, in other words, one in fifteen people emigrated, and the emotional implications of such subjects were only too familiar at that time.

The reasons for Baxter's financial failure can ironically be attributed to the very success of his process, and the widespread demand it produced for ever-increasing numbers of colour prints. Many other printers were, of course, struggling to achieve the same ends when Baxter perfected his process. Like Gutenberg, four centuries earlier, Baxter was unable to keep his 'secret', particularly after 1849, when his creditors advised him to license other printers. Nor, indeed, was the process a real secret in the sense that Böttger's discovery of the arcane mystery of making porcelain was in the early eighteenth century, for no new methods were involved. What was unique in Baxter's process was his ingenious use of an acquatint key plate in combination with up to twenty wood blocks, copper or zinc plates, or litho stones, all adapted to printing in oil colours. Various adaptions of these techniques were rapidly introduced in printing works up and down the country. The transfer techniques perfected by Messrs F. and R. Pratt enabled even pots of 'Perfumed Bear's Grease', 'Venetian Pomade' and various meat and fish pastes to be embellished with multi-coloured pictorial lids, sometimes using subjects adapted from Baxter prints. The change-over from black-and-white to colour, once begun by Baxter, was to proceed with the same celerity that we are familiar with today in the field of television.

Baxter's achievements as a colour printer can be assessed a century later with a more balanced awareness of their historical significance than was afforded them by the enthusiasts of the first Baxter Society whose activities form such an intriguing part of the story told by this book. To the student of the High Victorian age, his prints afford, as in a reducing mirror, a unique picture of the visual interests and tastes of a society that purchased in monthly parts the novels of Charles Dickens, that visited the Great Exhibition, and shared with their royal family a belief in the elevating effects produced by the contemplation of 'high art', and at the same time succumbed to the sentimental appeal of pictures that 'told a story' of happy domesticity. It was George Baxter's lasting achievement to add colour to this age.

Lionel Lambourne
Assistant Keeper, Department of Prints and Drawings,
Victoria and Albert Museum

Introduction

'It is only quite recently that Collectors of Prints have awoke to the fact that a genius once lived among them unawares, and passed away with but scant recognition of his work.' These words, written in 1895 by J. H. Slater, President of the first Baxter Society, are as true today as they were then.

George Baxter perfected and patented a process of printing coloured pictures from oil inks in 1835, and was the first man in Great Britain to illustrate books with pictures printed in colour. His prints sold in hundreds of thousands, and two of his major works were designed and executed by command of Queen Victoria herself. He came under the patronage of Queen Adelaide, Prince Albert, and many famous men, and received honours from the emperor of Austria, and the kings of France, Denmark, and Prussia. Yet on his death in 1866, a lonely, bankrupt, and embittered man, his name and work were largely forgotten.

During the past century, there have been two revivals of interest in his work. The first Baxter Society was formed in 1895, and the second in 1923. I have attempted here, after telling the story of George Baxter, to write for the first time the history of the Baxter Societies.

<div align="right">MEM</div>

Part I

The Life of George Baxter

Chapter 1 1804–1836

George Baxter was born on 31 July 1804, at 37 High Street, Lewes, Sussex. A sign on the house revealed that it was the residence of John Baxter, printer, publisher, and bookseller, so one can almost say that George was born with printers' ink in his veins.

He was the eldest son of John Baxter who, after establishing a book business in Brighton, moved to Lewes in 1803, where he set up his printing and publishing firm. He was an enthusiastic cricketer and his most successful publication was *Lambert's Cricketers' Guide*, named after the famous professional. This book, written by John Baxter himself, published for the first time the rules of cricket, and sold over 300,000 copies.

George started school at Cliffe House Academy, later moving to the High School, St Annes, Lewes. Here he came under the influence of the headmaster, who discovered in him an amazing ability and patience to execute perfect miniature drawings. There is some controversy regarding the name of this headmaster. Charles F. Bullock states in his *Life of George Baxter* (published in 1901) that he was Mark Antony Laver, a well known antiquarian, while C. T. Courtney Lewis (of whom much more later) asserts in the Picture Printer (1911) that he was Cator Rand. Whoever he was, he recognized George's talent, and by his encouragement of it exerted an influence that was to affect his young pupil's whole future life. Upon leaving school, George was apprenticed to a wood engraver, and afterwards spent a short time in London perfecting this art.

In 1824 he was returned to Lewes to work for his father. In that year they produced *The History of Lewes*, illustrated with many lithographs by George Baxter, which, while of only minor importance, showed that he already possessed a capable knowledge of the subject. They also published *Baxter's Stranger in Brighton's Directory* with a lithograph of Brighton chain pier (now demolished) as the frontispiece.

In 1825 George was again apprenticed to a wood engraver, a Mr Williams, in London. During the year's apprenticeship, he met Mary Harrild, daughter of Robert Harrild, a manufacturer of printing machinery. Harrild became very friendly with George's father and between them they invented the printer's roller, to take the place of the printers' ball. John Baxter had one made of leather by a Lewes saddler, and was the first to use the roller for printing.

In 1827 George became engaged to Mary Harrild and set up in business at Charlotte Street, Blackfriars, backed by his future father-in-law, who loaned him three printing presses. In August of the same year, the young couple were married and moved to 29 King Square, Goswell Road, Islington.

In 1829 George Baxter published his first colour print, 'Butterflies', obviously an experiment, and probably an illustration for a book. This print was hailed at the time as a milestone in colour printing. Baxter had not yet

perfected his use of oil inks which he was later to patent, but he did employ what was to become a characteristic of all his work, adding the title and his name and address beneath the print. Below 'Butterflies' is printed 'Engraved on Wood, and printed in colour by George Baxter, 29 King Square, Goswell Road'.

Little is known of George Baxter between 1829 and 1834 except that he must have been continuing his experiments in colour printing and the use of oil inks. Charles Bullock has left us this description of him:

> He was a man of medium height, with a florid complexion and dark curly hair. A deeply religious man, hard working and of great perseverance. Unfortunately he also had developed a pragmatic and quarrelsome nature, and was difficult to get on with. His ability in business matters was in inverse ratio to his talent as an artist, and although later he made money, he never had any. Nevertheless, he was extremely versatile, a complete perfectionist, and undoubtedly ranks with the chief creative men of his century.

C. T. Courtney Lewis, in *George Baxter His Life and Work*, adds:

> He had that instinctive way of evading intrusion so often to be noted in artists and men of letters, or men of affairs who display impatience or downright irascibility as a kind of protection from intruders. Much in this way Baxter came to be accounted retiring and exclusive. And, not having the gift of suffering fools gladly, was frequently abrupt in manner, tactless, somewhat vain and impetuous, even to eccentricity, and often he was quite choleric. His business ability was in inverse ratio to his talent as an artist. He made money but never had any. Baxter was a good husband and father and of a kindly and charitable nature. He gave readily part of the profits of some of his prints to assist the family of the Rev. John Williams, and the Missionary Schools at Walthamstow.
>
> Lithographer, engraver in wood, in mezzotint, stipple, aquatint, and occasional line, publisher, inventor, colour printer, and accomplished artist—George Baxter was no ordinary man. While as a colour printer he was unsurpassed, he was prevented by circumstances from attaining his full development as an artist which, under more favourable circumstances, he would have achieved.

By 1834 his experiments started to bear fruit, for in that year he began his association with Robert Mudie, a prolific writer, whose work was published by Ward & Co of 27 Paternoster Row. This association lasted until Mudie's death in 1842, Baxter illustrating thirteen of his volumes. The start of this collaboration was *Feathered Tales* which had the first coloured illustrations ever attempted in a printed book. These caused a sensation, and describing them Mudie wrote:

> I should mention that the vignettes on the title pages are novelties, being the first successful specimens of what may be termed "Polychromatic Printing" or printing in many colours from wooden blocks. By this method every shade of colour, every breadth of tint and every degree of evanescence in the outline can be obtained. I made him work from mere scratches of outline to test his

metal and I feel confident that the public will agree with me in thinking it stirling. Mr. Baxter had no coloured copy but the birds themselves in carrying out this very beautiful branch of typography into successful effect, and he has completed the last project which that original genius Bewick did not live to accomplish.

In 1804, the year in which George Baxter was born, Thomas Bewick completed his great work entitled *Birds*—a natural history of birds, published by S. Hodgson for Beilby and Bewick—which established his reputation as the premier wood engraver. The following is taken from the catalogue of the London Exhibition, 1923 (Second Baxter Society):

> Bewick hated London and hardly visited it for 50 years. It was fated that on his second and last visit in 1828 he met and greatly impressed George Baxter, then on the threshold of his career:
> The genius from the Tyne threw his artistic mantle over the shoulders of the enthusiastic and persevering young man on the shores of the Thames, who admitted that, in carrying this branch of the typographical art into effect, he had completed the last project that Bewick had not lived to accomplish.

Robert Mudie wrote his books in series. The first of these were entitled *Feathered Tribes* and the *Natural History of Birds*. In the latter book we find beneath the illustration of 'Eagle and Vulture' the first mention by Baxter of the oil-colour process of which he was so proud: 'Engraved and printed in oil colours by G. Baxter, 29 King Square, from a painting by T. Landseer'.

The books on birds were followed by *The Earth*, *The Air*, *The Heavens* and *The Sea*. The next series bore subtitles that were almost poems in themselves:

Spring or the Causes, Appearances and Effects of the Renovations of Nature in all Climates.

Summer or the Causes, Appearances and Effects of the Grand Nuptials of Nature in all Departments.

Autumn or the Causes, Appearances and Effects of the Seasonal Decay and Decomposition of Nature.

Winter or the Causes, Appearances and Effects of The Great Seasonal Repose of Nature.

These four had title pages and frontispieces by Baxter, as did Robert Mudie's series entitled *Man*:

Man His intellectual Faculties and Adaptions.

Man His Physical Structure and Adaptions.

Man In his Relations to Society.

Man As a Moral and Accountable Being.

In 1835 the Baxters moved again, this time to 3 Charterhouse Square, and it was from here that George applied for his patent, which was granted in 1835. The following is a short extract from the grant:

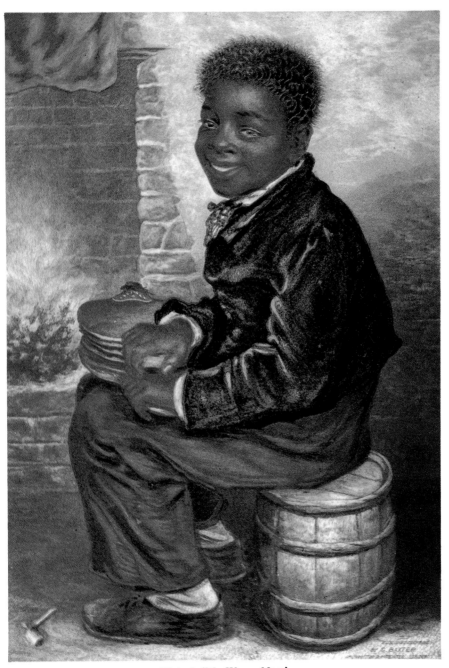

Plate 1 'Me Warm Now'

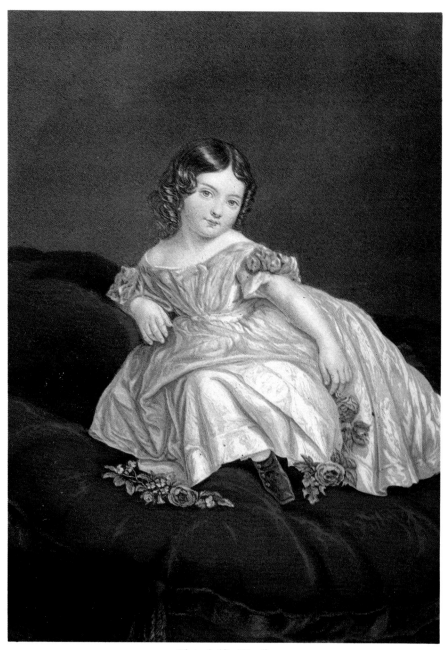

Plate 2 'So Tired'

WILLIAM the FOURTH BY THE GRACE of GOD of the United Kingdom of Great Britain and Ireland, King Defender of the faith TO ALL TO WHOM these presents shall come greeting WHEREAS George Baxter of Charterhouse Square in the County of Middlesex, Engraver hath by his Petition humbly represented to us that he hath invented "Improvements in Producing Coloured Steel Plate, Copper Plate, and other Impressions". That he is the First and True Inventor thereof and the same has never been practised by any other person or persons whomsoever to his knowledge or belief. The Petitioner most humbly prayed that we should be graciously pleased to grant him, his Exors. Admors. and assigns our Royal Letters Patent under our GREAT SEAL OF GREAT BRITAIN for the sole use and benefit and advantage of the said invention within England and Wales and the TOWN OF BERWICK UPON TWEED for the term of Fourteen Years, persuant to the statute in that case made and provided, and we have been willing to encourage to all arts and inventions which may be to the public good. Are graciously pleased to convenant to the Petitioners Request.

The following extract is from the Gazette of 23 October 1835: 'BAXTER George: Patent No. 6916:—Improvements in Producing Coloured Steel Plate, Copper Plate, and other Impressions.'

What was Baxter's patent process? Up to his time, colour printers had used wood blocks only, but Baxter's innovation lay in using a metal plate with the wood blocks. His process consisted of building up a series of tints one after the other, with the aid of engraved wooden blocks, upon an already perfect impression of a steel or copper-plate engraving. In some cases, he used as many as twenty of these blocks, which meant that the slightest inaccuracy in their registration would throw the picture out of perspective and result in a mess instead of a work of art.

What is astonishing is the accuracy with which the registration was carried out, each colour falling into its proper place without the variation of a hair's breadth. The success he had in performing this delicate work must be attributed partly to the fact that he was an artist of great ability, with a perfect knowledge of colour, and partly to the extreme patience (which he had already shown as a schoolboy) that he brought to his work.

Baxter describes how he achieved his perfect registration in his patent specification. The following is an extract from the official abridgement of the patent specification:

A.D. 1835. October 23.—No. 6916
BAXTER, GEORGE.—Improvements in producing coloured steel plate, copperplate, and other impressions.

The invention consists of colouring impressions of steel and copperplate engravings, and lithographic and zincographic, printing by means of block printing, in place of colouring such impressions by hand 'as heretofore practised'. In order to produce a number of ornamental prints resembling a highly coloured painting, whether in oil or water colours . . . I proceed first, to have the design engraved on a copper or steel plate, or on stone or zinc, as is well understood, observing, however, that I make several spots or points on the plate or the stone from which the impressions are taken, in order to serve

as register marks. Such points are very minute, and are so placed as to be hidden by the colour when laid on. Impressions of the print having been taken they are transferred to the colouring blocks, each of which is cut away so as to leave only its own coloured part in relief. Having taken the number of impressions . . . and having the necessary blocks in the press of the first colour on the tympan, there are four or other number of fine points to receive the impression, which is to be coloured by a series of blocks, the fine points receiving each engraving at the four points . . before mentioned, and on such tympan there are a number of points which are caused to strike through the paper in pulling the first printing of colour, and the point holes thus produced are those which are used for the purpose of securing a correct register in all the future impressions from the wooden blocks, the holes which were marked on the original impressions not being used after the first time. Metal blocks will answer the same purpose as the wooden.

It is a matter for conjecture whether his secret, if he had one, lay either in his patience and attention to minute detail, or in his knowledge of the mixing of colours. He had a great knowledge of these, and when he licensed other printers to carry out his process, although they were capable men, and some had Baxter's plates to work from, they were never able to reproduce his effects.

It has been said that Baxter never passed on the whole of his 'secret', which died with him. It is probable that the only part of his secret which was not imparted was his knowledge of colours and an 'infinite capacity for taking pains' which could not be passed on. Although his methods and processes are well known, they could not be copied today, as the sheer expense of carrying them out precludes their use in a branch of art which has become so mechanized.

Baxter's work began to attract much attention in the printing world, and by 1836 a vogue had arisen for illustrated books of poems and short stories. In that year, the famous publishing house, Chapman and Hall, decided to issue a deluxe volume to catch the Christmas trade and commissioned George Baxter to produce the pictures for the book, which was to be entitled *Cabinet of Paintings*.

There is no doubt that Baxter saw this as his great opportunity. Chapman and Hall was the leading publisher of the day, and the book, which was to be dedicated to King William IV, would certainly be the art work of the year. He decided to use all his skill and knowledge to produce a really outstanding work. Unhappily, his search for perfection was to be his undoing, because his experiments with tinted paper and various forms of colour printing took so long that the publishing date could not be met. Twice Chapman and Hall had to postpone publication, and when the book eventually appeared the result was disappointing. The publishers did not repeat the experiment.

This was most unfortunate. The book ranks as one of the rare items of book production, being the first produced in Great Britain entirely illustrated with pictures printed in colour. It was a small quarto volume published at

£1 11s 6d, and advertised in February 1837 as 'A splendid New Year gift bound in a peculiarly elegant and novel manner'. It contained eleven coloured plates (see Plates 3 and 4) with descriptive stories by J. Collier and poems by Miss Landon. The Preface, probably written by J. Collier, is most interesting, and is reprinted as Appendix IV at the end of this book. It traces the history of colour printing from the first example, a psalter printed in two colours by Faust and Schaffer at Mentz in 1457, through the sixteenth, seventeenth and eighteenth centuries, and concludes with a full description of the methods used by George Baxter in producing the plates, listed below, as in *Cabinet of Painting*.

VIGNETTE R. Westall, R.A.
CAPE WILBERFORCE W. Westall, A.R.A.
THE CARRIER PIGEON Miss F. Corbaux.
VERONA (from the original in the possession of John
 Braithwaite, Esq.) S. Prout
CLEOPATRA (from Guido) Miss E. Sharpe
LUGANO G. Barnard
INTERIOR OF LADY CHAPEL, WARWICK (from the
 Original, in the possession of Richard Hollier,
 Esq.) J. Holland
BOA GHAUT W. Westall, A.R.A.
ZENOBIA Wm. Pickersgill, R.A.
DESTRUCTION OF THE CITIES G. Jones, R.A.
JEANIE DEAN'S INTERVIEW WITH THE QUEEN Mrs. Seyffarth

Baxter himself tinted the paper for these plates, using a smooth letterpress method. He also evolved the idea of printing the complete picture in monotone, and then colouring it by successive applications of small wood-cut blocks, each one a different colour, as an artist building up his work. The result was a facsimile picture. The stories and poems were typically Victorian, the following by Miss Landon being a typical example:

Interior of the Warwick Chapel

> Low before the cross she weepeth,
> Weeping even while she prays;
> Golden o'er her mourning garments
> Fall the oriel's coloured rays;—
> Like the false and shining seeming
> Of this life's external show,
> Veiling with an outward glitter
> All that lies so dark below.

Many graves are round her lying,
Only one is in her heart;
How could one so lovely perish?
Why should one so young depart?—
With the crimson banners round her,
'Neath the scutcheon's gilded shade,
'Mid her old ancestral honours
Is a youthful maiden laid.

And that Ladye is her mother;
She had but that only girl;
Troubled were her life's deep waters,
But they yielded this one pearl,
Wayward are her other children,
Haughty, with their father's brow;
Their life-element is battle;
No one weeps beside her now.

Lonely in her bower at twilight,
Lonely in the festal hall,
No more amid sound or silence
Does she list one step's light fall.
Silent is the lute whose music
Used to float those towers around;
Never since that fatal evening
Has she borne to hear its sound.

And there comes a deeper sorrow
As she kneeleth by the dead;
Well she knoweth what heart-sickness
Bowed that young and radiant head.
'Twas the beating heart forbidden
Love that had been love for years;
Little thought the angry warriors
Of a women's silent tears.

Vainly did her mother chide her
With a chiding born of fear,
As she saw her pale girl drooping
For the sake of one too dear.
With a meek and sweet obedience
From her lover could she part;
But it cost the bitter struggle
Of a young and broken heart.

Every day her mother saw her
With a darker, sadder eye;
For the sake of that sweet mother
Did she struggle not to die:
But the soft low voice grew weaker,
And the step more faint and slow;
Heavily the languid eyelash
Veiled the large bright eyes below.

Stately were the kindred mourners
By the maiden's early tomb;
Tears were mingled with the shadows
Of the warrior's bending plume.
Soon the solemn funeral pageant
Left the maiden to her sleep;
One alone came back each twilight,—
'Twas the mother came, to weep!

Chapter 2 1837–1844

In 1837 Baxter met two people who were to profoundly influence the course of his life and work. The first of these was John Snow, who had been appointed publisher to the London Missionary Society in 1836. Baxter collaborated with him for ten years on what must have been, to a man of his religious nature, a most satisfying work. I will deal with Baxter's missionary period later, as the second introduction of that year had a far greater impact on Baxter's career.

The accession of Queen Victoria had its repercussions throughout the British Empire, but few of her subjects could have been so personally affected as George Baxter. What is astonishing is that although the queen must have known him, or even have met him in the first few months of her reign, there is no record of when, where, or how this most important meeting for Baxter came about. I have searched all available records, but even the *Sussex Express*, founded in 1837 by John Baxter together with his younger son William, which records Baxter's subsequent attendance at court in great detail, makes no mention of this meeting.

What we do know, however, is that Baxter was 'commanded' by the queen to attend her coronation ceremony in Westminster Abbey on 28 June 1838. He was given a seat in the Foreign Ambassador's Gallery and special facilities to make sketches of the scene so that he could print a picture to record the event for posterity. He was also commanded to be present in the House of Lords on 20 November of the same year to record the opening by the queen of the first parliament of her reign, and he was one of the only two artists admitted to see the baptism of the Prince of Wales, later to become King Edward VII, and here again special arrangements were made that he might make his drawings in comfort.

Baxter decided to issue a pair of prints of the first two events by subscription. They were to be approximately 21×17in in size, and the price for each was to start at 5 guineas. He collected a number of patrons for the project and issued a prospectus to advertise the forthcoming publication. The prospectus itself is quite interesting; some versions, probably intended specifically for his more important customers, had the royal coat of arms in gold and colours in the centre; others had the coat of arms only in black and white. The advertising matter read:

<div align="center">

Dedicated by Permission to the Royal Family
Two Splendid Pictures
one to commemorate
The opening of the First Parliament
By her most Gracious Majesty

and the other

</div>

The August Ceremonial of the Coronation exhibiting the magnificent spectacle as seen from the Gallery occupied by the Foreign Ambassadors and representing

The Queen

at the time when the Crown was placed on Her Majesty's head by His Grace the Archbishop of Canterbury.

Accurate portraits will be given of Her Majesty and suite, in the Dresses, Robes, Jewels and State Ornaments worn on the occasions.

The above Pictures will be printed in Oil colours by the Inventor and Patentee, George Baxter, 3 Charterhouse Square. Price to Subscriber Five guineas each.

Among the Present Patrons are
Her Royal Highness the Duchess of Kent
His Royal Highness the Duke of Sussex
His Royal Highness the Duke of Cambridge
His Majesty the King of Prussia
His Serene Highness the Duke of Nassau
His Serene Highness Prince Furstenburg
His Serene Highness Prince Esterhazey
His Serene Highness Prince Putbus
His Grace the Duke of Sutherland
His Grace the Archbishop of Canterbury
His Grace the Duke of Somerset
His Grace the Duke of Northumberland
The Most Noble the Marquis of Conyngham
The Right Honourable the Earl of Albemarle
The Right Honourable the Earl of Dartmouth
The Right Honourable the Earl of Fife
The Right Honourable the Earl of Shaftesbury
The Right Honourable Lord Viscount Palmerston
The Right Honourable Lord Willoughby de Eresby
The Right Honourable Lord Farnham
The Right Honourable Lord Barham
Sir Augustus Clifford Bart.
His Excellency Baron Bulow
Sir John Cowan Bart. Lord Mayor of London

The preparation of these pictures brought Baxter into close contact with many important and influential people, as is shown by the following extracts from the court journal;

Mr. Baxter the inventor of Oil Colour-Printing had the honour to attend Buckingham Palace on Wednesday and Thursday to complete the portrait of Her Majesty in the Robes of State for a Historical subject connected with the opening of the first Parliament of her reign.

Their Royal Highnesses the Dukes of Sussex and Cambridge honoured Mr. Baxter with sittings for the Coronation Picture. 16 February 1838

Mr. Baxter had the honour of attending the Palace to make a sketch of Her Majesty's Coronation Dress for his picture of the Coronation.
 28 August 1838

On Wednesday Her Majesty did Mr. Baxter the honour of inspecting the Picture which he has been so long preparing to celebrate the opening of the First Parliament of Her Reign, at which Her Majesty expressed the highest approbation. The Picture which will be executed in the highest style of Oil Colour Printing, was also exhibited in the Robing Room of the Peers, prior to the prorogation of Parliament. 18 July 1843

'So long preparing' was indeed true. Although the two pictures were begun in 1839 they were not issued until four years later, by which time interest in the events they portrayed had waned. Baxter employed his talent of miniature drawing to the full, and endeavoured to draw a recognizable portrait of every one of the hundreds of persons in the assembled gatherings. With the print of the coronation he issued a key giving the positions and names of over two hundred persons in the abbey, and with the print of the First Parliament he presented to every subscriber an historical account of the ceremony, together with a description of the art of oil colour-printing.

'Her Most Gracious Majesty Queen Victoria Receiving the Sacrament at her Coronation' shows the scene in the abbey as the queen kneels before the Archbishop of Canterbury. A shaft of sunlight from the great window behind illuminates her and the altar. Around the queen are grouped the Archbishops of York and Armagh, and the Bishops of Bath and Wells, Carlisle, Ely, Rochester, and Norwich. Lord Willoughby de Eresby stands on the queen's right holding the crown, with Lord Melbourne (the Prime Minister) the Duchess of Sutherland, the Duke of Norfolk, and Princess Doria Pamphilla behind him. On the queen's right, beside King Edward's Chair, stands the Duke of Wellington, behind him the Dukes of Sussex, Cambridge, and Ney-mours, and Lords John Russell, Cottenham, and Palmerston. The galleries behind are filled with the glittering assembly, tier upon tier soaring to the roof.

'The Arrival of Her Most Gracious Majesty Queen Victoria at the House of Lords to Open Her First Parliament' shows the procession approaching the Royal Gallery at the house of Lords between two long rows of guardsmen in their scarlet tunics and bearskin busbies. The queen is in the centre, surrounded by her ladies-in-waiting, and preceded by Lord Cottenham, the Lord Chancellor, carrying the royal purse and accompanied by his page. The Duke of Somerset carries the crown, and Lord Melbourne holds the sword of state. On the queen's right are the Duchess of Sutherland, Mistress of the Robes, and the Marchioness of Lansdowne, Principal Lady of the Bedchamber.

On her left are the Herald King of Arms, the Earl of Shaftesbury with the cap of maintenance, and the Earl of Albemarle, Master of the Queen's Horse. Following the queen, behind the guardsmen, were once again the members of the distinguished assembly.

The two pictures were acclaimed as Baxter's finest achievements, and although perhaps of no great artistic merit are of great historical interest. The accuracy with which the smallest details are portrayed shows the infinite patience which he took in his work and his capacity to exploit in full the advantages of his oil-colour process. Unfortunately the project was a financial disaster. During the four years in which he was employed upon it Baxter neglected his other work; as a consequence he spent every penny in his possession and would not have been able to complete the pictures had his family not come to his aid. By the time the pictures were published he owed over £2,500, a colossal sum at that time. The pictures were issued at 5 guineas each unframed and at £10 each in gold frames with a crown on a cushion at the head; small copies were offered at £3 6s each. However, Baxter could not possibly recuperate from their sale more than a fraction of the money spent on their preparation. He struggled on for three years, but by 1844 his financial position was so bad that he had to call a meeting of his creditors and put before them a statement of his affairs. He produced his books and accounts and showed that his financial position was not caused by extravagance or idleness, for he had worked for ten to fifteen hours a day, but by his meticulous search for perfection. His creditors were indulgent, accepting a payment in full settlement of only 2s 6d ($12\frac{1}{2}$p) in the pound, allowing him four years in which to pay this.

One casualty of his financial collapse was unfortunately the projected print of 'The Baptism of the Prince of Wales'. Baxter had completed his water-colour painting, which received the queen's approbation and was exhibited at the Royal Academy. Advertisements appeared immediately after the event of his intention to produce a print which was to have been the same size and a companion to the 'Coronation' and 'Parliament' prints, but after the loss he had already made on the earlier venture, he could not afford to carry on with this commission. The following is an extract from C. T. Courtney Lewis' book, *George Baxter—His Life and Work*:

> There is in the Baxter family a very beautiful water colour which is probably the original from which the print was to be taken, and in it Baxter's own portrait is visible among the assembled company on the Royal platform of this 25th January 1842.

The King of Prussia expressed a desire to purchase the painting, but died before the deal could be completed. The following extract from the court journal of 18 August 1843 is relevant:

> The pictures "Coronation" and "Parliament" were submitted to the Queen Dowager at Marlborough House for her inspection, and also after an introduction by The Ambassador the Chevalier Bunsen, Mr. Baxter had a long interview with the King of Prussia. His majesty had had the Coronation print shown to him by the Dean Lord John Thyme on his visit to Westminster Abbey, and desired to have the process explained to him. He expressed his admiration for the art and passed a high eulogium upon the skill and talent of

the Artist, and honoured Mr. Baxter with his patronage of the then intended print of the Baptism of the Prince of Wales.

Mr. Baxter also had the honour of submitting to Her Majesty and Prince Albert an outline of the "Baptism of the Prince of Wales" with which Her Majesty and His Royal Highness were pleased to express their approbation.

Baxter commenced his association with the missionary societies in 1837. In the nineteenth century, missionary societies were very active and wealthy enough to finance expeditions to all parts of the world. The reports of their activities were eagerly followed and famous missionaries achieved the status and hero worship afforded to film stars today. Baxter's co-operation with the societies was a happy union; for a man of his religious nature it was a most satisfactory work, and the societies were able to follow up the interest aroused by the exploits of their famous men with his coloured prints, which were a novelty, since photography was not then in use.

Baxter's first commission for John Snow of Paternoster Row, London, the Secretary to the 'London Missionary Society', was to illustrate *A Narrative of Missionary Enterprises* by the Reverend John Williams. The frontispiece to the book was a portrait of the author, which was the first portrait in colour that Baxter had attempted. Of this portrait the Rev Williams wrote:

> At the express wish of many highly esteemed friends, the author has introduced a portrait of himself in the present edition and, as he has spared no expense in the execution of it, he hopes not only to enhance the value of the volume in the estimation of his friends, but also to introduce to more general notice an art which appears to him exceedingly beautiful and worthy of every encouragement.

John Snow thought that the portrait might find a ready sale if issued separately on a cardboard mount, and he commissioned Baxter to print him a supply, which he offered for sale at 1s 6d ($7\frac{1}{2}$p) each. These were the first non-royal prints that Baxter had produced mounted separately and not in a book, and he was quick to see the commercial advantages of the idea that Snow had stumbled upon. Almost all his work until then had been commissioned by book publishers but issuing separate mounted prints would enable him to publish them independently, and sell direct to the public. Baxter's action greatly annoyed Snow, who resented Baxter's use of his idea, and this led to a violent quarrel between the two men. The rift was eventually healed, however, and they worked together for ten years.

The collaboration with the missionary societies was given great impetus by a tragic event that occurred in 1839. The Rev John Williams was held in such high esteem that his book *A Narrative of Missionary Enterprises* was described as 'a supplement to the Acts of the Apostles'. On 11 April 1838 he sailed from Gravesend on the missionary ship *Camden* at the head of an expedition bound for the South Seas to investigate the possibilities of setting up missions in the islands around New Guinea.

On 18 November 1839 the *Camden* arrived at the island of Tanna, where

the missionaries were well received by the natives. The next day they set sail for Erromanga, which they reached on 20 November. Here they repeated the procedure of endeavouring to make friends with the natives by presenting them with gifts of beads, mirrors, and other small objects. All went well at first, and the Rev Williams and his companions were treating on the shore with the inhabitants of the island. Then, without warning, the atmosphere changed. Morgan, the captain of the *Camden*, standing in the long boat a little way off from the shore, saw the danger and sounded the alarm. The missionaries tried to reach the boat, but not all were successful. The scene that followed was described by Mr Leary, who reached the safety of the boat:

> The scene was of a most startling and appalling character. Here were all the appliances and splendours of a tropical landscape. From the romantic mountain a waterfall descends in its closely sinuous and sparkling course to the Savanah, where there is a scene of wild commotion. The natives, every countenance expressive of the most diabolical malice and rage, armed with spears, massive and murderous clubs made of the hardwood of the island, slings, bows and arrows, seem intent on the work of death. In the middle distance by the side of a brook, Mr. Harris has fallen beneath the blows of his assailants, he is endeavouring to defend himself, while a number of natives stand over him striking him with their deadly clubs and spears. Mr. Williams alarmed by the exclamations of those in the boat and hastening from the fatal shore, has just got within the spray of the flowing tide, when he is brought to the ground by a blow from the club of one of the natives. The savages then, alas, massacred the unfortunate missionaries and ate them.

The news of this terrible event shocked the world. Baxter produced two large prints in commemoration: 'The Reception of the Rev. J. Williams at Tanna in the South Seas the day before he was Massacred' and 'The Massacre of The Rev. J. Williams and Mr. Harris at Erromanga'. (Plate 5) He donated the profits from the prints to the fund set up to help the Williams family. (See Historical Note at the end of this chapter.)

Baxter's work with the missionary societies was now greatly increased. He worked for the London Missionary Society, the Baptist Missionary Society, and the Wesleyan Missionary Society, printing thirty-five missionary subjects in all, which included nine different portraits of the Rev Williams. This work, which was destined to enhance his reputation and was most satisfactory to him spiritually and artistically, was, owing to his methods of work and ceaseless search for perfection, commercially disastrous and helped towards his financial débâcle in 1844.

One curious by-product of Baxter's missionary work was his commission to execute portraits of Charles Chubb, founder of the famous firm of locksmiths, and his wife Maria. The Chubbs had eight children, one of their daughters being married to Dr Elijah Hoole, secretary to the Wesleyan Missionary Society. All the Chubb children wanted portraits of both their parents, and, sixteen oil paintings being out of the question, Dr Hoole suggested that Baxter execute a pair of the portraits for each of the children.

This was arranged, and for a fee of £60 Baxter painted portraits of the couple and produced nine or ten pairs of prints from his pictures. As such a small number was produced, these prints have assumed a rarity value, one pair being sold at Puttick and Simpson's Auction Rooms on 10 July 1924 for £900—still the world record for a pair of Baxter prints. The Victoria and Albert Museum has the portrait of Mrs. Chubb, the Maidstone, Reading and Lewes collections have the pair.

In 1846 the newspaper *The Patriot* which was associated with the missionary societies, printed the following announcement:

> The publishers of The Patriot have been considering how they might suitably acknowledge the 14 years support afforded to their journal by their patrons. They now announce how at vast expense this desirable end will be achieved. It is proposed to issue a series of expensive and costly gifts to regular subscribers. These will consist of large and magnificent portraits of the most celebrated British Missionaries, and in order to ensure the highest merit, George Baxter, the ingenious inventor, and sole Patentee of the beautiful art of oil colour printing has been engaged at great expense, and once in six months, each actual subscriber will be presented with a beautiful portrait to the value of £1.

The first gift portrait issued with the paper was 'The Lamented Missionary, The Rev. John Williams' (see Plate 6); the second of Rev. William Knibb, who was instrumental in the abolition of slavery in the West Indies, and the third and last was of Robert Moffat, the father-in-law of Dr Livingstone.

This was not intended to be the last of the series, but once again Baxter was so late with his deliveries that the publishers of *The Patriot* lost their patience, and ended the scheme and their association with him in 1847. This marked the end of Baxter's missionary work.

Two books which Baxter illustrated during this period should be mentioned. The first was a monumental work entitled *The History of the Orders of Knighthood of the British Empire and The Order of The Guelphs of Hanover; with an account of the Medals, Clasps and Crosses conferred for Naval and Military Services* by Sir Nicolas Harris Nicolas, KGMC.

Baxter executed the frontispiece, title page, and twenty plates for this work, which was in four volumes. Of the plates, the printer, Charles Wittingham, wrote:

> No expense will be spared to make the volume worthy of the noble names it will record: and to make it strictly correct arrangements have been made with Mr. George Baxter, Patentee for Printing in Oil Colours, to execute the illustrations in his best manner, from drawings made by Mr. Hunter (Robe Maker to Her Majesty by Appointment) from the actual insignia of the several orders, and all the engravings with facsimiles of the originals.

The plates are very beautiful: the frontispiece, which shows Queen Victoria standing in a Garter Stall, is a riot of colour, the golds, reds, and

blues, of her robe glowing even today, 130 years after the book was printed. The plates of the collars and jewels of the orders are also most splendid, the golds, enamels, and jewels reproduced in meticulous detail and standing out brilliantly.

Perhaps one of the most interesting plates is that showing the medals awarded to Lord Nelson, The Duke of Wellington, and Thomas Hardy. The latter is inscribed: 'Thomas Masterman Hardy, Esq., Captain of HMS Victory defeated the combined fleets of France and Spain 21 October MDCCCV.'

The second book is chiefly remarkable for its title, which must be of record length even for Victorian days. Baxter engraved thirteen plates of technical diagrams for Isaac Frost's scientific work: *The two systems of Astronomy. First the Newtonian systems, the rise and progress thereof, by a short historical account, the General theory with a variety of remarks thereon. Second, the system in accordance with the Holy Scriptures, showing the rise and progress from Enoch, the seventh from Adam, the prophets, Moses and others in the First Testament; Our Lord Jesus Christ and His Apostles in the New or Second Testament, Reeve and Muggleton in the third and last Testament, and a variety of remarks thereon by Isaac Frost. Nevertheless, we, according to His promise, look for new Heavens and a new Earth, wherein dwelleth righteousness.*

This is an extremely rare book, the plates being uncoloured and showing by various graphs and charts 'Heaven, the residence of God, infinite in length, breadth and height, The Kingdom of Eternal Life and Light.'

Historical Note

The Erromangan Chief who had killed the Rev Williams was later converted to Christianity. He was contrite about his murderous deed, and presented the club, with which he had struck the fatal blow, to the missionary who converted him. This club was in the museum of the London Missionary Society until 1966, in which year the missionary societies merged and became the Council of World Missions. It is now in the archives of the CWM at their headquarters, Livingstone House, St James, as is a proof copy of Baxter's portrait of 'The Lamented Missionary, The Rev. John Williams'.

In 1844, in order to commemorate the Rev John Williams, a missionary ship was named after him, thus founding the 'John Williams Line' which is still in existence. There have been seven 'John Williams', which are:

John Williams I (Barque)	Launched at Harwich and sailed 1844. Based at London to which she returned four times. Her cruises between Australia and the islands each lasted three or four years. Wrecked on Danger Island, 1864.
John Williams II (Barque)	Built at Aberdeen. Sailed 1866. Wrecked on her first voyage on Savage Island (Niue) in 1867.

John Williams III (Barque)	Built at Aberdeen. Sailed 1868. Based at Sydney, NSW. Never suffered an accident in 26 years. Sold 1894 and disappeared on her first voyage under new management.
John Williams IV (Steamer)	Built at Glasgow. Sailed 1894. Based at Sydney. After 36 years' service sold in 1930 to a firm of Shanghai merchants. Became a 'China coaster'.
John Williams V (Auxiliary Motor Schooner)	Sailed 1930. Based on Suva, Fiji Islands. Voyaged regularly among the Gilbert and Ellice Islands. Wrecked off Savai'i on her last voyage, Christmas 1948.
John Williams VI (Diesel driven)	Named by HRH Princess Margaret at London and sailed 1948. Based on Suva.
John Williams VII	Named by HRH Princess Margaret, Countess of Snowdon, at Tower Pier London, 29 November 1962.

Chapter 3 1844–1850

On 27 March 1844 Baxter moved to 11 Northampton Square, Islington, where he was to remain for the remainder of his career, enlarging the premises by incorporating the next door house, No 12, in 1851. He immortalized the front door of No 11 on his print 'Morning Call' (see Plate 15).

The seven years from 1844 to 1850 were his most successful period from the commercial angle, and probably the only time in which he made a profit from his prints. After his chastening experience with his royal and missionary prints, he turned his attention to publishing smaller pictures which were easier to produce, and cheaper to sell. Here he was helped by the vogue current at the time for ladies' pocket books. These small elegant volumes, usually leather bound and gilt edged, were considered most suitable gifts for Victorian ladies, for they improved the mind and increased the knowledge of the recipient.

Baxter's most prolific publishers in this field were Suttaby and Co of Stationers Court, who produced many series issued annually. Each volume contained, in addition to an engagement diary and almanack, short stories, poems, 'charades and enigmas', fashion pictures, and landscapes. It was with these landscapes that Baxter found his most remunerative work. Until 1846 all illustrations in these books had been in black and white, but on 5 December 1846 the *Sussex Express* printed the following announcement:

> Messrs. Suttaby, who for upwards of 50 years have maintained the highest reputation as publishers of ladies pocket books, have this year called to their aid the celebrated patentee of colour printing, Mr. G. Baxter, who has embellished their pocket books with some of the most beautiful gems of art, and this has been done without any increase to the public. Every pocket book contains one or more of Mr. Baxter's productions, which is worthy of a place in the boudoir as a cabinet picture.

The books in the series that Baxter illustrated for Messrs Suttaby were *Le Souvenir, The Sovereign Pocket Book, Carnan's Ladies Complete Pocket Book, Marshall's Cabinet of Fashion*, and *Poole's London Repository*. He also illustrated the pocket books issued by Ward & Co of Paternoster Row for the Religious Tract Society, and *Little Richard's Almanack* published by Kent & Co, also of Paternoster Row. Each pocket book contained from one to five prints with short explanations of the pictures. Baxter poured out a great number of landscapes and small pictures for this purpose. All his small landscapes were used in pocket books. They are listed, with the title and series in which they appeared, in the Appendix of Prints at the end of this book. As an example, I give the prints and 'Descriptions of the Plates' which appeared in *Le Souvenir Pocket Tablet* for 1848:

Description of the Plates

Frontispiece—The Bride

Forever thine, whate'er this heart betide,
Forever mine, where'er our lot be cast,
Fate, that may rob us of all wealth beside,
Shall leave us love—'till life itself be past.

The world may wrong us, we will brave its hate,
False friends may change, and falser hopes decline,
Though bowed by cankering cares, we'll smile at Fate,
Since thou art mine, beloved, and I am thine!

Forever thine, when circling years have spread
Time's snowy blossoms o'er thy placid brow,
When youth's rich glow, its 'Purple light' is fled,
And lilies bloom where roses flourish now.

 Say, shall I love the fading beauty less
Whose springtide radiance has been wholly mine?
No—come what will, thy steadfast truth I'll bless,
In youth, in age—thine own, for ever thine!

For ever thine; at evening's dewy hour,
When gentle hearts to tenderest thoughts incline;
When balmiest odours from each closing flower
Are breathing round me—thine, for ever thine!

For ever thine! 'mid Fashion's heartless throng;
In courtly bowers; at Folly's glided shrine;—
Smiles on my cheek, light words upon my tongue,
My deep heart still is thine—for ever thine!

For ever thine, whate'er this heart betide;
For ever mine, where'er our lot be cast;
Fate, that may rob us of all wealth beside,
Shall leave us love—till life itself be past!

AAW

Andalusian Ladies

The Andaluzas (says the author of "A summer in Andalusia") take prece-
dence of all the women of Spain in point of beauty, grace and vivacity. When I

Plate 3 'Interior of the Lady Chapel Warwick'

Plate 4 'Jenny Deans' Interview with the Queen'

had been some short time in the country, I began to wonder how it was that on first landing I had experienced disappointment. The fact is, that "the features of the Andaluzas", as observes their countryman, Blanco White "seem to improve every day, till they grow beautiful." An Englishman, just arrived from his own land, with the clear complexions of his countrywomen fresh in his memory, is hardly capable of doing justice to the dark-skinned Andaluzas; but, after a short time, he begins to find their full black heart-searching eyes, their elegant forms, and graceful steps, not inferior to the more delicate but less graceful charms of his fairer compatriots, and that the duskyness of their complexions

> "Is but the embrowning of the fruit, that tells
> How rich within the soul of sweetness dwells."

It is worthy of remark, that while some travellers have extolled Spanish beauty to the skies, others have passed through the country and seen scarcely one woman whom they deemed beautiful. Dr. Southey expresses his disappointment in the Espanolas; and Inglis saw little beauty in Spain, yet was compelled to confess some admiration of the Andaluzas. He, whose standard of beauty is confined to blue eyes, light hair, and a clear ruddy complexion, will see little to fascinate him in this sunburnt land; but the impartial observer will find it difficult to deny that in material charms the Andaluzas are excelled by few of their sex.

Claremont

The mansion of Claremont near Esher, in Surrey, was originally built by the Duke of Newcastle, who named it from his title of Earl of Clare. It was subsequently purchased by Lord Clive, who pulled it down, and employed the celebrated Capability Brown to erect the building which now exists. After having passed through the possession of Lord Tyrconnell, and C. R. Ellis, Esq., it became the property of Prince Leopold, the husband of the late Princess Charlotte, and now King of Belgium. It is an elegant structure, built in imitation of one of Palladio's designs, with a noble portico, supported by Corinthian columns, with a flight of steps leading to the grand entrance of the house, which is a square building, and occupies a considerable space of ground. The engraving represents the garden front. Standing on an elevation, its north and east fronts command extensive views over Clagget Woods, and a fine opening towards Box Hill, and the scenery of Norbury Park and Fetcham. The south side looks towards St. George's Hill, but is very much closed up by wood. The park forms a circumference of five miles. In front of the house, at some distance to the left, is a sheet of water; beyond this, the grounds abound with noble timber, which ranges in a circular direction all the way to the gamekeeper's lodge, from whence the woods take a sweep round the extremity of the grounds, and close up the park towards the high road. The farm, surrounded with wood, is between the road from the lodge gate and the sheet of water in front of the mansion. The gardens are extensive, and contain every species of the choicest fruit. The shrubberies, etc., behind the house, have avenues cut through them in a variety of directions. Her Royal Highness, the Princess Charlotte of Wales, resided and died in this mansion.

The Conchologists

When some species of shells are held to the ear, a low murmuring sound is heard, which bears a resemblance to the rippling of waves on the seashore. It is probably occasioned by the passage of air through the interior of the shell. One of the fair conchologists is represented as listening to it. Landon, in his poem of Gebir, has a beautiful allusion to this property of the shells in question. A sea-nymph says to Tamar, the brother of Gebir

> "——I have sinuous shells, of pearly hue
> Within, and they that lustre have imbibed
> In the sun's palace porch; where, when unyoked,
> His chariot wheel stands midway in the wave.
> Shake one, and it awakens; then apply
> Its polished lips to your attentive ear,
> And it remembers its august abodes,
> And murmurs as the ocean murmurs there."

The Chalees Satoon, on the Jumna side of the Fort of Allahabad

The Chalees Satoon, or the Forty Pillars, is a pavilion attached to the Palace of Allahabad, and was erected by the Emperor Akbar. It is built of grey granite and freestone.

The Fort of Allahabad is favourably situated on the point where the rivers Ganges and Jumna unite. The numerous vessels to be seen on these rivers, particularly on the former, give great spirit to the scenery.

The buildings in general here are in the grandest style of Mahommedan architecture.

Allahabad is a very ancient city, resorted to by many devout pilgrims from all parts, and conveniently situated for defence and commerce in an angle formed by the junction of the Jumna and Ganges. 296 miles S.E. of Agra, 703 from Hydrabad, 550 from Calcutta, 90 from Onde, 977 from Bombay and 1055 from Madras. Some writers suppose this to have been the site of Palibothra, which others may have placed at Patna, at Canoge and near the mouth of the Soane. The fort, a structure of immense size, but of little strength and no elegance, is said to have been constructed during the latter years of Akbar's reign. It contains an imperial palace, built of stone, and several ornamental buildings.

The soil, for several miles in its vicinity, consists of mortar, broken pottery and brick dust. The present city, containing about 16,000 inhabitants, exhibits a picture of poverty, ruin and desolation, though the straggling huts cover a space of five miles.

Baxter had no rivals in the art of colour-printing until the year 1847. (Charles Knight had patented a colour-printing process in 1838, but his process differed from Baxter's in that Baxter coloured with blocks an impression from a plate, while Knight printed his colours first from blocks and then added impressions from plates.) In 1845 three of his former apprentices,

Charles Gregory, Alfred Collins, and Alfred Reynolds, who had completed their indenture in 1843, established themselves in business at 108 Hatton Garden, Holborn. They did not make any immediate impact on the printing world, but in 1846 they managed to secure Baxter's old premises at 3 Charterhouse Square, and from here they not only obtained work from several of his patrons, but they produced prints, more or less on Baxter's lines, using their knowledge of his process to keep themselves from infringing his patent, and on the right side of the law. Baxter bitterly resented this encroachment into a field in which he had hitherto had a monopoly, and his chagrin increased when another former pupil, George Cargill Leighton, began producing prints in the manner in which he had been taught by Baxter.

To counter this opposition, and to distinguish his work from any other, Baxter decided that his prints would in future carry some distinctive sign or imprint, and he designed what has become known as the 'Baxter red stamp'. The first print on which this was used was 'River Scene, Holland'. Originally an illustration to *Le Souvenir*, it was issued in 1847 as a separate print, and had the red stamp on the bottom left-hand corner of the mount. Baxter was continually altering the design of his stamps, and also of the seals which he introduced later. This led to a great deal of nonsense being talked and written about them, particularly in the days of the Second Baxter Society, some of whose writers attributed an almost Talmudic significance to the different variations. In order to try and get this matter into a correct perspective, a full description of the stamps and seals is given in Appendix I.

In 1848 Baxter produced a pair of prints entitled 'The Queen and the Prince Consort on the Balcony' which gave him his largest popular success up to that date. The first, 'Her Most Gracious Majesty the Queen' (Plate 9), portrays Queen Victoria, wearing the order and robes of the Garter, standing on a balcony near Windsor, with the castle and the River Thames forming the background. The balcony has a tessellated pavement, in one of the squares of which Baxter has printed his name and address: 'Baxter's Patent Oil Printing, 11 Northampton Square'. This was the first print on which Baxter 'signed' his name in the actual body of the picture. The companion print, 'His Royal Highness Prince Albert' (Plate 10), shows the Prince Consort also on a balcony near Windsor, wearing military uniform and the Garter riband. There are two versions of this print; it is said that Prince Albert took exception to the first, in which he is shown wearing long blue pantaloons, and so the second version shows him wearing cream buckskin riding breeches and top boots. Naturally, over the course of years, the prints have become known as 'Prince Consort, Blue Breeches', and 'Prince Consort, Cream Breeches'.

In 1849, Baxter was once again faced with annoyance from his former apprentices. His patent expired in that year, and on his application for a renewal he found this fiercely opposed by George Cargill Leighton, who appealed to the Privy Council:

My Lords,

George Baxter Patentee of Oil Colour Printing, having had the benefit of his Patent for 14 years, and refusing to grant a licence, has applied for a renewal, or extension of the said Patent.

I, George Cargill Leighton of 19 Lambs Conduit Street, Holborn, together with the undermentioned persons, Alfred Reynolds, of Stoke-upon-Trent, Alfred Crew, of Holborn, Harrison Weir, Thomas Thompson and Thomas Dowlem, all of whom have served an apprenticeship to the aforesaid George Baxter's Patent with the intention of PRACTISING SAME when at liberty so to do, do hereby object to the Petition for the renewal of George Baxter's Patent for Printing in Oil Colours being Granted.

15 March 1849

Leighton followed up this objection by filing the following grounds for opposing the petition:

(1) Because renewal to Mr. Baxter of the right to the exclusive use of working his process would totally debar me (Leighton) together with others who have likewise served an apprenticeship of seven years (under the full impression of participating in its advantages at the expiration of the patent granted to him) from enjoying any benefits in return for such service.

(2) Because of my application to him for a Licence, or the consideration of the terms on which he would allow me the use of it until the expiration of his Patent, He, notwithstanding the aforementioned claims which I have given to some participation in its advantages because of my seven year servitude to him as an apprentice, declined unconditionally to acede to my request, though I was desirous of paying him a fair consideration on such terms as he might have arranged for such permission, which I asked only on those terms, and not as a gratuitious permission in any way.

The case came before the Judical Committee of the Privy Council on 21 June 1849. The judges were Lord Brougham, the ex-Lord Chancellor who presided over the committee, the Rt Hon S. Lushington, Judge of the Admiralty Court, Lord Langdale, and the Rt Hon Pemberton Leigh, Chancellor of the Duchy of Cornwall. The Attorney General watched the case for the Crown. George Leighton was unrepresented. If he had been represented the case might not have progressed very far, for Lord Brougham knew Baxter well and was an admirer of his work. They had first met in 1844 when Lord Brougham presided over a meeting of the Anti-Slavery Society where it was proposed that Baxter should reproduce a celebrated picture by Hayden (now in the National Portrait Gallery) of Thomas Clarkson, addressing an anti-slavery meeting in 1840. After this meeting, Lord Brougham became a patron of Baxter and allowed him to copy a portion of a tapestry in his possession, producing what eventually became Baxter's most popular print 'Holy Family' (also known as 'The Madonna'—Plate 11).

In a letter to Baxter sent from his Grafton Street home in May 1848, a year before he presided over the Judicial Committee, Lord Brougham wrote:

I want to show the "Madonna" to the Duke of Wellington and others, and, therefore, wish you would send a half dozen copies today.

The trial started most inauspiciously for Leighton. A great number of Baxter prints were presented to the court, including the pair of 'Queen Victoria and Prince Consort on the Balcony'. Lord Brougham immediately admired these pictures and said he would like to purchase them. The petitioners' counsel offered to present His Lordship with a pair, but Lord Langdale interposed saying that if Lord Brougham did not pay for the pictures, he would be accepting a present, and liable for impeachment.

Baxter's counsel called as witnesses first William Baxter, founder of the *Sussex Express*, who told of the time and patience which his brother had spent in learning and perfecting his craft, and two artists, David Roberts, RA, and John Noble, MSBA, who testified that Baxter's discovery was meritorious and one which would make the world acquainted with what is good in art. The case was completed by Baxter's accountant producing his books and ledgers to show that so far he had not profited by his invention.

Leighton produced as his witnesses Alfred Crew and Charles Gregory, but when the latter stated that Baxter had taught him all he knew, and that he was then employed by Mr Kronhiem at a salary of $2\frac{1}{2}$ guineas (£2.62p) a week, the attorney general stopped him and said: 'Then there is the end of the case'. Consequently, he told Leighton to call no more witnesses.

Lord Brougham then delivered his judgement, of which these are the salient portions:

Their Lordships are of the opinion that there is a great merit in this Patent, but it has not been of benefit to the Patentee. Their Lordships are of the opinion that it is of great public utility because making good coloured prints almost with the merit of oil paintings, is of great benefit to the common people, to the cottagers and to the labourers.

It is a pleasure to them, and now it is made a cheap pleasure, it is a very innocent pleasure, and far more innocent than many other pleasures to which they have recourse, and far more refined. It is of an improving nature to their minds, and whatever works tend to give taste of a refined and intellectual nature to the working people are of great benefit, not merely to their happiness, but to their morals and good conduct in society.

It, therefore, appears to their Lordships to be perfectly clear that there is an end of Mr. Leighton's case and that the Patent should be extended for a period. Their Lordships have come to the resolution to extend it for five years without any condition or terms whatsoever.

I hope the Petitioner will have the benefit of the opinions expressed here today which will help him in his further proceedings. My advice is that he should profit by his past experience by selling licences, and not injure himself by speculations as a print seller. A man may be a skilful inventor and a very fit patentee originally to get a grant and to get an extension of the grant, but a very unsuccessful speculator to merchandise goods.

Baxter decided to act on this advice, and granted a number of licences to work his process. The work of the 'Baxter licensees', as they became known, is dealt with in Chapters 6 and 7.

Baxter found a further remunerative field for his work in the production of needle-box prints. The needle boxes consisted of a flat box approximately 6×5in and about $\frac{3}{4}$in deep holding ten small boxes, each 2in long and $1\frac{1}{2}$in wide. The small boxes contained packets of needles, and on the lid of each box was a miniature print, executed with the greatest attention to detail, the ten prints forming a 'needle-box set', with a print on the cover of the containing box of an allied subject. The insides were tinted pink or blue, and the whole item was delicately produced in order to form a suitable and useful gift for Victorian ladies.

Fancy names were given to these sets: the first was 'The Queen and Prince Consort on the Balcony', followed by 'The Queen's Floral Needle Box Set', 'La Tarantella Set' (Plate 12), 'Fairy Scenes Set' and 'Pas des Trois Set' (Plate 13), 'The Allied Sovereigns and Commanders of their Forces' (issued during the Crimean War) and 'The Religious Events Set'. The latter set was also issued mounted on a card, each small print being surrounded by a gold scroll, so that it could be cut into small cards to be used as gifts for Sunday-school children. This led to the introduction of Baxter's pictorial notepaper which consisted of packets of tinted sheets, each headed by a needle-box print, with a large print on the outside of the packet. The idea of issuing the religious events set on a card led naturally to the selling of the other needle-box sets in sheets of ten and strips of five, which the purchasers could cut into separate prints if they so desired.

Chapter 4 1850–1855

There is no doubt that if Baxter had confined himself to the production of those items which were easy to make and sell, such as the pocket-book and scrap-book illustrations, needle-box sets, and notepaper, he would have made his process pay, and been commercially successful. Unfortunately, he once again came under the influence of the royal patronage which had already had such a disastrous effect on his finances, and the lure of 'prestige productions' was too strong for him to resist.

Lord Brougham had continued to take a great interest in Baxter's work, and in May 1850 took him to Buckingham Palace for an interview with Prince Albert. The *Sussex Express* of 18 May 1850 loyally chronicled the event:

> Mr. George Baxter had the honour of being taken to attend Buckingham Palace by Lord Brougham by Command of the Prince Consort to show His Royal Highness the picture of "The Madonna" taken from a splendid tapestry belonging to Lord Brougham, and to explain to the Prince Consort the process of Oil Colour Printing, as employed in this beautiful Cabinet Picture.

Prince Albert showed a great interest in Baxter's work, and during the discussion he intimated that he much preferred Baxter's larger prints. At this time the prince was deeply involved with the organization of the Great Exhibition of 1851. The idea for a national exhibition had been put forward in 1844 by Mr Wishaw, Secretary of the Royal Society of Arts, but it did not gain much ground until 1849, when Prince Albert, who was then President of the Royal Society, announced at the annual meeting:

> Now is the time to prepare for a Great Exhibition, one worthy of the greatness of this country, not merely national in its scope and benefits, but comprehensive of the whole world. I offer myself to the public as their leader, if they are willing to assist in this undertaking.

Naturally, with this impetus the whole project exploded, and Britain was in the grip of 'exhibition fever'. The exhibition was planned to open in Hyde Park in 1851, but by 1850 no design for the building had been chosen. After 245 plans had been rejected, Sir Joseph Paxton came forward with his design for a glass building. His plans and specifications were completed in a few days and submitted to the prince at Buckingham Palace. The projected design was next published in the *Illustrated London News* of 6 July 1850, and instantly found universal favour. Apart from its suitability as an exhibition building, the novelty of the design was in itself an attractive exhibit and helped to make the undertaking a success. The erection of this huge structure was facilitated by Paxton's original details of measurement. Everything in the building was a dividend or multiple of twenty-four; scaffolding was almost entirely dispensed with, and little machinery was used in its construc-

tion. Its extreme length was 1,848ft, with a width of 408ft. The entire area of the building occupied about nineteen acres, nearly seven times as much as St Paul's Cathedral. Work upon the site was begun on 30 July 1850; the first column was placed in position 26 September, and all was ready for the opening by the queen on 1 May 1851. This occasion gave *Punch* an opportunity to poke good-humoured fun:

> You must see they call me early—call me early, there's a dear!
> To-morrow will be the best of a joke of all the days in the year.
> No doubt 'twill go off well love—but still 'tis a trying day,
> For I am the Queen, and it's May, my dear; I am the Queen
> and it's May.
>
> Pray tell Gold-Stick in waiting that the moment he's awake
> He'll have all the Bed-Chamber ladies up before the day doth
> break:
> You know those horrid robes of State must be put on for the day,
> For I am the Queen, and it's May, my dear; I am the Queen
> and it's May.
>
> Little Albert shall go with us—it is well he should be seen,
> And you'll take care and bow my dear when they cry 'God save
> the Queen';
> When I can't bow to them myself, any longer, that's to say:
> For I am the Queen, and it's May, my dear; I am the Queen
> and it's May.
>
> The carts still come and go, I hear, into the house of glass;
> And the helpless folks in Knightsbridge they grumble as they
> pass;
> But, of course, dear, all must be ready, or what will people say?
> For I am the Queen, and it's May, my dear; I am the Queen
> and it's May.
>
> So you'll see they call me early; call me early, there's a dear!
> To-morrow will be a triumph for you, love, never fear;
> But still, you know, it's sure to be a very fatiguing day,
> For I am the Queen, and it's May, my dear; I am the Queen
> and it's May.

Baxter, of course, had whole-heartedly entered into the project. Throwing caution to the winds, he enlarged his premises by acquiring the next door house, No 12 Northampton Square, and started work. His first product was *Baxter's Pictorial Key to the Great Exhibition and Visitor's Guide to London*, which was presented as a companion to the official guide. Written in English, French and German, it contained a plan of the exhibition building, a guide to London, and the sights to be seen in the surrounding countryside.

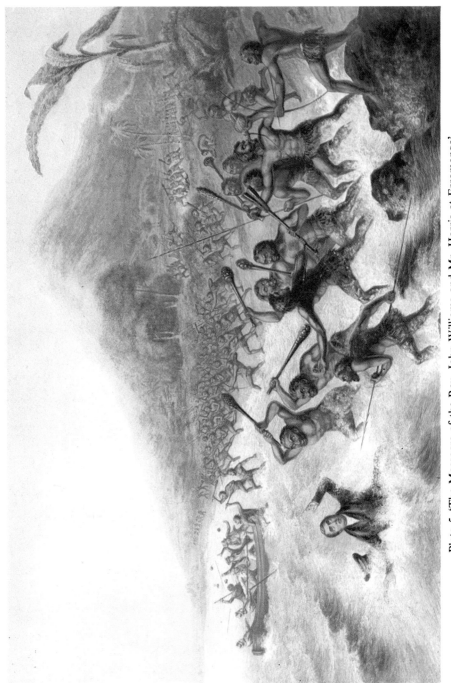

Plate 5 'The Massacre of the Rev. John Williams and Mr. Harris at Erromanga'

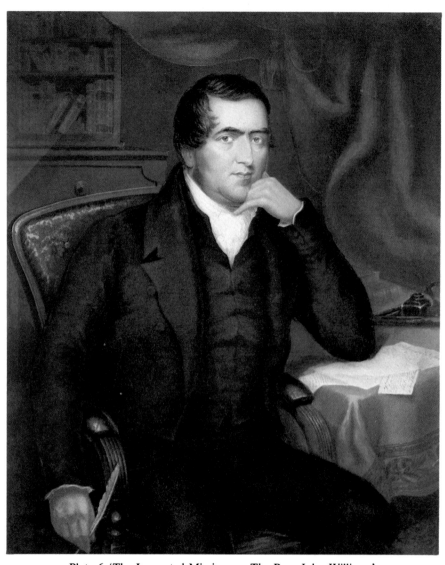

Plate 6 'The Lamented Missionary, The Rev. John Williams'

Plate 7 'The Bride'

Plate 8 'The Conchologists'

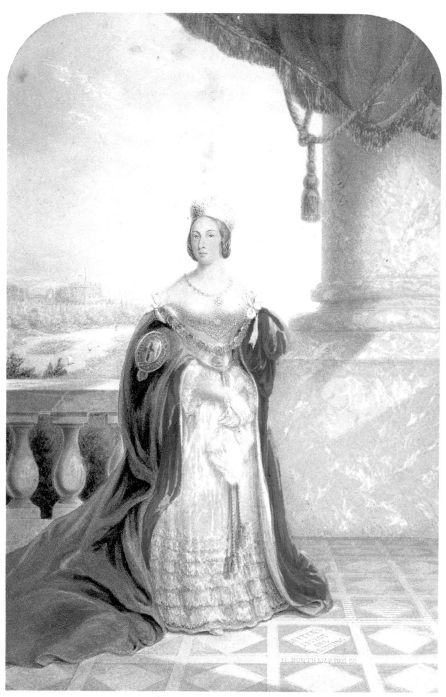

Plate 9 'Her Most Gracious Majesty the Queen'

Baxter had obviously taken to heart the advice given him by Lord Brougham at the privy council appeal, as the 'key' included the following advertisement:

Licences granted to work Baxter's Patent Process of Oil Colour Printing, in Great Britain 200 guineas, in France, Belgium, Germany etc. 1260 Francs, instructions to licencees at 11 and 12 Northampton Square, London.

Unfortunately, due to Baxter's incurable inability to have anything ready in time, the 'pictorial' portion of this book consisted of only two pictures of The exterior of the Great Exhibition and the new Houses of Parliament, which opened in 1852. The most remarkable section of the 'key' is Baxter's introduction. This shows the euphoric state that his mind was in at the time. He was certainly riding high, working with the Prince Consort, and being received by kings and emperors. The introduction in full is:

In submitting to the world Baxter's "Pictorial Key to the Great Exhibition and Visitors' Guide to London", the proprietor deems it a favourable opportunity which has attended his exertions to improve the hitherto imperfect style and effect of colour printing. In the Fine Arts Court of the Crystal Palace are exhibited upwards of sixty specimens of Baxter's Oil Colour Printing, consisting of Historical and Architectural subjects, landscapes, portraits and flowers, and such has been the demand for these gems that it has been requisite to reproduce them, the sale of some having exceeded 400,000. It may very naturally be asked what has produced this extraordinary patronage. From many enconiums bestowed by the public press on the Patentees productions, he flatters himself he is justified in asserting that, whether as works of mechanism or of art, the minuteness of detail and the fidelity of their execution form no insignificant attributes to their success—of their delicacy, brilliancy, transparency and harmony of colour no doubt is entertained; these grand features which produce extraordinary effect render every print a picture in the fullest sense. They have another prominent feature, and one of which the Patentee is pre-eminently proud, that while artistic beauty may procure for them a place in the Royal Palaces throughout Europe, the price at which they are retailed introduces them to the humblest cottage. . . .

The Patentee has ever been convinced that cheap artistic pictorial illustrations are calculated to prove a great benefit to the million, as a higher important addition to the means of youthful instruction, and he flatters himself that on this point his exertions in Oil Colour Printing have been pre-eminently successful, as by no other means can such extreme detail, such truthful colouring, and such unlimited numbers be produced. In almost every part of the habitable globe Baxter's Oil Colour Prints have had a most favourable reception. There is scarcely a town or village in Great Britain, or in the whole continent of Europe, which they have not found admirers, and this, in the face of high art in the principal cities of France, Germany etc., is a circumstance engendered in the inventors mind a source of personal gratification. The elaborately decorative inhabitants of the East have also borne unqualified testimony to their beauty, and China has foregone its usual exclusiveness, and admitted them to the "Celestial Empire."

The Patentee could say more, but fearful of the charge of Egotism, he must content himself and conclude with expressing his sincere thanks to his patrons, assuring them that his grandest aim will ever be to secure for Oil Colour Printing every maximum quality that it is possible for Science and Art to accomplish.

The period between 1850 and 1855 must certainly have been the zenith of Baxter's career. He said at one time that he produced twenty million prints in his lifetime. If this is correct, the bulk of that quantity must have been manufactured during these years. Of 'The Madonna' alone, later known as 'The Holy Family', he sold 700,000 copies.

Baxter was hard at work on his exhibition series, but the only print which was ready for opening day was 'The Exterior of the Great Exhibition'; its companion print, 'The Interior of the Great Exhibition', was not ready until closing day, 15 October 1851. However, as the building was transferred to South London—Queen Victoria opened the Crystal Palace, Sydenham, in 1854—he was able to have his book *Gems of the Great Exhibition* finished in the intervening years and ready for issue in 1854.

The 'gems' were large prints about 9×5in in size (exact measurement are given in the Appendix of Prints), all except Gem No 7 having domed tops with gold borders. The gems each showed a different court of the exhibition. The first five gems each have three groups of statuary in the foreground, and were designed so that one could cut them into three separate prints, a similar idea to the needle-box strips (Plate 14).

The book, which was dedicated to Franz Joseph, Emperor of Austria, had nine gems: 1 'The French Department'; 2 'The Belgium Department'; 3 'The Russian Department'; 4 'The Foreign Department'; 5 'The Austrian Department'; 6 and 7, 'The Amazon' and 'The Veiled Vestal', single groups of statuary; 8 and 9, the exterior and interior of the Great Exhibition. Baxter also issued seventeen prints of groups of statuary obtained by cutting the first five gems into three, together with gems 6 and 7 as the 'Single Statue Gems'.

The Emperor of Austria bestowed on Baxter the Great Gold Medal of the Austrian Empire as an act of appreciation. The *Sussex Express* of 5 June 1852 records the event as follows:

On Thursday last Baron Hubeck informed Mr. George Baxter that he had received instructions from His Imperial Majesty the Emperor of Austria to present him with a Gold Medal for "Literary and Artistic Merit", and on the afternoon of that day Mr. Baxter waited by appointment upon The Baron at the Austrial Legation, and he had the honour of receiving this valuable present. Baron Hubeck in presenting it, complimented Mr. Baxter upon the success which had attended his invention of the beautiful art of Oil Colour Printing, and especially those productions representing the Departments of The Great Exhibition of 1851, which surpassed in detail and beauty of execution all the other productions of a similar character which had been produced. This medal is the highest compliment that Mr. Baxter could receive, as it emanates from a Government that does more in its own printing office for

Lithography than has been affected by any other Nation. It may be remembered that the Austrians exhibited at The Crystal Palace the best specimens of Lithographic coloured drawings, very far eclipsing all the French, English and American drawings in the same style, and with the exception of Mr. Baxter's specimens in the rival art of Oil Colour Printing, surpassing all the other printed pictures of the Exhibition. To receive, therefore, from his generous rivals this mark of respect for his talent, is an honour far more valuable than any other, and one which does great credit to the Austrian Government.

This article may, of course, have been meant as a reprimand to the Fine Arts Committee of the Great Exhibition which awarded Baxter only an 'honourable mention'.

The 1851 exhibition was a great personal success for Prince Albert, and his venture started a series of similar events in other countries. Baxter received medals for his exhibits at the New York Exhibition of 1853, and the Paris Exhibition of 1855, which Queen Victoria and the Prince Consort honoured with their presence.

Baxter now greatly widened the field of the subjects for his prints. In 1852 he issued 'So Nice', which was the first of those prints which so well illustrated different facets of contemporary Victorian life, The cheerful little crossing sweeper in 'Copper Your Honour', the little chimney sweep in 'Morning Call' (Plate 15) and the other presentations in this series are figures which must have been commonplace in those times and are now gone forever.

He also began to produce topical prints influenced by events of the day. The Crimean War prompted the issue of four prints. News from the battlefront must have been very scarce at the time, as the only print which depicted an actual event of the war was 'The Siege of Sebastopol'. The other three prints were obviously contrived to capture the public's interest in the war:

'The Soldier's Farewell or the Parents' Gift' depicts a wintry scene with bare trees and the ground covered in snow. At the gate of his cottage, a tall guardsman holds his sobbing wife to his breast with his right hand, while with his left he accepts a parting present of a Bible from his father, as he bids his family farewell.

'The Review of the British Fleet at Portsmouth'. Of this event *The Times* wrote:

Some faint idea may be formed of yesterday's review from the aggregate of guns, horse power, and tonnage of the Fleet involved, there were employed 1,076 guns, the power of 9,680 horses, 40,207 tons of shipping, and ships companies that amounted to 10,423 hands. . . . The Queen in Her yacht led the squadron to sea, occupying a central position between "The Duke of Wellington" on the starboard side and "Agamemnon" on the port. The fleet reached Spithead about 6 o'clock, and on its arrival the signal was given for the gunboats of all the ships to assemble manned and armed round the Royal

yacht. This terminated a spectacle unprecedented in this Country and that could be produced nowhere else.

The companion print records another event of August 1853, 'The Charge of the British Troops on the Road to Windlesham'. *The Times* recorded this event on 5 August 1853:

> In Catlins Valley Lord Seaton proceeded to fight a Grand Battle. . . . While the retreating squadrons sought the cover of their guns. . . . The whole line advanced by Brigades to the charge which was executed with splendid effect. The Guards rushed on impetuously on the right, and Sir R. England's Brigade on the left. The charge in which the whole Brigade joined, the Blues and the Scots Greys in the centre, with the Hussars and Light Dragoons on either side, was the finest thing of the kind we have witnessed, and electrified every onlooker by its brilliance.

The gold rush inspired 'Australia: News from Home' and 'News from Australia', and the death of Wellington 'The Funeral of the late Duke of Wellington'. Portraits of celebrities were excellent sellers—those of Lord Nelson and the Duke of Wellington (Plate 16) each sold over 300,000 copies. He produced portraits of Queen Victoria, Prince Albert, the Prince of Wales, the Princess Royal, Sir Robert Peel, Napoleon III, and many other soldiers, sailors, statesmen, and royalty. One curiosity among Baxter's portraits is that of Edmund Burke. This small print ($2\frac{1}{2} \times 3\frac{1}{2}$in), which shows the famous statesman as a young boy with long brown hair and a lace collar, was copied from a sketch made by Sir Joshua Reynolds in the possession of Lord Brougham. A copy of this print was sold at Puttick and Simpson's auction rooms in April 1926 for £250.

At this time Baxter also produced the five prints which have become known as 'Baxter's young ladies'. These large prints, made in deference to Prince Albert's liking for larger pictures, are 'The Day before Marriage', 'The Fruit Girl of the Alps', 'The Bridesmaid', 'The Lovers' Letter Box' (Plate 17) and Baxter's largest print 'The Parting Look'. Prince Albert took a personal interest in this print, which represents the scene from the *Vicar of Wakefield* in which Olivia leaves her parents' home. The first version depicted a servant carrying Olivia's trunk down the path, but Prince Albert preferred the young lady to be shown on her own, so Baxter painted 'The man with the box' out of later versions.

Another field for Baxter's work at this time was the decoration of sheet-music. Here he worked with a most extraordinary character, the French composer and conductor, Julien, who held a series of annual concerts at the English Opera House. He always employed the largest orchestra and the best musicians and soloists he could procure. His speciality was the 'topical quadrille'. Every year he produced a quadrille or 'galop' descriptive of some important event of the day. Some of those which used Baxter's themes were: 'News from Home Quadrille', 'The Prince of Wales Galop', 'The Hibernian Quadrille', 'The Queen's Town Galop', and 'Vive l'Empereur Galop'. For

these he would augment his orchestra with as many as six military bands. He had a special ivory baton bedecked with jewels to conduct these *pièces de résistance*. This was brought to him, together with a new pair of white gloves, on a silver salver while he reclined in his elaborate crimson and gilt chair. He became known as 'The Mons' after a cartoon about him in *Punch*, which described him as:

> An imposing figure, coat flying wide open, white waistcoat, elaborately embroidered shirt front, wrist bands of enormous length, a mass of black hair and an enormous moustache. With indescribable gravity and magnificence he went through the Pantomime of the Quadrille he was conducting and at the finish sank exhausted into a gorgeously upholstered armchair he had ready for the purpose.

Baxter must have given considerable thought to the method by which he might advertise his offer for licensees. He devised a most ingenious solution to the problem by which he was able to advertise the offer at almost no cost to himself. His method was to use his red stamp seal which gave the title of the print, Baxter's name and address, and the wording 'Inventor and Patentee of Oil Colour Printing'. Underneath was printed 'Licences granted to work the Process', which was later changed to 'Licences granted to work the above process in Great Britain 200 Guineas, France, Belgium etc. etc., 1260 Francs, instructions given to Licensees 252 Francs'.

His advertisements brought results for six English firms purchased licences. The 'Baxter Licensees' were Myers & Co, 4 Budge Row, Cannon Street, London; William Dickes, 5 Old Fish Street, Doctors Commons, London; Bradshaw and Blacklock of Manchester and 59 Fleet Street, London; Joseph Mansell, 35 Red Lion Square, London; Joseph Kronhiem of 36 Paternoster Row, London, and Le Blond & Co, 4 Wall Brook, London. As far as is known, no continental firms availed themselves of this offer.

Chapter 5 1856–1866

By 1856 the clouds were once more gathering over Baxter's career. The preceding five years had seen him become rich in prestige, but poor in pocket. His book *Gems of the Great Exhibition* was published too late to reap the market of the exhibition itself. Now he found that he not only had to contend with the rivalry of his own licensees, but had also to face the competition of the new art of photography, which was arousing great public interest.

The Frenchman, Daguerre, was making a name for himself with his photographs in sepia, called 'daguerrotypes'. To counter this, Baxter produced his 'baxterotype' prints. He evidently decided that religious studies would be the most appropriate subjects for this medium and published his baxterotypes of the famous Raphael cartoons. A short history of the cartoons will explain his reason for this choice.

The cartoons are part of a set of ten commissioned by Pope Leo X in 1513 for tapestries which were designed to complete the decoration of the Sistine Chapel in the Vatican, and which are now exhibited in the Vatican Gallery. The cartoons represent subjects drawn from the lives of St Peter and St Paul. The tapestries were woven in Brussels by Pieter van Aelst, royal tapestry maker to the King of Spain, and were designed by Raphael of Urbino, the famous painter who received from the Pope a thousand ducats for his work. The Papal Master of Ceremonies, Paris de Grassis, records that:

> The Pope ordered his new, most beautiful, and precious pieces of Tapestry to be hung in the Sistine Chapel on Christmas Day 1519, at the sight of which the whole Chapel was stunned, and it was the universal judgement that there is nothing more beautiful in the world.

On arrival in Brussels the cartoons were, according to common practice, cut into strips to facilitate their use, and almost immediately came to be regarded as major works of art in their own right. By 1623, they had been returned to Italy, and on the 28 March of that year, Charles, Prince of Wales (later to become Charles I of England) wrote from Madrid asking for money to be provided to purchase the cartoons 'For making thereby a suite of Tapestry'.

Accordingly, on 28 June 1623, Sir Francis Crane, Manager of the Mortlake Tapestry Works, founded by James I, journeyed to Genoa, and purchased for £300 the seven remaining cartoons, three having been lost in the hundred years since their execution. Thus the cartoons came into the possession of the British Crown where they have remained ever since. About twelve sets of the tapestries were made by the Mortlake Works; the finest of these bearing the Royal Arms of England was bought by Cardinal Mazarin, and is now in the Garde-Meuble in Paris. There is another fine set in Dresden, and others are at Forde Abbey, Belvoir, Woburn and Chatsworth.

In 1700 Sir Christopher Wren was commissioned to rebuild Hampton Court Palace, and he included a gallery for the display of the cartoons. The strips into which they had been cut were pasted together and they were returned, as far as intervening wear and tear would allow, to the form in which they had left Raphael's studios. Sir Christopher Wren refers to the gallery 'to be fitted for the Cartoons with wanscot on the window side and below the pictures and between them, and with wanscot behind them to preserve them from the walls.'

The cartoons remained at Hampton Court until 1763. They were then removed to the 'Saloon' at Buckingham House, where they remained until they were transferred to Windsor Castle in 1787. In 1804 George III ordered their return to Hampton Court. Later in the century Prince Albert became personally engaged in the study of Raphael and his works. It was natural, therefore, that Baxter, when seeking a subject for his religious baxterotypes, should choose one that interested the Prince Consort. After Prince Albert's death in 1861 his eldest daughter, then Crown Princess of Prussia, proposed that the cartoons should be transferred on loan to what was then the South Kensington Museum. The loan was approved by Queen Victoria in 1865, and since that date the cartoons have, by permission of successive sovereigns, remained on public view in what is now the Victoria and Albert Museum.

In 1855 Baxter was elected a member of the Royal Society of Arts, and in 1857 he was presented by the King of Sweden with the Grand Gold Medal of Sweden as a tribute to his methods as an oil-colour printer. In spite of these successes, he was fighting a losing battle as his licensees and former apprentices encroached upon the fields in which he once held a monopoly.

George Cargill Leighton, who had opposed the renewal of Baxter's patent in 1849, was now, with the expiration of the five-year extension, able openly to work the process. The *Illustrated London News* decided to use oil-colour illustrations (the first English magazine to do so) and awarded to Leighton the contract for this remunerative and pioneer work, although it was executed entirely on the lines of Baxter's patent process.

The most formidable competitor to Baxter among his licensees was the firm of Kronhiem & Co. Joseph Kronhiem was a very capable printer, and, in contrast to Baxter, a thoroughly successful business man. He never attempted to achieve Baxter's degree of perfection in his work, but he was able, by his efficient methods, to produce an enormous output and keep his delivery dates. He employed Charles Gregory, another of Baxter's former apprentices who had opposed the renewal of the patent, as his manager. They were able to wrest from Baxter a share in the work of illustrating Suttaby's Pocket Books, and, unkindest cut of all, secured the contract for illustrating those of the Religious Tract Society, completely ousting Baxter.

Although Baxter had advertised for the licensees and had been paid by

them for the right to use his process, he could not accept the fact that they did indeed have this right. He never failed to resent them and imagined that they were passing off their work as his. He constantly changed his mounts and seals in order to prevent their prints being mistaken for his own, and increased the use of his name in the body of the prints. Eventually, he was so exasperated that, in January 1834, he issued the following notice:

CAUTION

OIL COLOUR PICTURES

Many complaints having been made at Mr. Baxter's offices of parties attempting to pass off their hastily got up and inferior subjects as Mr. Baxter's productions by closely imitating his private stamp, which he had introduced to verify the genuineness of his pictures and prevent their being taken for the works of other persons, he begs to give notice to the public that all his future productions will be embossed with his autograph in the centre of the die, and surrounded by the words "Inventor & Patentee, 11 and 12 Northampton Square."

The penalties attached to the imitation of an autograph are well known. To that protection Mr. Baxter feels that he may add the sense of Justice of the public, who are best able to appreciate his Productions.

Attention is requested to the fact that while the name of Baxter is conspicuous on the imitation of the Patentee's Private Stamp, the names of the Licensees are put upon their pictures so huddled together as not to appear to a common observer. Another Licensee has also made similar attempts to pass off his work more closely imitating the Private Stamp of the Patentee by adding the Crown to the imitation.

Patentees office, 11 and 12 Northampton Square

Baxter's temper was not improved by the troubles which had beset him. He quarrelled with everyone with whom he came in contact, except his parents. He almost quarrelled with his father, who admonished him over his attitude to his father-in-law. Although his wife's parents had provided the funds with which he built his house, 'The Retreat', at Sydenham, Baxter had no contact with them.

In 1858 John Baxter died. He forgave his son all his debts, but George Baxter refused to attend his father's funeral. The exact reason for this has until now only been surmised, but I am indebted to Allen Grove, Curator of the Maidstone Museum and Art Gallery, for permission to publish a letter which gives, for the first time, the explanation for his conduct. As Mr Grove writes, the letter came into the possession of the museum in the following manner:

It was given to the Museum (accession No. 24/1938) in 1938 by Miss Sarah Harris, the Grand-daughter of Edwin Harris of Rochester who had been apprenticed to William Baxter. She gave it through Mr. John W. Bridge, F.S.A., who was a member of the Museum Committee. I have a letter which she wrote to him at that time, the relevant parts are as follows:

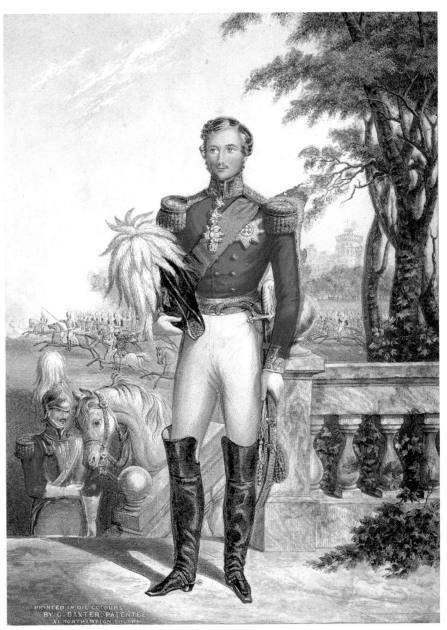

Plate 10 'His Royal Highness Prince Albert'

Plate 11 'Holy Family'

<div align="right">
Hereward,

20 New Road,
Rochester.

12.1.39.
</div>

Dear Mr. Bridge,

Herewith the letter. I think that there is no doubt as to its authenticity. As I told you my Grandfather was for a time "Town" (London) traveller for the firm and I presume that it came into his hands at that time.

<div align="right">
Believe me,
Yours sincerely,
Sarah F. Harris
</div>

Mr Grove adds that Miss Harris' father, Edwin Harris, was a printer and bookseller of Rochester. This is the letter; it is most dificult to read, and a few words are indecipherable:

'The late Mr. John Baxter, Proprietor of the Sussex Express'

Several persons having expressed their surprise that I, the eldest son of the above-named gentleman, declined to attend his funeral by the wish of several friends it is my intention to publish, entirely for private distribution among those connected with our families, a phamplet containing an account of the origin and causes—the "Insults", "Indignities", and "Gross Provocations"—put forth towards me by William Edwin Baxter, now Proprietor of the "Sussex Express", and Mrs. William, his wife; showing how my brother William, without doubt, took advantage of the position he occupied so close to my father's elbow, and used his influence causing himself to be made Executor, to the exclusion of myself—*his elder brother*—who was always miles away pursuing my profession.

In a letter written to me by my late father, which I have by me, he states:—"It is not from any disrespect or want of confidence in you, or any other qualities; only forgive your brother, then I should be pleased in making you both executor." My brother offered me his hand at Lewes, a few days back, evidently only to deceive our dying father. Had he been *sincere* in his desire to bring about a reconciliation, he would have thrown himself in my way while our father was in health, and capable of carrying out his own expressed wish, "that both brothers should be mutual executors". William offering me his hand, only intended to deceive our parent, who was then on his deathbed. I am sorry to say that this disruption of brotherly love has been caused in a great measure by the conduct of Mrs. William Baxter—and the extraordinary temper which she displays towards her husband. I cannot help thinking of a circumstance which took place whilst my brother William and his wife were on a visit at my house. After a grand display of the tantrums, my brother saw Mrs. William to the railway station, popped her into a carriage for Wales; and, with a countenance beaming with joy at his wife's departure returned to my house, offered his hand to my wife, and asked her to accept an apology for Mrs. William's conduct. I feel bound, therefore, in justice to myself, to enter, however reluctantly, into some explanations with my friends;

for which purpose, I intend publishing a History, which will contain, amongst other matters, extracts from letters written by my late father. I shall also include in my statements, letters showing that throughout my life my father and I were united in the sincerest bonds of friendship, and proving that my exclusion from the Executorship did not arise from his want of affection or confidence towards me. Also extracts of letters from my brother William and myself, as well as by other members of the family explaining the "origin and true causes" of his disunion. I may here remark upon their disgraceful mode of announcing my father's death, which was communicated to me by a clerk, under the direction of William. While my brother was in the house, why did he not write the mournful intelligence himself to me as well as to other parties? The announcement of the funeral was written in a most off-hand manner, on two of my brother's Trade Circulars. Could my father have ever believed such an act would have been committed! I was sorry to hear further that there was no clergyman to meet my father's remains at the church. My mother may very properly say, "Oh! William, William; is this the way you commence carrying out the sacred duties of an Executor?" Immediately, on his return from the funeral, up jumped Executor William who seemed in his glory; and, unlocking a cupboard, took out the Will, quite lively and anxious for business. The Will!! The Will!! What a pity it is he did not get a small work published by Bell & Co., London, entitled "Some Practical instructions for the Guidance of Executors"; the fourth paragraph of which runs thus:— "The Executor will act wisely if he causes the funeral to take place, & —— *meal* since to be finished before the Will is opened and read to the persons interested thereunder. Painful expectations may thus often be avoided at a time when all should be tranquil." This quite accorded with a lady's remarks to Mrs. William *on her being desired by him to stay and hear the Will of the late Mr. Baxter read.* She declined to do so, and replied, "We are not mercenary". And being asked her meaning, again answered, "We are not so avaricious after money". She felt indignant at the want of respect paid to the memory of a gentleman by the *premature* reading of his Will *before even the earth had been placed upon the coffin.* It is my duty to make complaints where there is such an unusual and extraordinary cause for them; indeed such a case, take it altogether, never has been known in Lewes, of which place my father was an old and respected inhabitant. William was not admitted to the funeral of my late father in law, Mr. Harrild; in consequence of this he seemed much chagrined. The fact is William was never a favourite of Mr. Harrild's; and Mrs. Harrild seemed pleased that I objected to his company and so did the principal part of the family. William and his wife were friendly with Robert Harrild (only) at that time, but selfish occurrences of the last few years have caused "Birds of a feather to flock together". Of course, if William and I had been friendly, he would have been there. All that I said when the list of attendants was read was, "If William attends I shall retire". Robert Harrild, the *eldest* executor, in a twinkling, dashed his pen through his name as quick as our Guards dashed their bayonets through the Russians. At the funeral of Mrs. Harrild his name was never mentioned.

George Baxter

London,
Nov. 18th, 1858.

At the time of his father's death, Baxter's career was drawing to a close. In 1859 he published only eight new subjects. He had not lost his skill, as the large pair 'Summer' and 'Winter' issued on Christmas Day 1859 equal any of his work. In 1860 he published his final print, 'Dogs of St. Bernard', after a painting by Sir Edwin Landseer—one of his largest prints and one of the very few animal subjects he issued.

Baxter retired in 1860 and set about disposing of his enormous stock of prints, plates, blocks, plant and machinery. To this end he called in the leading firm of auctioneers of the day, Southgate and Barrett, of 22 Fleet Street, London, who advertised as follows:

> A fortnight's sale commencing on 6th May 1860, at 6.00 every evening, of the remaining stock of valuable plates and block, and the Patent, plant, lease, machinery and fixtures. . . . The Purchaser of the lease to have permission to use Mr. Baxter's name as his successor, and the advantage of receiving foreign as well as home orders.'

Unfortunately the sale was not a success. The lease of 11 Northampton Square was sold, but that of No 12, most of the stock of 150,000 prints, the plates, blocks, fixtures, fittings and machinery remained.

Baxter then closed his premises, and travelled the country, holding sales in provincial towns in an endeavour to raise money. These he held in Bristol, Birmingham, Sheffield, Derby, Newcastle-upon-Tyne, Sunderland and Wolverhampton. While they were at Wolverhampton, his manager, Davis, was injured in a railway accident, and Baxter had to abandon this method of disposing of his goods. He returned to London and engaged a Mr Bean to hold an auction at 12 Northampton Square on 26 and 27 July 1864, but this was also a failure.

He was now at his wit's end. He was pressed by creditors on all sides, most of his staff had gone, and he still had a vast accumulation of goods on his hands. As a last desperate attempt to dispose of them, he reopened his premises at 12 Northampton Square and issued the following circular:

> Republishing Mr. Baxter's celebrated pictures in Oil colours.

> Mr. Baxter having offered his plant and business for sale, but not having found a purchaser, has at the wish of the trade, recommenced business and has republished his subjects at a low price to insure an immense sale, and will continue in business until he disposes of the plant which cost upwards of £50,000.

This last attempt was also labour in vain and in 1865 Baxter had to bow to the inevitable, and on his own petition was adjudicated bankrupt. Although he was left personally without means, it was most fortunate for him that not only had his wife a comfortable income, but their residence at Sydenham had been purchased by his wife's family in her name, so he had a home and was not in want.

The aptly named 'Retreat' was an unusual house for those days and had

been designed by Baxter himself. A 'one storeyed edifice', it had a flat roof with a dome in the centre over the drawing-room. This dome, together with the door panels, Baxter had painted elaborately. The house had extensive grounds, well laid out with avenues of nut trees, blackberry bushes, and watercress beds.

By the time that Baxter retired, he had become estranged from almost everybody he knew. Except for his son and daughter, no member of his or his wife's family came to visit him, and his wife was completely cut off from her family. He had become very difficult to live with, hot and hasty of temper, abrupt in manner, and impatient of contradiction.

He did not give up his struggles easily, and made one last attempt at business. There had remained in his possession after his bankruptcy a number of plates and blocks which were to have a far-reaching subsequent history. Baxter persuaded his son George to offer them for sale to the firm of Vincent Brooks and Co, later to become Vincent Brooks, Day and Son, of Gate Street, Lincolns Inn, London. This company agreed to the purchase on condition that George Baxter junior would join their firm in order to supervise the production of the prints. This was arranged, and work began immediately. Baxter himself, having no business of his own, helped his son. The venture was not a success, Vincent Brooks, Day and Son finding the process too costly for them to carry out their intention of selling the prints at cut prices.

Baxter was not to enjoy his retirement for very long. In 1866 he was mounting a horse omnibus at The Mansion House, London, when the horses of the following omnibus bolted. In the ensuing collision he was struck a violent blow on the back of his head from which he never recovered. He died at 'The Retreat' on 11 January 1867.

Baxter had known fame and glory, had been received by kings and princes, and his work had been admired by the highest in the land, but having quarrelled with his friends and relatives, he died a lonely, embittered and disappointed man.

Baxter's prints passed into obscurity on his death, but after thirty years there was a revival of interest in them. This did not last for very long, but there was to be another and most remarkable episode in their history soon after 1918. The story of these regenerations is told later in the chapters on the First and Second Baxter Societies.

George Baxter's Application for his patent

"I George Baxter of Charterhouse Square in the County of Middlesex, send greetings. . . . My Invention and Improvements in Producing Coloured Steel Plate, Copper Plate, and other impressions. . . . My Invention consists in coloring (*sic*) impressions of steel and copper plate engravings, and lithographic and zincographic printing, by means of block printing, in place of coloring such impressions by hand as heretofore practised, and which is an expen-

sive process, and by such improvements producing colored impressions of a high degree of perfection, and far superior in appearance of those which are colored (*sic*) by hand, and such prints as are obtained by means of block printing in various colors uncombined with copper, steel, lithographic, or zincographic impressions.

"The Process of printing landscapes, architectural, animal, and other decorative impressions, by means of wooden blocks, being well known and in common use, it will not be necessary to enter very extensively into a description of that art, further than to explain its application to coloring of impressions of copper and steel plate and of lithographic and zincographic printing.

"In order to produce a number of ornamental prints resembling a highly colored painting, whether in oil or water colours, according to my Invention, I first proceed to have the design engraved on a copper or steel plate, or on stone or zinc, as is well understood, observing, however, that I make several spots or points on the plate or stone from which the impressions are taken, in order to serve as register marks for the commencement of the register, which is most material in carrying out my Invention with correctness and effect. . . . I will therefore principally confine myself to the description of the process of coloring the impression No. i. (Cleopatra, an illustration to the Cabinet of Paintings) taken from a steel plate, though I propose afterwards to give some other instances and examples in order that my Invention may be fully understood. . . .

"Having possessed myself of an engraving of the subject which it is desired to have colored to represent a highly finished oil or water color painting and having a copy of the painting before me of which it is desired to produce an extensive series of imitations, and having determined on the number of colours and tints it will require, which is a matter of taste, at the same time depending on the nature of the painting which is to be copied; but this is the same as (if the copies are to be produced merely by a succession of printings from a series of wooden blocks without having my improvements combined therewith) that of taking such printings on to impressions from steel or copper plates or from stone or zink (*sic*) in order to color the same, thereby produce colored impressions having a high degree of finish. . . .

"It will be found that by thus coloring such descriptions of impressions the result will be that the prints produced will be more exquisite in their finish, more correct in their outline, and more soft and mellow in their appearance, for it will be found that successive colourings and tints of a series of blocks being received on copper or steel plate or lithographic or zincographic impressions, more body and character will be given to the finished print than when the colored print is the result of the same series of blocks taken on plain paper, which has been the practice heretofore. . . .

"Having determined on the number of blocks which are to be used, I take an equal number of impressions on paper off the engraved plate No. I, and successively place one face downwards on each block, and subject them respectively to the pressure of the press. By this means the blocks will each have an impression of the engraving. I then proceed to mark out carefully the particular parts which are to be left in relief of each block, by coloring them in those parts, having the painting before me, by which I readily observe to what extent each color is laid on the original picture, and the various shades to be

produced, and by this means, when the blocks have been properly cut, I thus obtain a series of blocks suitable for the particular print which is to be produced; but I would remark such designing and cutting of the blocks form no part of my Invention, but are in common use. . . .

"Having taken the number of impressions . . . and having the necessary block in the press for the first color on the tympan, there are four or other number of fine points to receive the impressions which is to be colored by a series of blocks, the fine points receiving each engraving at the four points, before mentioned, and on such tympan there are a number of points which are caused to strike through the paper in putting the first printing of color, and the point holes thus produced are those which are used for the purpose of securing a correct register in all the future impressions from the wooden blocks, the holes which were marked on the original impression not having been used after the first time . . . from the foregoing description an intelligent printer, with the aid of persons accustomed to engrave on wood, will readily make himself acquainted with the nature of my Invention, and will be enabled to carry the same into effect. . . .

"I would observe that throughout the description I have spoken of the blocks for printing the colours as being of wood; but it will be evident that metal blocks, being engraved in relief, in like manner to wood, would answer a similar purpose."

PART II

THE LICENSEES

Chapter 6 1850–1890

Although not strictly Licensees, as neither ever purchased a license, the firms of Vincent Brooks Day & Son and George Cargill Leighton must be included under this heading as they both produced coloured pictures by the Baxter Process.

Vincent Brooks Day & Son

When Vincent Brooks purchased the plates and blocks from George Baxter Junior, as told in the previous chapter, they commenced work immediately with the intention of republishing Baxter's work at greatly reduced prices. They made no alterations to the pictures, and all the original lettering was left on, with the exception that at no time did they use any of Baxter's seals or stamps. This is why copies of prints in Vincent Brooks' republication list can be found which, while conforming in every way to the originals, do not carry the seals, etc attributed to them. If such a print should be found, it is almost certainly by Vincent Brooks. I give Vincent Brooks' republication list in full in order to assist in the identification of these prints. As George Baxter and his son assisted in their production, they are generally accepted as genuine Baxters.

Republication of Baxter's Celebrated Oil Prints at greatly reduced prices.

Originally published at 10/6 [52½p] each, now 6/- [30p].

The Bridesmaid, Camellias, The Crucifixion, Gardener's Shed, First Impression, Lake Lucerne, Lovers' Letter Box, The Slaves, Day before Marriage, Fruit Girl of the Alps, Hollyhocks, Summer, Winter, Mountain Stream, The Wreck of the Reliance, Reconciliation, Review of the British Fleet at Portsmouth, Charge of the British Troops on the Road to Windlesham, Dover, and Arctic Expedition in search of Sir John Franklin.

Originally published at 3/6 [17½p] now 2/6 [12½p]

Belle of the Village, The First Lesson, The Ninth Hour, Saviour Blessing the Bread, The Third Day, Crucifixion, and The Bride.

Originally published at 1/6 [7½p] now 1/- [5p]

So Nice, The Cornfield, Summer Time, Come Pretty Robin, The Saviour, It is Finished, Puss Napping, So Tired, Stolen Pleasures, Short Change, Birth of the Saviour, Returning from Prayer, Daughter of the Regiment, Crystal Palace, Red Riding Hood, So Nasty, See Saw, News from Home, News from Australia, The Soldier's Farewell, Girl at the Bath, Verona, Hop Garden, Fruits No. 1 and No. 2, Infantine Jealousy, Christmas Time, and the 4 prints of the Ascent of Mont Blanc.

Portraits at 1/- [5p]

The Queen, The Prince Consort, The Princess Royal, The Prince of Wales, The Duke of Wellington, Lord Nelson, Sir Robert Peel, Rev. J. Wesley, Emperor of the French—Napoleon I, Napoleon III.

The venture was not a success; although the prints sold well, Baxter's process was so expensive to operate that it was impossible to make a profit from it, and on the death of George Baxter in 1867, Vincent Brooks Day and Son, as the firm had then become, terminated their agreement with George Baxter Junior and sold the plates and blocks to Abraham Le Blond for £300.

George Cargill Leighton

Leighton was born in 1826 and became a pupil of Baxter at his Charterhouse Square premises. He served a full seven-year apprenticeship and, when Baxter applied to have his patent extended, attempted to defeat this application. As told in a previous chapter, this extension was granted and Leighton joined the firm of Baxter's chief rivals, Gregory, Collins and Reynolds. Leighton was a capable man and his experience soon led to a marked improvement in the quality of this firm's work. The business passed entirely into his hands about 1850, and was later taken over by Vincent Brooks.

In the January 1851 edition of *The Art Journal* a drawing after Landseer, 'The Hawking Party', appeared reproduced by Leighton from wood blocks, a process learned by him while an apprentice under Baxter. This was so extravagantly praised by *The Art Journal* that Baxter inferred derogation of his own work, and wrote a letter of protest which was published by the journal, together with the following conciliatory article:

> We were perfectly aware at this time [when the offending article was published] that Mr. George Baxter had for a considerable period practised this art with great success but, as we thought, on an entirely different method. Having, however, received a communication from Mr. Baxter, who considers that justice has not altogether been rendered to him, we feel it quite right to give him an opportunity of showing his claim to a large share in the honours arising from the perfection to which this art has of late years been brought. . . .

There followed a long article tracing the history of colour printing through the fifteenth, sixteenth, seventeenth and eighteenth centuries, which concluded with the words:

> The prospect before Mr. Baxter is now encouraging . . . his perseverance in bringing his work to the degree of perfection it has attained, unquestionably deserves to be commended, and whatever right he justly claims he should undoubtedly possess in all its integrity.

Leighton's work was shown at the Great Exhibition of 1851. The prints were mounted on plate paper within a gold line border, and compare favourably with those of Baxter, who never forgave him for his opposition to the renewal of his patent.

About 1852 George Leighton was joined by his brothers Blair and Stephen. They transferred their premises to Lamb's Conduit Court, WC1, and altered their name to Leighton Brothers.

In 1855 the proprietors of the *Illustrated London News* were most interested in adding colour work to their journal, a step that no magazine in England had yet taken. They consulted Leighton on the matter, and in 1858 he was appointed as their printer and publisher. By 1860 he had almost entire control of the paper, with which he stayed until he retired in 1884.

Leighton produced excellent work for the *Illustrated London News*, mostly using the Baxter process, and also illustrated many books including Jane Austen's *Pride and Prejudice*. He closed his business on his retirement in 1885 and died nine years later.

Myers & Co

Very little is known about this firm and it is obvious that they made hardly any use of their license to work the Baxter process. They had premises at 4 Budge Row, Cannon Street, from 1842 to 1851, in which year they purchased the Baxter licence and moved to 45 Ludgate Hill, where they stayed until 1857, when they moved to 9 and 10 Peterborough Court, Fleet Street; there is no record of them after 1858.

Only about twelve subjects are known to have been issued by them, their principal prints being 'The New Houses of Parliament', 'Windsor Castle', 'Osborne House', and 'Clean Your Boots Sir'. These were published on mounts with a gold border around the print, and their name below. They also did some colour-print work for advertisements, putting their name on the picture. *Peter Parleys Annual* of 1855 had an illustration by Myers & Co of 'The Death of Cardinal Wolsey'.

William Dickes

William Dickes was born on 7 May 1821 in a small village near Bath. On reaching boyhood he was sent to London by his parents and apprenticed to Thomas Branston, one of the foremost pupils of the famous engraver, Thomas Bewick. He showed great artistic ability and on finishing his apprenticeship became a student at the Royal Academy Schools where he worked well and was awarded several silver medals for his prowess.

On leaving the schools he was engaged by Robert Cavell to superintend the engravings on wood for the Abbotsford edition of *Waverley* by Sir Walter Scott. This work, which lasted for four years, must have provided him with a great deal of experience, for he executed many of the drawings and engraved a proportion of the woodcuts himself.

He commenced business on his own account in 1846 at 4 Crescent Place, Bridge Street, Blackfriars, EC2. In 1850 he purchased the license to work the Baxter process and moved to 5 Old Fish Street, Doctors Commons, EC1. Here his business increased rapidly, and by 1864 he moved to more commodious premises which he had built at 109 Farringdon Road, London EC2. From here he advertised that he would undertake 'Engraving on steel, copper

and wood, commercial and general lithography, and colour and general printing for book illustrations and catalogues'.

He exhibited at the Great Exhibition, 1851; the Paris Exhibition, 1855; the London International Exhibition, 1862; the Dublin International Exhibition, 1865; and the Universal Exposition, Paris, 1862. At each of these, except the first, he was awarded prize medals.

In 1858, at the time of the marriage between the Princess Royal of England and Prince Frederick, Crown Prince of Prussia, he was commissioned to design and print the 'Souvenir of The Royal Wedding'. This included portraits of the happy couple after Sir John Corbould, and the following poems:

To Her Royal Highness
Victoria Adelaide Mary Louisa
Princess Royal of England

Accept, Princess, on this bright vestal day,
All that thy own dear native land can give
of loyalty and love. On thee always may such
devotion wait, and mayst thou live shrined in
a people's heart, where, far away beyond the
waters of the silver Rhine,
The Rose of England shall its bloom display,
And round a foreign stem in beauty twine.
And still, Princess, in that fair Prussian land,
When many a noble knight, and many a dame,
In days to come, shall kiss thy Queenly hand,
Be mindful thou of Albions rocky strand
Seek in a people's love thy proudest fame,
And add fresh splendour to Victoria's name.

To His Royal Highness
Frederick William Nicholas Charles
Crown Prince of Prussia

Full many a league of land and stormy sea
Divides old England from the stately halls
to which, Sir Prince, with joyous chivalry,
Thou lead'st thy bride. Oh! bright and fair and free
Be sun, and cloud, and every wave that falls
before the Royal prow in peaceful foam,
or leaps to greet the bark, with happy glee,
Guard well, Sir Prince, the fair and priceless flower,
which loving hands this day have giv'n thee!
That so, thy winter's drearest, darkest, hour

May turn to summer; while her name shall be
A lasting emblem of true virtue's power,
And lead thee on to noblest victory.

 B.G.J.

Dickes' most important work was his *Studies of the Great Masters*. This was published between 1859 and 1862 in eighteen monthly parts, each issue containing one print with a descriptive commentary by the Rev B. G. Jones, a specimen of whose work we have just seen in the two poems of the 'Royal Souvenir'. The eighteen parts were later issued in one volume. The paintings which were illustrated, together with the artists are: 'The Blind Beggar', Dyckmans; 'Ecce Homo', Guido Reni; 'The Infant Samuel', Sir J. Reynolds; 'Christ Blessing Children', Hess; 'The Holy Family', Correggio; 'The Schoolmistress', Stothard; 'Christ Entombed', Guercino; 'The Spanish Flower Girl', Murillo; 'The Prodigal Son', Spada; 'The Idle Servant', Nicholas Maas; 'Christ in the Garden', Correggio; 'The Itinerant Musicians', Dietrich; 'The Infant Academy', Reynolds; 'The Two Misers', Quintin Matsy; 'The Three Maries', Anibal Caracci; 'La Menagère', Gerard Douw; 'Cottage Children', Gainsborough; 'Landscape-Evening', Cuyp.

All are signed below the print with the exception of 'The Schoolmistress', 'The Misers' and 'The Three Maries' which are signed on the prints themselves. Most of the prints are very fine; they were also issued separately from the parts on stamped mounts, with Dickes' black and white label on the back.

Dickes also produced coloured versions of the Raphael cartoons using Baxter's key plates. As Baxter only produced these in sepia (baxterotype) there is no possibility of any mistaken identity. Dickes signed most of these and issued some on stamped mounts.

Dickes was employed as the principal colour printer to the Society for the Promotion of Christian Knowledge. He also did a great amount of work for *The Religious Tract Society*, *The People's Magazine*, *The Gentleman's Journal* and *Queen*.

He was most versatile in his fields of work. He designed and printed the matchbox labels for Bryant and May. These were mostly comic and are now very rare and much sought after by luminorogists. He also designed the well known bull's head for Colman's Mustard, which decorated their famous yellow tins until recently. His animal drawings, in fact, excelled in quality any other of his work, and he found great scope for this ability in the school reward cards which he printed for the SPCK. In the days before the education acts, these were in general use, and some are of high artistic merit. Dickes published over forty of these sets, most of which contained twelve different cards, and some as many as twenty-four or forty-eight. About half of the sets had religious subjects, the remainder depicting flowers, dogs, birds, peoples of Europe, seaweeds, butterflies, British animals, and wild animals. The reward cards were produced with great skill and form a fascinating

study. It is a great wonder that they never became a subject for collectors.

William Dickes invented a development in colour printing called the 'chromograph process'. He never patented it, but was enabled to greatly cheapen his costs of production by its use. I give a full account of this process at the end of this chapter taken from *The Colour Prints of William Dickes* by Alfred Docker. This book, published in a limited edition of 350 copies in 1924, includes a chapter by R. W. Baxter, who gives an interesting account of his apprenticeship to William Dickes and describes the chromograph process.

Dickes was most unlike George Baxter in many ways, yet he was the only one of the licensees with whom Baxter never quarrelled and with whom he remained on good terms, probably because Dickes never slavishly imitated Baxter's work, and only obtained a licence with the primary object of using a key plate in connection with his own process.

William Dickes was good tempered, a competent musician, able to perform on the piano, violin and flute with equal skill and possessed a fine tenor voice. He was a deeply religious man, and a painter in oils and water colours of great ability, yet he was also an extremely good business man, and one of the few who worked Baxter's process never to have any financial problems. He was a family man and very good father, having nine children, several of his sons being in his business. He retired in 1878 to his house at 75 Loughborough Park, Brixton, where he died on 29 February 1892 at the age of 76.

A Glance at William Dickes
and his process

I was considered to be very fortunate to have the chance of being apprenticed to William Dickes, as his work was held in very high repute at the time.

My uncle, Mr. Thomas Whetstone, who had business relations with him, introduced me to the firm, and I well remember the eventful day in March, 1874, when he took me along, armed with specimens of my work and full of great expectations, to be interviewed by this great man. No. 109, Farringdon Road, was rather an imposing building and the interior had quite an ecclesiastical air about it, the pointed arch being much in evidence and reproductions of the old masters, mostly religious subjects, hanging on the walls.

I was ushered into Mr. William Dickes' private room. It was furnished as a study, with bookcases and pictures, giving a mellow tone which made a fine setting for the venerable looking old gentleman seated at the writing table. He had a very refined face, clean shaven regular features and a profusion of white, wavy hair—he reminded me of the Vicar of Wakefield. I do not remember the beard, shown in his portrait, which was probably grown later. His manner was very precise and courteous and, in short, he was a typical early Victorian gentleman.

He examined my little drawings and designs with care and interest and, to

my great joy, decided to take me as an apprentice to learn the mysteries of the craft of colour printing and the making of plates for the same.

Mr. Dickes gave me a little homily on what I should do to become a successful artist, and informed me that Keely Halswill and other eminent men had been trained by and under him. He ended with a smile and the words "Go thou and do likewise!"

I saw very little of the old gentleman after I was apprenticed, as the eldest son, Mr. William Frederick Dickes, was just then taking over the management of the business as his father was on the point of retiring. He was quite a different type of man, very nervy and excitable, rushing around and speeding things up in every direction. "Mr. Fred" was tall and wore his fair hair rather long with a flowing beard of a light brown colour, which gave one the impression that it was always blowing in the breeze, owing to his rapidity of motion. Nevertheless he was quite a gentleman, too, and a good master.

The younger son, Mr. Walter Dickes, who was also a partner, was in the counting house. He was a little dark man with black hair and moustache, and always very quiet and reserved.

The greatest character in the firm was the foreman printer, Mr. Charles Roker, an old boy of about 60, very tall and thin, who wore spectacles and had a white billy-goat beard and a clean upper lip. His trousers were extremely tight, his coat tightly buttoned, and he wore a short close fitting little white apron tied over it. He looked like Uncle Jonathan in the garb of a potman!

The main building comprised offices, showroom and warehouses. The machine and press room was built in the rear on a slightly lower level, and ran back to Ray Street where there was a back entrance for goods. It was a very fine room with a glass roof and contained all the presses and machines. At the end nearest the main building Mr. Fred Dickes had his office, where all the machines, sheets and proofs were examined and passed for the printer. Everything going forward in the machine room could be seen from here, the office having a glass screen and being raised about nine feet above the machine room.

Looking down the room the hand presses were on the left hand side with copper plate, letter-press, and lithographic presses—about twelve in all. The machines were placed on the right-hand side, and comprised, as nearly as I can remember, four double platen machines, a two-colour machine, two Wharfedale, and three double demy lithographic machines.

The artists' room was built over the centre of the machine room and was rather long in shape, with windows along the whole length of the room on both sides. Altogether there must have been bench room for about twenty men.

Some of the engraver's tables were not used during my time, as the aquatint plate had superseded the engraved block. There were five artists and two engravers employed during my apprenticeship, and we were doing lithographic work as well as the aquatint process. Very little work was being printed from the hand presses, which were mostly used for proving.

William Dickes himself was a fine draughtsman and one of the best wood engravers of his time. He engraved on metal as well, and painted in water colour and oils. He produced many of the original drawings for his prints and he also made the drawings for his "Book on Figure Drawing," and very

excellent they were. One has only to examine his botanical and natural history prints to realize what a thoroughly painstaking craftsman he was. The detail in this class of work is simply marvellous. The same attention is noticeable in the reproductions of the old masters.

Although William Dickes was certainly a great Baxter process printer, it was his development of the "Chromograph" which gives him a prominent place in the line of notable colour printers.

In the Chromograph there is a vigour, freedom of style, and a richness of colour which is greatly admired by artists and expert engravers of today, and which is in marked contrast to the obviously laboured work in the Baxter print.

It is much to be regretted that he did not produce more of these Chromographs before they became degenerated by the cheaper process of machine printing. They are rare and unique works and should be preserved, for future generations will appreciate them more and more.

The advent of the Chromograph in 1860 enabled Mr. Dickes to print on the power machine and thus cheapen the production of prints very considerably. For the first time in the history of colour printing it became commercially possible for publishers to introduce coloured pictures into their magazines, journals and books. We may therefore say, with truth, that William Dickes was *the pioneer of colour printing for the people.*

He never patented his process and I and others who learned it, introduced it later to other colour printers.

He printed a great number of illustrations for "The Gentleman's Journal," "The Picture," "The Queen," "People's Magazine" and other papers, besides doing much work for the S.P.C.K., Sunday School Union, Church Missionary Society, and many firms of publishers.

The name "Chromograph" was never in general use; to the craftsman engaged in the process it was known as "Aquatint." In a very short time the process was adopted by a number of printing firms, among them Messrs. Kronheim and Co., and Marcus Ward's of Belfast, who both produced some very good work, the latter notably an illustrated book, published in parts, called "Our Native Land," and a large number of children's books. "The Graphic" also used it for their coloured pictures and supplements for a number of years.

But when the lithographic machine entered into competition in 1873 and became generally used for colour printing, it gradually supplanted the aquatint process, as the cost of producing the work on stone was so much cheaper and the stones could be used, almost indefinitely, for other work—copper plates could not.

It is interesting to note that the same fate befell the hand-printed chromo-lithograph. About 1845, Messrs. M. & N. Hanhart produced the first chromo-lithograph. It was a small picture of Clanes Church. The second was "The Hawking Party" after Fred. Taylor. These chromos sold from 7s. 6d. to £3. 3s. each until the lithographic machine, in 1873, knocked out the hand press, when down went the price and quality.

It may here be noted that my definition of a "Chromo" is a reproduction of a sketch or painting in colours, as distinct from original wood block prints, or original lithographs, in colours.

One of the first works on colour printing was Jackson's Essay on "The Invention of Engraving and Printing in Chiaroscuro." His quaint advertisement says "The print gives a faint idea of what is to be done in colours with respect to Buildings and Vegetables—this will make a lasting and genteel furniture, as all this colouring is done in oil and not subject to fly off." George Baxter with his invention improved upon the ideas of Jackson and others. He employed the hand press for his work.

Then followed the Chromo-lithograph in 1845, to produce which the hand-press was also used. William Dickes invented the Chromograph machine in 1860 which revolutionized the art of printing in colours, until it was eclipsed by the Chromo-lithograph machine in 1873.

A BRIEF DESCRIPTION OF THE MAKING OF
AQUATINT PLATES

First a very elaborate tracing is made of the sketch or painting on gelatine, engraved with an etching point. The cut lines are then filled in with transfer ink and wiped clean, as in copper plate printing. This tracing is called the key and is transferred to stone.

For every colour to be drawn, an impression is pulled in very soft black ink on a hard paper. Before the ink is dry these impressions are transferred to the various copper plates, which have been coated previously with a granulated etching ground.

The ground used by Mr. Dickes was called the "Hunt" ground. Hunt was an old aquatinter who invented the ground for this particular process. It was obtained by coating the copper plate with a solution of resin, Burgundy pitch and gum, dissolved in spirits of wine. The solution is floated evenly over the plate and as the spirit evaporates it reticulates and forms a granulated surface. The coarseness or fineness of the grain can be varied according to the artist's requirements. When the ground is thoroughly hard the transfer of the key is made, and the plate is ready for the artist.

Suppose he is drawing the blue plate. He decides on the strength and tone in which it will be printed and proceeds to paint out with Brunswick black all the darkest tones of blue in the sketch he is reproducing. These touches will be the polished surface of the plate as the etching will not go through the Brunswick black. The acid test attacks the deepest reticulations where the film of resin is thinnest. After the first etch he paints out the next tone lighter, and then etches for a lighter tone still and so on, alternately painting out and etching, until the grain has become a mere dust which represents the palest possible blue in the sketch. When the plate is finished, and the Brunswick black is cleaned off with turpentine, the parts which are to be white are cut away and the plate mounted on a wood block, ready for the press. An impression from this plate will give all the shades of blue in the sketch as in a wash drawing.

The average number of plates used to produce a chromograph print was from ten to twelve—sometimes even more were used.

I have found it rather difficult to describe a technical subject in non-technical language, but I hope I have made myself intelligible to our readers.

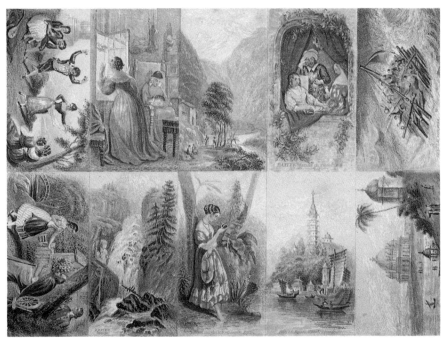

Plate 12 'La Tarantella Set'

Plate 13 'Pas des Trois'

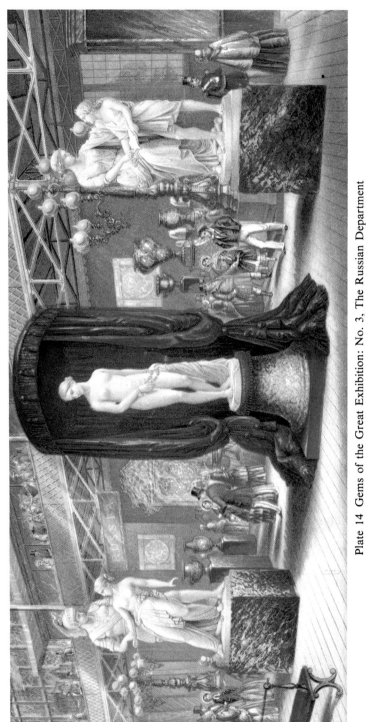

Plate 14 Gems of the Great Exhibition: No. 3, The Russian Department

It has been a great pleasure to me to make this small contribution to Mr. Alfred Docker's book as it has awakened many pleasant memories of the early days of my working life with William Dickes, when work was far more interesting for the art craftsman than it is in these days of fierce competition and mechanical contrivance, and I thank Mr. Alfred Docker for the opportunity he has given me, and sincerely trust that his book may prove, as I feel it will, a lasting tribute to the life work of William Dickes.

R. W. Baxter

Mr R. W. Baxter was technical instructor in lithographic drawing to the London County Council School of Photo-engraving and Lithography at the time of writing this article.

Chapter 7 1850–1890 (continued)

Le Blond & Company

The firm of Le Blond & Company are recognized as the most important of the Baxter licensees, their work being the nearest to Baxter's in style and quality. Extremely methodical, they gave serial numbers to all their prints, and never published one without putting their name to it.

Established in 1842 at 4 Wallbrook in the City of London, there were two brothers, Robert and Abraham Le Blond, who had descended from an old Huguenot family. It is said that when Louis XVII and his wife fled from France in 1848, Abraham Le Blond saved the queen's life. The elder brother, Robert, had very advanced views for his day, and pioneered ceaselessly for a relaxation of the Victorian Sunday, particularly for the opening of museums and places of instruction.

They purchased a license to work the Baxter process in 1850, at the same time persuading Baxter's manager, Sidney Wright, to join them. Wright was a very efficient production manager and, with his help, Le Blond and Co were soon producing large quantities of prints by the Baxter process, concentrating at first on those lines which they knew were good sellers, such as pocket-book illustrations, small landscapes, needle-box prints, and pictures of the royal family. They evidently took to heart Baxter's statement at the 1849 tribunal that the first prints to show him a profit were those of Queen Victoria and Prince Albert on the balcony, as they produced their own versions of these pictures, as well as many other studies of the royal family and its activities.

In 1856 Robert Le Blond and his son, Robert Emmet, gave up their interest in the firm and emigrated to America. They found some difficulty in importing prints into the States, as at that time there were severe laws against the importation of English goods unless there was an American name on them. To overcome this difficulty, Robert Le Blond made an arrangement with Elliot and Co of Boston to have their name, in addition to that of Le Blond and Co, on prints to be imported into America. Robert Le Blond returned to England in 1862, but before doing so, he sold the distribution rights of Le Blond prints in America to Elliot & Co.

The prints which have made Le Blond famous are the series which have come to be known as 'Le Blond ovals'. In these prints, Le Blond and Co introduced a completely individual manner of production and style, breaking away from the Baxter tradition.

The ovals are a set of thirty-two prints, all measuring $6\frac{1}{2}\times5$in, printed in the centre of a mount 10×8in. They are unique since they were not cut out and fixed on the mount by adhesive, as were Baxter's prints, but were printed directly on to the mount. The picture was surrounded by an embossed rim, and the title and serial number of the print were also embossed in a small panel in the bottom right-hand corner of the mount. Thus in one operation,

print, mount, surround and title were completed, there being no lettering printed on the mount. The two names 'Le Blond and Co. London' and 'L. A. Elliot and Co. Boston, U.S.' being placed on the bottom of the print itself, usually just off centre.

The subjects of the ovals were also original. They present a nostalgic picture of rural village life in England in the early part of the nineteenth century. All show the same features. The foreground of each picture is dominated by the subject matter of the title, the background being uncluttered, with just sufficient detail to complete the picture. They are very well produced, brilliant in colour, and the only works of any of the licensees to compete on equal terms in popularity and price with Baxter's. They have become collectors' items in their own right.

Less well known than the ovals, but very popular with some collectors, are Le Blond's 'Lonely Maidens'. Le Blond published twenty-three prints in which these graceful ladies wander scantily clad, and alone, through a romantic world. Among the titles of these pictures are: 'The Lady of the Lilies', 'The Butterfly Belle', 'The Flower Maiden', and 'The Tambourine Girl'.

In their small landscapes, Le Blond & Co come nearest to the work of Baxter. These, usually produced on a mount with a gold surround, were very well drawn and had a large sale. Some of the titles are: 'Lake Lugano', 'Castle of Heidelberg on the Rhine', 'New York Bay', 'Ballinahinch Lake and Castle Connemara' and 'Lock Katrine, Scotland'.

In 1868, a year after Baxter's death, Abraham Le Blond purchased the sixty-six sets of Baxter's original plates and blocks, previously mentioned, from Vincent Brooks Day & Co, and produced what have become known as the 'Le Blond Baxters'. Le Blond erased Baxter's signature, and usually substituted his own name on the prints. They were not published on mounts like Baxter's, but usually on plain cardboard. Le Blond retained Baxter's lettering and also placed a blue or plum-coloured label on the back with the title of the subject, and Le Blond's name and serial number.

The Le Blond Baxters were very cheaply produced, and do not compare with the originals. Le Blond endeavoured to make the prints cheaply and profitably by taking short-cuts in their production. He was fairly successful in this operation and produced a large quantity of prints, which is why many Le Blond Baxters can be found today. However, they have a very poor finish, typified by uncoloured facial details; sometimes lips, hair and dress details show signs of hand-colouring. It is possible that the plates and blocks had become worn, as Baxter had used them for many years, or that, having been unused for some time, the plates had rusted and the blocks warped and cracked. Nevertheless, it is certain that Le Blond did not use the same quality of inks and paper as Baxter, and sometimes did not use all the blocks intended.

These prints brought a certain amount of disrepute to Baxter's work during the 1920s, which were the heyday of the Baxter prints. Unscrupulous

dealers would cut off Le Blond's name and sell the inferior products as Baxter's work, which was in great demand then (see the chapter on the Second Baxter Society).

Le Blond and Co produced only two needle-box sets, but these were so profusely printed, literally in hundreds of thousands, that if one finds a needle-box set today, it is more likely to be one of these than by any other of the licensees or by Baxter himself. This being the case, I think it is of value to give details of the subjects of the prints, most of which are miniatures of Le Blond's larger prints.

The Fancy Set consists of ten upright prints in two rows of five. Top row: 'The Sisters'; 'Nearly Ready for the Bath'; 'The Flower Maiden'; 'The Tyrolean Waltz'; 'A Castle Scene'. Bottom row: 'Queen Victoria on Balcony'; 'Prince Albert on Balcony'; 'In Contemplative Mood'; 'Queen of the Harem'; 'River Scene'.

The Regal Set consists of ten horizontal prints in strips of five. Left strip: 'Prince Albert in St. James Park'; 'Queen Victoria at Windsor'; 'Her Majesty Leaving Portsmouth Harbour'; 'Her Majesty and His Royal Highness at Balmoral'; 'Her Majesty Opening Parliament'. Right strip: 'Her Majesty at Balmoral'; 'The Great Exhibition (Exterior)'; 'Venice'; 'Brothers Water'; 'Osborne House'.

Although Le Blond & Co called themselves licensees, they never at any time mentioned Baxter's name on their prints, and after the expiry of Baxter's patent, they dropped the description Licensee on their work. When they produced the Le Blond Baxters, they deleted Baxter's signature from the prints, and endeavoured to suppress his name.

Le Blond & Co, ceased production of the Le Blond Baxters by about 1870, by which time the firm had moved to Carron House, 14 Upper Thames Street, London, EC4. Their business gradually declined, and in 1894 Abraham Le Blond was unable to meet payments due for money borrowed on debentures, and a receiver was appointed for the business, the goodwill of which was purchased by Barclay & Fry. Sidney Wright, who had left George Baxter's employment in 1850 to become Le Blond's manager, found himself in 1894 without employment for the first time in his life.

Abraham Le Blond died in 1894, but before his death, he added one more paragraph to the story of the plates and blocks sold to Vincent Brooks by George Baxter Junior in 1865, which we meet again in the chapter on the First Baxter Society.

The following is an extract from a letter by Robert E. Le Blond (son of Robert Le Blond) to the editor of the *Inland Printer* (Chicago) of February 1909, which describes the operation of Baxter's process.

HOW 'OIL PRINTS' WERE MADE

I worked in the office of Le Blond & Co., 24 Budge Row, London, who were licensees of Baxter; this was in 1854 and 1855. The firm of Le Blond & Co. was composed of my father, Robert, and his brother Abram. My father came to America in 1856, leaving his brother Abram in charge of the business.

The actual printing of the "oil prints," as they were designated by us, was carried on in the workshops at No. 4 Walbrook, a small street leading out of Budge Row and coming out on Cheapside, by the Mansion House. This work was all done on hand presses; in fact, outside of the newspaper and large book offices, there were no power presses then. We had over twenty hand presses at Walbrook, and at Budge Row half a dozen lithograph presses and as many copperplate presses. I pulled a hand press in the room just outside of the one where the oil prints were printed. I was then fourteen years old. As a rule, the other employees were not allowed in there, and of course, strangers visiting any workshop in the old country was, and is, entirely out of the question.

According to my recollection, these prints were first engraved on a steel plate, a key-plate, or, as I should call, a master-plate. From transfers from this the different colour-blocks were engraved mostly on boxwood, some on copper. In printing, each form contained two blocks, each of a different colour, two colours being used at a time on the ink table. The roller had about two inches cut out of the centre, so that the colours would not mix. When the top sheet on the tympan was printed, it was taken off the points and put on the lower set of points and a new sheet put on above. At times, the pressman touched up a certain part that needed it, with a little pad of composition carrying a different tint to what was on the roller. This, as you may imagine, was slow work; I should say that nine hundred a day was the maximum; there were almost invariably two to a press—one journeyman and one apprentice—except with the more advanced apprentices, who had charge of a press with a younger apprentice to help them.

The sheets were printed on dry paper. The colour was furnished us dry and was ground and mixed as it was needed, mostly by the apprentice, while the journeyman made the forme ready. This was generally the rule all over the shop. All colours came dry, except Chinese blue and black, and perhaps a few others.

A man was employed to grind most of the ink, where comparatively large quantities were needed, but on smaller and more particular jobs, each pressman had his own stone muller and ground and mixed his own ink. In the oil-print department they had certain standard tints, of which they kept a little stock on hand, carefully protected from drying, and replenished them by fresh grinding when needed.

Bradshaw and Blacklock

Bradshaw and Blacklock were the publishers of the world-famous railway guides. They had an office at 59 Fleet Street, London, but their main establishment was in Manchester. The senior partner in the firm, Bradshaw,

was a Quaker, and, probably through his work with the missionary societies, came into contact with George Baxter, and was most interested in his process. Through his influence, the firm was one of the first to purchase the license to work the Baxter process. His partner, Blacklock, had very little interest in it, and on the death of Bradshaw in 1853, the use of the process by the firm waned. They did, however, continue using it until 1856, and in the few years of its use produced a large quantity of work.

Their most important publication was *The Pictorial Casket of Coloured Gems*, described as 'A carefully arranged selection of these universally admired productions of art, with descriptive articles on each subject by talented authors'. This work was first issued by subscription in fifteen monthly parts at 2s (10p) each. Each part consisted of two highly finished prints accompanied by descriptive articles. The prints were a varied collection, including portraits of the royal family, pictures of the royal residences, and religious subjects, such as 'Ahasuerus sending out Messengers' and 'The Judgement of Solomon'. *The Pictorial Casket* was published in book form containing thirty-three prints in 1853, and was successful since it was reprinted in 1854.

Bradshaw and Blacklock published many different needle-box sets, some of the subjects being: 'Cathedrals of England', 'Castles of England', 'Months and Seasons Set', 'Crimean War Set' and 'Sea and Landscape Set'. These sets consisted of from ten to sixteen prints each, but they also published many sets of five and six slightly larger needle-box prints, and one set for 'Best London Hairpins'. They also published many small views and landscapes of the British Isles and abroad, and country subjects such as 'The Gleaners', 'The Farmer's Boy', and 'Rustic Anglers'.

Bradshaw and Blacklock are the only licensees who mention Baxter's name on their prints, most of which are engraved beneath on the margin 'Bradshaw and Blacklock, Licensees, Manchester by Baxter's Patent'. They also issued some prints on stamped mounts with the stamp consisting of a shield with an oblong lozenge beneath. The shield contains the words: 'Printed in Oil Colours by Bradshaw & Blacklock Licensees, Manchester by Baxter's Patent'. The title of the print was placed in the oblong lozenge beneath.

Frederick Shields, who worked for Bradshaw and Blacklock, at a wage of seven shillings a week, has left us an account of what working conditions in the firm were like:

"Here, in the extremest drudgery of commercial lithography, I endured daily torture of mind, suffering also from a disease, brought on by semi-starvation, which sapped my strength for four years, and made me of sad aspect. A broad black ribbon round my face supported the lint applied to a running ulcer which plagued me for many months. The kindness of Dr. Whitehead eventually cured me of this affliction, which had made me a shamed and marked youth wherever I went. Months passed in this new circle of misery and then I was dismissed for inability to execute, with sufficient

nicety, repetitions of bobbin tickets; some eighty on one cold stone to be neatly painted with the brush for printing from. Conceive the dull round of agony; suffering as of the victim of Inquisition under the slow drops of water falling on his chest. In vain I strove to satisfy the foreman, for my heart loathed the task, so again I was without means of breadwinning.

"Mr. Blacklock, discovering after my dismissal that I had talents unexercised in his service, asked me to make two large drawings of the exterior and interior of McCorquodale's works at Newton. The interior entailed much intricate drawing of machinery, of the bookbinding and typesetting departments with the men at their employment. During the last three days of this work I had not a fragment of food, and worked in hope of the paltry payment I received from that wealthy business man—seven shillings. I remember tramping to Liverpool, thirty-two miles by road, with a few pence in my pocket, and back without any, in search of work. On my way a tramp begged from me: 'Master, I'm clemming'. I could but answer, 'So am I.' Returning, I reached Bootle (midway to Manchester) footsore and penniless. I looked at a wheatfield, stacked with new-cut sheaves, and thought to sleep among them; when a band of Irish reapers stopped me, demanding with half threatening humour, 'Are you a Ribbandman or an Orangeman?' I knew not the distinction, and could only reply that I was a poor lad, hungry, weary, and shelterless. 'Bedad, then, come along with us and get a plate of porridge into ye.' They took me to a large farmhouse kitchen, fed me as they had proposed, and then took me into the great raftered room above, spread with many mattresses on the floor, where, sandwiched between two strong harvestmen, I slept off my exhaustion; and after a morning plate of porridge and many hearty expressions of goodwill from my benefactors, I resumed my tramp to Manchester. My heart warms to the poor Irish from that day, and I have known many worthy of deep esteem. But still I had no employment. What to do? I thought of my father's friends at the Newton works—poor but warm-hearted; they might show me kindness. There, at the tariff of seven shillings a head, they found me physiognomies enough to keep my pencil busy for months. They were drawn on tinted paper, life-size, in black and white chalk with a little red. Excellent practice and joy delirious after the grinding bondage of bobbin tickets, daily to strive to catch something of the grace or strength of Nature's most exalted work. But the mine of the little town grew exhausted, and at this juncture old Bradshaw, the Quaker partner in the Railway Guide printing firm, sent for me and said, 'Dost thou think thyself able to design for Baxter's patent Oil Painting Process?' Modestly but confidently I replied, 'Yes.' 'What wages wilt thou require?' Seven shillings a week had I received at bobbin tickets, and I dared to ask ten shillings a week for the coveted post of designer, and returned to my old shop in honour. The despised became a head, with a little room to himself where no defilement of bobbin tickets ever entered; and I revelled in gleaners, and milkmaids, and rustic lovers, and a box of colours for the first time."

Bradshaw died in 1853 and Blacklock, who was a very shrewd business man and a typical Mancunian, was never a wholehearted believer in his firm's venture with the Baxter process. The firm ceased producing prints by this method in 1856 and Blacklock retired one year later. Both Bradshaw

and Blacklock possessed considerable means when they died—in fact, the latter left a large fortune.

Joseph Mansell

Joseph Mansell was a Londoner. He was established in 1849 at 35 Red Lion Square, Holborn, where he was in business as a manufacturing stationer, producing embossed and cut work, such as paper dish-covers, menus, memorial cards, lace papers, ham frills, stove ornaments and cut tissues, all of which the mid-Victorians loved. He acquired the license to work the Baxter process in 1850 and exhibited at the Great Exhibition, 1851, the Paris Exhibition, 1855, and the International Exhibition, 1862, in London.

His work is extremely florid, and his prints can be recognized by his liberal use of bright greens, reds and yellows which make them a riot of colour. Most of his colour work consists of small prints measuring about 2×3in up to $3 \times 3\frac{1}{2}$in, usually issued on sheets of from six to twelve prints. He specialized in country and sporting subjects. Almost all his prints have central figures with country backgrounds. He signed very little of his work.

Mansell never published portraits, historical subjects, or portrayed topical events. He did produce needle-box sets, which can be recognized by the predominance of bright red in the colouring.

Two of his larger prints are 'Flowers of Autumn' and 'Woodbine Blossoms', a pair of upright ovals measuring 10×8in, showing bare-shouldered young ladies in the Baxter manner, gathering flowers. These were also used on sheet-music covers.

Mansell never discontinued his cut paper and embossing work, and in fact combined this with his colour printing on Valentine cards and the mementoes which were so popular at that time to mark any festive or great occasion.

As recounted in Chapter 5, Southgate and Barret, the auctioneers, held a sale of George Baxter's effects in 1860. In the list of buyers Joseph Mansell is mentioned as the purchaser of Lot 3054, which comprised 'the engraved steel plates and eleven engraved blocks for the tints, all locked up in chases' for printing four Baxter landscapes, 'Warwick Castle', 'Netley Abbey', 'River Tiefi Cardiganshire' and 'Lake Como'. Mansell produced prints from these plates, but never achieved Baxter's perfection.

A true Londoner, Mansell was born at Clerkenwell in 1803, and lived and worked all his life in the metropolis. It is not surprising, therefore, that his best work is his set of 'The Cries of London'. This consists of six prints, each a three-quarter length illustration of a young lady, crying her wares, set against a background of the London streets, which Mansell knew so well. These pictures have the stamp of authenticity. The subjects are 'Apples Sweet Apples', 'Watercress', 'Who'll Buy My Flowers', 'Milk Ho', 'Who'll Buy My Carols' and 'Fancy Fire Screens'. Each print measures 6×4in, and an attractively framed set, makes a decorative and interesting small collection of London history.

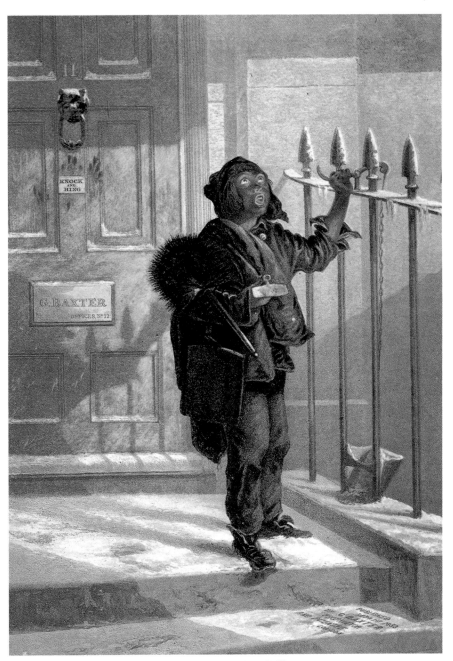

Plate 15 'Morning Call'

Plate 16 'The Late Duke of Wellington'

Plate 17 'The Lovers' Letter Box'

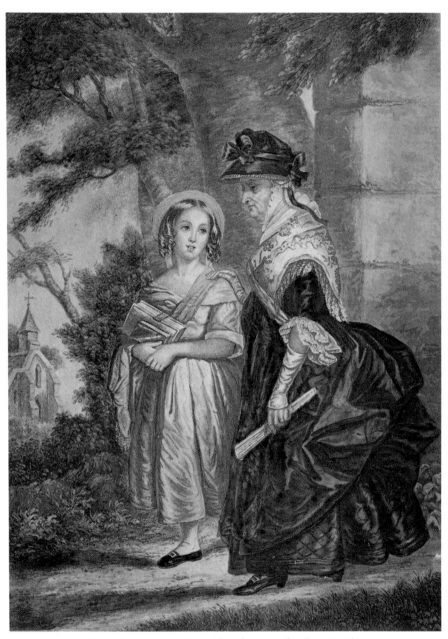

Plate 18 'Going to Church', a forgery of a Baxter print

Mansell died on 8 November 1874 at 71 Addison Road, Kensington. He wrote in his will, 'My business has always been profitable', and indeed he left a considerable estate.

The firm of Joseph Mansell continued until 1890 when it was split into two parts. The paper manufacturing side was amalgamated with W. F. Hunt & Co of 25 Great Windmill Street, and Catty & Dobson of Dyers Buildings, Holborn, and became Mansell, Hunt, Catty and Co Ltd. The colour-printing section continued under the name Joseph Mansell Ltd, but was wound up after a short existence.

Joseph Martin Kronheim

Joseph Kronheim was born in Germany in 1810. He arrived in Scotland when he was 22 and worked in Edinburgh, where he stayed for eight to ten years, before moving to London. By 1846 he was established at 36 Paternoster Row, the centre of the printing and publishing world of London. He acquired the license to work the Baxter process in 1850.

Kronheim was a very efficient and prolific printer, and was not happy with the time that had to be taken on the Baxter process. He tried many methods of accelerating it. His first adaptation was the use of zinc blocks instead of wood blocks. This method, however, resulted in flatness and loss of life in the finish.

In 1851 he tried another method and advertised as follows in the *Art Journal*:

> Printing in oil colours. Pictures for the million. Mr. Kronheim of Paternoster Row has discovered a new method of printing in oil by means of lithography, which represents a manifold improvement over all previous methods to imitate by the press the effects of a picture. It accomplishes in short all that can be achieved by such a process, and that too, at a price so moderate as to render it accessible to all, enabling the public to purchase a large copy in oils, affording a very good copy of the original, at half the price of an engraving.

He describes the process, and explains how 'By the use of as many as 40 stones in the process, the colours are so exquisitely graded that a print of a group of flowers might readily be mistaken for a painting.' In spite of this panegyric, Kronheim soon abandoned this lithographic process and returned to his previous methods.

In 1852 he was joined by Oscar Frauenknecht, a young man of 30 who brought capital into the business and enabled Kronheim & Co to move to larger premises at Bangor House, 64 and 65 Shoe Lane, the following year. The firm used the Baxter process to such effect that they are said to have issued over a thousand different subjects by 1854. They produced a great number of prints for the Paris Exhibition of 1855 and, at the close of this exhibition, Kronheim sold his interest in the business to Frauenknecht and retired to Germany.

Frauenknecht carried on alone for two years, and in 1857 took into partnership Charles Gregory, who had been employed by Joseph Kronheim ever since he had completed his apprenticeship with George Baxter, and Otto Mayer.

Meanwhile Kronheim, who found his retirement irksome, had disastrously invested the money which he had made in London. His first failure was a venture into the manufacture of bronze powder, on which he lost heavily. He then tried to establish himself as a printer in America, but this also failed. So he returned to London, rejoined his old firm, and produced thousands of colour prints. It is said that Kronheim and Co published over three thousand subjects compared to the less than four hundred produced by Baxter.

So numerous was their output that it is difficult to single out any particular prints for mention. There was hardly any class of pictorial colour work which the firm did not produce, and most of that published between 1850 and 1875 was by the Baxter process. Of these, the most common were hunting, sporting, landscape and farmyard subjects, usually printed in sheets of nine or twelve prints each, approximately $2\frac{1}{2} \times 3\frac{1}{2}$in. Sometimes, but not always, the name J. M. Kronheim & Co is printed below the picture on the left, and 'Licensees' on the extreme right. Their best-known larger prints are 'The Winetasters' (issued on 1 September 1854 and one of the very few of their prints to be dated), 'The Village Schoolmaster', 'The New Houses of Parliament' and a set of four coaching scenes entitled 'After the Seasons'.

In 1875 the firm installed steam litho machines and ceased the use of the Baxter process. Frauenknecht died suddenly on 11 December 1883 at the age of 62. Kronheim stayed with the firm until 1887, when he retired once again and died in Berlin on 25 March 1896, aged 85.

After Frauenknecht's death the two partners reformed the company as Mayer and Gregory, and continued with difficulty for a few years, but had to sell out in 1891.

Edmund Evans

Edmund Evans was born at Southwark on 23 February 1826. He was educated at a School in Jamaica Row, London, kept by Bart Robson, an old sailor. At the age of 13 he was put to work at Samuel Bentley's printing establishment, Bangor House, Shoe Lane, as a reading boy. Six months later, on the suggestion of the overseer, who found that the lad had a talent for drawing, he was apprenticed by his parents to Ebenezer Landells to learn the art of wood engraving. His parents were fortunate in securing his apprenticeship to Landells, who was a former pupil of Thos Bewick. Landells was the projector of *Punch*, the first issue of which was published during Evans's apprenticeship, on 17 July 1841. However, Landells soon sold his interest to the Printers, Bradbury & Evans, for £350, on condition that he was employed for a fixed time as engraver for the journal.

At the conclusion of his seven years' apprenticeship in May 1847, Evans started in business as a wood engraver, taking small premises in Wine Office Court, Fleet Street, and afterwards moving in 1851 to larger premises at 4 Racquet Court, Fleet Street. Here it was he obtained his first order for colour printing, which was executed on hand presses like Baxter's. Birket Foster, his fellow-apprentice, was preparing for Ingram, Cooke & Co a set of eight illustrations to Madame Ida Pfeiffer's *Travels in the Holy Land* (published in 1852). These were entrusted to Evans, who engraved them for three printings, a key-block giving the outlines in brown, and two other blocks adding tints in buff and blue. This first attempt of Evans in chromo-xylography cannot be said to rank with Baxter's first efforts.

Evans's first colour prints to make a mark were in *The Poems* by Oliver Goldsmith (1858), 41 plates, the drawings being by Birket Foster. Foster made his drawings as usual on the wood block, and then coloured a proof pulled on drawing paper. This was carried out by Evans, who used the artist's actual colours, grinding and preparing them for inking himself.

Although not actually a licensee, Edmund Evans used the Baxter process in his colour printing. It was the opinion of H. G. Clarke, who published *Baxter Colour Prints* in 1919 and who was the editor and sole contributor to a twelve-part series of colour magazines in 1920–1, that Evans' work was the nearest to Baxter's. His association with Birkett Foster and Kate Greenaway are sufficient to make his work of interest.

Evans illustrated the following books for Kate Greenaway:

> *Kate Greenaway's Alamanac 1883–1897*
> *A Day in a Child's Life*
> *Birthday Book for Children*
> *Language of Flowers*
> *Little Ann and Other Poems*
> *Marigold Garden*
> *Under the Window*
> *Mother Goose or the Old Nursery Rhymes*

Chapter 8 1895–1920

The First Baxter Society

When Abraham Le Blond ceased publication of the Le Blond Baxters in about 1870 it seemed that George Baxter and his work would fade into obscurity and eventually become completely forgotten; this indeed was the case for nearly twenty years, but interest in the prints was rekindled by two dedicated collectors.

The first of these was Dr Lawson Tait, who had a large collection, which he exhibited in Birmingham in 1893. This was the first Baxter exhibition to be held in that town, and it aroused great interest. Strangely enough, Birmingham became the centre of the Baxter revival which occurred over the next thirty years.

About the same time as Dr Lawson Tait held his exhibition, another gentleman was in the process of accumulating the largest collection of 'Baxteriana' that anyone had been able to amass. This was Frederick Mockler, a bank manager of Wotton-under-Edge, who inherited a large collection from his father. Mr Mockler Senior had met George Baxter at the Great Exhibition in 1851, and had bought his first prints from Baxter himself at his stand there. For the rest of his life he was a dedicated Baxter collector, inspiring his son to follow in his footsteps. The two collections together were the largest in England, but Frederick Mockler was not content to stop there. In 1893 he discovered that Abraham Le Blond was alive and still had all the Baxter plates and blocks which he had bought in 1868. Such was Mockler's insatiable desire to possess Baxter material that he immediately travelled to London to buy it from Le Blond. We therefore come to the final chapter in the story of the plates and blocks which Baxter sold to Vincent Brooks in 1863.

Le Blond proved a very tough negotiator. Realizing Mockler's eagerness to possess the Baxter plates, Le Blond would only sell them if Mockler bought all of his own goods as well. Mockler was not to be denied, and he bought everything for the sum of £800.

Mockler intended to reproduce the original Baxter prints from the plates and blocks which he had purchased, but he found this feat beyond his capabilities. He did, however, produce a folio of prints in black and white, and he issued the first catalogue of Baxter prints in 1894. This first-ever catalogue and folio of prints aroused a great deal of interest in Birmingham and, by the following year, sufficient like-minded gentlemen had gathered together to form the First Baxter Society.

Mockler was the moving spirit and secretary, and Lord Leighton, the President of the Royal Academy, consented to become patron. The society had a large and influential committee. In 1895 it started publication of *The Journal of the Baxter Society* and decided to hold an exhibition. The exhibi-

tion was held at the Royal Masonic Hall, Birmingham, in December 1895. It was a most ambitious affair, Mockler being the organizer, financier and principal contributor of the nearly nine hundred items shown.

The President of the Society, J. H. Slater, a London barrister, wrote a long essay on Baxter which was published in the exhibition's catalogue. The following is an extract:

> It is only quite recently that collectors of prints have awoke to the fact that a genius once lived among them unawares, and passed away with but scant recognition of his work.
>
> That time will do justice to the name of George Baxter is the opinion of many whose acquaintance with art is sufficiently deep to invest their utterances with respect.
>
> Albrecht Dürer did not cut his own blocks, but he prepared the designs for them, and it is his masterly work with the pencil which invests his work with enduring fame. Baxter also drew his own designs, and it is the quality of his work in this respect, no less than his skill in preparing his plates and blocks which will sooner or later cause his name to be known, and his talent to be recognised.

In spite of the coupling of Baxter's name with that of Albrecht Dürer, the exhibition was a financial failure. Mockler, who had taken responsibility for the whole affair, found himself faced with an enormous bill. The exhibition had been an elaborate and expensive project in a very large hall. The unfortunate Mockler found that his funds were exhausted, and, in order to meet his commitments, he had to sell the entire Baxter collection which he had spent nearly all his life accumulating.

The collection was auctioned in Birmingham in 1896. About 150,000 prints, together with original plates and blocks, were sold without reserve, and Birmingham was flooded with Baxter prints at less than 1d ($\frac{1}{2}$p) each. One dealer bought twenty-five sets of Le Blond ovals in their original envelopes at 2s 6d ($12\frac{1}{2}$p) per set, and other dealers bought them at 2d (1p) per dozen. This fiasco proved too much for the Baxter Society. The society's journal ceased publication after three issues. Mockler moved to Bath, where he took a librarian's job, and the first Baxter Society quietly died.

Once more all interest in George Baxter seemed to have evaporated, but again, through the perseverance of a few dedicated gentlemen, his name was kept alive, and this time his fame was to be brought to the highest peak it has so far reached.

This was mainly due to the efforts of C. T. Courtney Lewis who, by his own efforts and undoubted personality, brought George Baxter out of obscurity and made his name famous in the first quarter of this century. Courtney Lewis was born in London on 1 November 1856. The son of C. T. Lewis, Deputy Governor of Marshalsea prison, he was educated at Charterhouse and later apprenticed to the firm of Worthington Evans in the City of London. After his apprenticeship, he carried on a successful solicitor's business in the City on his own account. The following is an

appreciation of him written by Carl F. Leake, President of the Second Baxter Society, on the death of Courtney Lewis on 23 May 1931.

> No man has done so much for the cult of the Baxter print, and it is very improbable that any other will rise of such eminence. Indeed, there is now no longer the scope for such painstaking research and indefatigable perseverance as he brought to bear on the subject, and every bit of knowledge recently gained has been only additional to the knowledge he placed in our hands. He found the Baxter Print in a precarious position as a collectable article, with uncertainty as regards data, and little knowledge of the man himself, and he placed it on the pinnacle which it has since attained, and has produced for collector and student alike a series of books of reference replete with all the requisite information as regards the man who produced the prints, his method of production, and the number and varieties of his prints.

Courtney Lewis brought out his first book, *George Baxter, His Life and Work*, in 1908. Although other books had been published, notably one by Charles F. Bullock, a member of the committee of the First Baxter Society, in 1901, Courtney Lewis' book was the first definitive work on Baxter and aroused great interest.

The following year, a large collection, the property of a Dr Howard Jones, was auctioned in London. The prices obtained, reaching figures never obtained before, astonished the trade. This led to a flood of prints coming on to the market. Naturally, prices fell a little, but the public's interest in 'Baxters' was now thoroughly aroused, and continued to grow.

In 1911 C. T. Courtney Lewis wrote his second book, *The Picture Printer of the Nineteenth Century*, and followed this in 1913 with *The Baxter Year Book*, a small volume, intended to be published annually, giving the current and auction prices of all Baxter prints. World War I ended this plan, but immediately after the war, Courtney Lewis gave up his practice, and opened premises at 29 Martin Lane, Cannon Street, in the City of London, where he devoted his whole life to dealing in, and writing about, Baxter prints; he published his second *Baxter Year Book* in 1919.

In that year, Lady Bearsted presented to the town of Maidstone her almost complete collection of Baxter prints; at the same time, her son, the Hon Walter Samuel, presented the town with a collection of Japanese works of art. The two collections were unable to be properly displayed until 1924, when Lord Bearsted built a new wing to the museum for this purpose. There was an imposing opening ceremony of the wing, attended by many notables, including the Japanese ambassador; Lady Bearsted was presented with a bouquet, a replica of that held by the bridesmaid in Baxter's print of that name. The mayor, thanking the family, said that the people of Maidstone now had the opportunity of viewing the finest collection of Baxter prints in the world, and congratulated Lady Bearsted on making such a collection, which he was sure would increase in value.

The wing, which had been erected to house the collection, was unfortunately designed and built without any regard to the correct setting for

such an exhibition. The room was roofed with a large skylight, although it was well known at that time that Baxter prints should not be exposed to strong daylight. The prints were displayed face up in showcases down the centre of the room, and naturally faded. Even worse, the skylight was not watertight and rain seeped through to add to the damage caused by the unfortunate mode of display.

When Allen Grove took over as Curator of the Maidstone Museum and Art Gallery, the Bearsted collection was in such a poor state that it had to be closed and the prints stored away for many years. It has only recently reopened, and it is a pleasure to say that Mr Grove has completed the job in a most efficient and tasteful manner. The collection is beautifully laid out, and is without any doubt the best Baxter exhibition in England.

Mr Grove has combined the Baxter collection with a display of church musical instruments, and items connected with church music from the sixteenth century. The two collections blend very well; the musical display is in long showcases down the centre of the room and the Baxter prints surround it on the walls.

The Baxter collection is almost complete. It includes 'Butterflies', 'The Chubbs' and the 'Coronation' and 'First Parliament'. A most interesting print is a first pull of 'The Large Queen'. This was originally produced with Queen Victoria flanked by two ladies-in-waiting, the Marchioness of Normandy, and the Duchess of Sutherland, but before the print was published the ladies-in-waiting were removed, and the print never issued in this state. There is also a most interesting collection of books, including *Missionary Enterprises*, many Victorian pocket books, and *The History of Knighthood* (complete) by Sir Nicholas Harris Nicolas, and George Baxter's letter, printed in full in Chapter 5.

There are other collections at Birmingham, the British Museum, Lewes and Reading. The Birmingham collection is housed in the city's magnificent reference library, and can be seen on request. The British Museum collection is in the Print Room, and although interesting and almost complete, can be inspected only by persons in possession of a students' ticket. The Victoria & Albert Museum has a very fine collection, mostly donated by a grand-nephew of George Baxter, which can be examined on request.

The Reading collection was presented to the town by Arthur Knox of Fairfield Wargrave, Berks, a Director of Gasgoines Dairies, and a great Baxter enthusiast, who made their collection his lifetime hobby. He used C. T. Courtney Lewis as his buying agent and saved every letter and catalogue that Courtney Lewis sent him. Mr Knox had his prints beautifully framed. The Reading Municipal Art Gallery has two shows each year of items selected from the collection. The collection includes 'The Chubbs', 'Butterflies' and the very rare 'Edmund Burke'. There are about three hundred prints in all, but what makes this collection unique are the following items which are not duplicated anywhere else:

3 packets of letters from C. T. Courtney Lewis to Arthur Knox.

Courtney Lewis's buying lists.

Puttick & Simpson's auction sales' catalogues with pencilled notes by Courtney Lewis in the margins.

What is believed to be George Baxter's original key to the 'Opening of Parliament', with notes in Baxter's handwriting.

A small album containing postcard reproductions of the Le Blond ovals (published by Ernest Etheridge, Secretary of the Second Baxter Society), inscribed by Arthur Knox, 'Presented to my daughter Rosamund, Xmas 1924'.

18 Baxter Society exhibition programmes.

7 pocket books with frontispieces by Baxter.

All of Courtney Lewis' books.

Various Baxter and licensee catalogues.

Original needle boxes with their prints.

The collection at Lewes provides a direct and continuous link with the Baxter family. There is still a 'Baxter Shop' at 34–35 High Street, Lewes, a few doors from No 37 where John Baxter established himself in 1803, and where George was born one year later. The firm is known now as W. E. Baxter Ltd, the 'W.E.' being William Edwin Baxter, George Baxter's youngest brother, who continued the business until his death in 1873. Baxter's was then a private company, the last member of the family to sit on the board being Wynne E. Baxter, who retired in 1899.

In 1864, one George Holman was apprenticed to the Baxters for seven years. On completion of his indentures he stayed with them, and occupied every position in the firm from journeyman to company chairman. He became an alderman, a JP, and was seven times mayor of Lewes.

In 1921, Alderman Holman presented his collection of Baxter prints to the Brighton Corporation, Lewes having no suitable premises to house it. The collection was on display at the Brighton Municipal Art Gallery until the outbreak of war in 1939, when it was packed away and returned to Lewes in 1941.

In the same year the printing firm of W. R. Royle of London made an agreement with Baxter's, providing for the sharing of equipment and machinery should the London firm be 'bombed out'. Eric Vernon Royle joined Baxter's board in 1943 and the two firms co-operated closely. In 1955 Baxter's had a disastrous fire and was completely taken over by Royle's in 1961. W. E. Baxter of 34–35 High Street, Lewes, now an associate company of W. R. Royle and Son, of Royle House, London, N1, held a centenary Baxter exhibition at Lewes Town Hall in 1967. I am indebted for most of the above information to Mr W. B. Reynolds of Lewes, a member of the firm for many years, and managing director when he retired.

The collection itself, which is now housed at the Lewes Municipal Library, is not on display, but can be seen on request. I am afraid that it is very disappointing as most of the prints are dark, faded or foxed. The most

interesting items are the original letters patent granted to George Baxter by William IV on 23 October 1835 with the great seal attached, and the grant of the extension in 1849. An item which was in the collection in 1921, but now appears to be missing, is a blotting case with a lithograph of butterflies, said to have been the earliest colour work produced by Baxter. This blotting case had been greatly treasured by Alderman Holman, as it had been given to an aunt of his by George Baxter's father, in the original shop.

One very interesting item in the collection is *Advice on Care of the Teeth* by Sir Edwin Saunders. This little book, published in 1837 by Thomas Ward & Co of 27 Paternoster Row, has as its frontispiece a print of a female head to which there is an uplifting piece showing underneath the jaws and the teeth, which are depicted in great detail. This, as far as I know, is the only 'animated' print by George Baxter.

Chapter 9 1921–1967

The Second Baxter Society

By the end of World War I interest in Baxter prints had grown to such an extent that the Second Baxter Society was formed in 1921. This was a very different organization from the First Baxter Society, which was made up of dedicated amateurs. The second society had a strong committee of capable men, many of them professional dealers in antiques and prints, who succeeded in raising the status of the Baxter print to heights never reached before. The members of the first committee, who were drawn from all over the country, were:

President	Mr C. T. Courtney Lewis	London
Vice Presidents	Mr Alfred Docker	London
	Dr Bond	Godalming
Committee	Mr J. R. Hall, DLJP	Newcastle-upon-Tyne
	Mr Frank J. Harper	Shrewsbury
	Mr J. W. Heath	Wellington
	Alderman J. Holman, JPLA	Lewes
	Mr G. E. Lambert	Solihull
	Mr A. E. Owen	Sutton Coldfield
	Dr Page Robertson	Glasgow
	Mr Frank J. Rymer	Ilford
	Mr Walter Simmonds	Birmingham
	Mr J. Wilson	Skipton
	Mr W. A. Stachan	Gateshead-on-Tyne

The secretary of the society for the whole of its existence was Ernest Etheridge. He was an antique dealer of Queen's Buildings, Birmingham, a member of the British Antique Dealers Association, and it was undoubtedly due to his efforts that the Second Baxter Society flourished for so long. He organized almost single-handed Baxter exhibitions in Birmingham in 1921 and 1922, and succeeded in making that city the centre of the Baxter world.

In 1923 the society decided to follow the example set by the First Baxter Society and publish its own magazine, but this was a far more successful venture than the first. The *Baxter Times* ran for fifteen years and reached a circulation of over a thousand copies. It was published monthly at 1s 3d (6p) and the first editor was C. T. Courtney Lewis. The society also published a quarterly journal at 5s (25p) per copy which was available only to members of the society. Every issue of the *Baxter Times* included the following announcement:

> The Baxter Society has been in existence since 1921, and its influence has become very strong in the collecting world. Its objects are:—

To study, promote and stimulate interest in the life work of George Baxter, who was born at Lewes in 1804 and died at Sydenham in 1867.

To diffuse knowledge upon all matters relating to him and his work, and that of his licensees, and other early Victorian picture printers.

To suppress malpractices and expose frauds relating to prints, mounts, seals and other matters, and if deemed adviseable to take legal action or other steps against delinquents.

To hold exhibitions, arrange lectures, the reading of papers, the writing of articles and to promote or assist anything which in the opinion of the Council may be helpful to the objects, including the half yearly journal, which is issued free to members only.

To assist and advise members in every possible way and to make a charge for the same in such cases as may be deemed adviseable.

Members of the Society may have their prints guaranteed at a very small charge.

The Society has done much to put down the production of fraudulent prints and advance the interest of Baxter collectors. The ordinary membership subscription is one guinea per annum.

This announcement appeared in the Baxter journal in 1923 after Ernest Etheridge had organized the Baxter exhibitions in Birmingham:

We are informed that Mr. Ernest Etheridge is now fully entitled to place the letters O.B.E after his name.
(Organizer Baxter Exhibition).

This advertisement follows:

HOW TO INCREASE THE VALUE OF
YOUR COLLECTION

Have Your Prints Guaranteed By The Expert Committee
Of The Baxter Society

A wish having been very generally expressed that in addition to the Guarantee Stamps already issued, (which are placed on the back of any genuine print submitted, and are in consequence hidden if print is framed) some method of certifying prints should be adopted which would be apparent from the front when the print is framed, and to meet this want, the Council of the Baxter Society have had struck a small circular die, which will in future be placed on the bottom of each print, stamped, in the case of a Baxter print at the bottom left hand corner, and of Le Blond or other Licensees at the bottom right hand corner.

This small circular die stamp which is neat enough not to disfigure even the smallest print will be placed half on the print and half on the mount binding both, and it will now be possible to stamp prints which have for any reason been remounted and which are not on original mounts, this not having been practicable before on account of the risk of unscrupulous persons removing prints from mounts with stamps on and substituting inferior or wrong prints on the stamped mount, whereas now if such a thing should be done the print or the mount when separated would only bear half the stamp, and the fraud

would be easily detected, in addition to which a Baxter print would have half the stamp on the left hand bottom corner and a Licensee print on the right hand bottom corner, and it is hoped that this is such an effective method of stamping that such changeovers will not be possible.

In addition to the stamp for binding together mount and print the Council have had struck 3 dies as illustrated so that plain mounts can be stamped if desired, and also a number of stamped mounts have been obtained on which prints at present unmounted can be mounted, and it is confidently hoped that these mounts may become so popular that every collector will require to have his or her prints either stamped or mounted on the Society's stamped mounts, which are in no way an imitation of Baxter mounts, but which will safeguard the collector as to the genuineness of any prints he has or may buy.

The prices for Guarantee Stamps remain as before, 1/- for each Baxter print, and Sixpence for each Licensee print, but in addition to this charge, for stamping the impressed seal on any plain mount print may be already on, a charge of sixpence per print will be made, and for mounting prints on Baxter Society Stamped Mounts the charges are as follows:

For small prints 1/- [5p] per print; for prints measuring over 6 inches in length, 1/6 [7½p] per print; and for prints measuring over 12 inches in length, 2/6 [12½p] per print; and for the few very large prints, such as "Parting Look", and "St. Bernard Dogs", 5/- [25p] per print;

Under the capable leadership of Ernest Etheridge, both the Baxter Society and the *Baxter Times* flourished. In April 1923, on the occasion of the marriage of the Duke of York to Elizabeth Bowes Lyon (later to become King George VI and Queen Elizabeth), the Society presented the royal couple with a pair of Baxter prints (Nos. 179 and 180 in the Catalogue), and the gift was suitably and graciously acknowledged:

His Royal Highness wishes me to ask you to convey to the President, Council and members of the Baxter Society his warm thanks for the interesting and beautifully framed prints of H.M. Queen Victoria and the Prince Consort. The Duke has great pleasure in accepting this gift, and will much value these two specimens of one of the early forms of colour prints, which to him have the additional advantage of being family portraits.

His Royal Highness hopes that you will realise what real pleasure the Baxter Society have given him.

In August 1923 the society was able to hold its first exhibition in London, undoubtedly the climax of its existence. This was held at Puttick and Simpson's premises, Joshua Reynolds House, 47 Leicester Square. This exhibition was a great success; it was opened by the Mayor and Mayoress of Westminster, Councillor and Mrs Rye, and the traditional ceremony of presenting the opener's wife with a replica of the bouquet portrayed in 'The Bridesmaid' was performed by the wife of the President of the Society, Mrs C. T. Courtney Lewis. There were over a thousand different exhibits, including every one of Baxter's prints, many in each state of issue, illustrating his methods.

Some of the most interesting items were a scrapbook, compiled by George Baxter for a niece, containing many prints; thirty of Baxter's original steel plates; and some of the Baxter pocket books. There were also examples of the needle boxes in their containers, and many of the oil paintings from which Baxter took his copies.

Apart from the exhibits, lectures were given daily. C. T. Courtney Lewis and Ernest Etheridge alternated as speakers, and the general consensus of opinion was that it was the most successful event ever organized by the Baxter Society.

The members of the society took their subject seriously, and their actions and speeches aroused some adverse comment from their contemporaries. During the London exhibition a letter written to the Press was most critical:

> Philatelists are serious enough, but the solemnity of those who gather at the shrine of George Baxter far surpasses that of stamp collectors. A congregation listens and applauds lectures on Baxter and his work, conceived and expressed in a key of emotion that would not be inappropriate to a Rembrandt Society although it would not be used there. George Baxter seems to have been a man of rare technical genius and appalling taste. His subjects are characteristic of what a few years ago were thought the full horrors of mid-Victoria:— Prince Albert on a balcony in lavender tights, men and women in bright tartens, swan-necked ladies with narrow shoulders ogling old oak trees and putting love letters in holes therein.

This diatribe, of course, aroused the righteous wrath of the members of the society, but the writer was well put in his place by C. F. Leake, who gave a special lecture at the exhibition, in which he said:

> I suppose that it is written in sarcasm, but it is certainly bad English. It is really an unconscious tribute to those who are sufficiently interested in Baxter's work to collect his prints.
>
> Whether the Victorian era is less to be admired than the times in which we are now living, is a question which is open to various opinions, and future generations might hold the present race and our work at a lower estimate than the Victorian age.
>
> But I am more concerned with what this critic had to say about George Baxter's work than with his opinion of collectors. You have only to look at the prints on these walls to form your own opinion as to Baxter's taste, at any rate his taste was clean!
>
> "The Day Before Marriage" which depicts a swan-necked maiden with narrow shoulders etc, is from the painting by Fanny Corbeaux.
>
> "The Lovers' Letter Box" is after the original by Jessie Macleod. Why blame Baxter for merely copying by his process the pictures which were liked and appreciated at that time, it is what engravers of any age have done.
>
> But I do not wish to occupy any more of your time tonight in answering this apparently unfriendly criticism. I think that this service was most effectively done in advance seventy-five years ago by Lord Brougham who presided over the judicial committee of the Privy Council, in giving judgement on Baxter's application for the renewal of the patent of his colour printing process; that judgement I will read you later.

We will be content with dismissing our friend with these few remarks, and the hope that at a future time a kindlier feeling will be generated in his heart towards Baxter and his collectors. [Loud applause]

The exhibition had further and more serious repercussions. At this time Courtney Lewis, was working on his final and most complete book, *The Picture Printer*, which was to be published in 1924. He no doubt felt that he was in the unassailable position of being the highest authority in the land on his subject. Unfortunately, he used his position as editor of the *Baxter Times* and the society's journal to criticize the prints exhibited by other members of the society. To insult these gentlemen's Baxter prints was worse in their eyes than impugning their honour or their integrity—in fact no greater insult could be imagined.

At the time of the Birmingham exhibition, George Lambert, a vice-president of the council, had remonstrated with Courtney Lewis over these criticisms, saying that his unfair and unnecessary remarks had offended many members of the society, and Lambert had expressed the hope that there would be no repetition of the incident. On the contrary, however, Courtney Lewis took the first opportunity to criticize the prints owned by Lambert. After the London exhibition, Courtney Lewis stated in *The Baxter Times* that Lambert's prints were faded, cut down, second-class and unsatisfactory.

This second attack by Courtney Lewis caused trouble. There were emergency meetings to discuss the matter; the issue of the journal was temporarily stopped, and when the dust settled, the journal reappeared with the following explanation:

> On account of the very unfortunate happenings during the past two months and the consequent resignation of Mr. C. T. Courtney Lewis as editor of the Journal, the Council have as a body decided to keep faith with its members, whose subscription entitles them to a December Journal, and to publish this issue themselves rather than to immediately appoint an editor in place of Mr. Lewis.
>
> The least that is said about such an unfortunate affair the better, but in fairness to all concerned, some mention must be made as to what has transpired, in order that every member may be fully informed and that the Council as a body may be able to justify the position they have felt compelled to assume.
>
> During the past year the matter appearing in the Journal has not always been in the best interests of the Society.
>
> Exception was taken at criticism by a fellow exhibitor levelled at members' prints lent for the exhibition at Birmingham, several of our best members and largest exhibitors being very much upset by what they rightly considered to be uncalled for and in some instances unjust criticism.
>
> As these complaints were brought to the notice of the Editor, it was hoped that such a course would not again be adopted, but unfortunately the same thing has again happened in connection with the London exhibition, and in consequence one of our Vice-Presidents, Mr. Lambert, who is a very highly

esteemed member, and one who in fact probably went to more trouble and expense than any other contributor, came in for a share of criticism which was unkind, unjustifiable, and incorrect.

The direct result of the review of the exhibition with this criticism appearing in the Journal was to cause the gentleman concerned a feeling of disappointment and sense of injustice, and he wrote to the Editor explaining very fully his feelings and views, and requesting the publication of his letter in the next Journal, only to receive a reply intimating that the Editor did not think it wise to publish it.

The next step was taken by the Council, who passed a resolution, with one dissentient only, that the letter written by Mr. Lambert be published in the December Journal.

In reply, the Editor advised the Secretary that he had no intention of publishing the letter or, indeed, of writing a line of the Journal until after the Annual Meeting, in consequence of which the Council felt regretfully compelled in the interest of the impartial treatment of any or all of its members to ask the Editor to publish the Journal and include the letter as already suggested, and, as stated, the much to be regretted result has been the resignation of Mr. C. T. Courtney Lewis as Editor.

Any shortcomings in this issue will be no doubt overlooked by every member who has the interests of the Society at heart.

At the annual general meeting of the council at the Grand Hotel, Birmingham, the resignation of Courtney Lewis as president of the council and as editor of the *Baxter Times* and *Baxter Journal* was accepted. In view of his great service to the society, Courtney Lewis, was made an honorary life president. It was felt that the office of president should be an annual award, Dr Page Robertson being the elected first of this line.

Lambert's letter (which appears in full at the end of this chapter) perfectly illustrates the attitude that the writer to the Press found so unacceptable.

The Baxter Society now passed through a more tranquil phase. The new arrangement whereby a different member of the committee took the presidential chair each year encouraged each holder of the office to entertain the members to the best of his ability. The president for 1927, A. E. Owen, invited the members to a garden party at his moated home 'New Hall', Sutton Coldfield:

The afternoon passed all too swiftly, the guests amused themselves with bowls and croquet. Then followed a delightful repast, after which a tour was made of Mr. Owen's stately home. During the examination of the rooms the attention of the host and hostess was called to some valuable prints on the walls, whose worth had not been known till then, pointed out by Mr. Rylatt, of Puttick & Simpson, one of the guests. Everyone expressed their pleasure at the beauty of the ancient House.

The following year, with Alfred Docker as president, the annual general meeting was held at the Grand Hotel, Birmingham:

Immediately at the close of the meeting the members present were joined by many ladies and other visitors, and after a pleasant tea entered with delightful

zest into a novel competition of choosing the three finest Baxter prints on exhibition, each lady and gentleman being allowed 30 votes and they had about 100 prints to make the selection from. After the names of the owners of the three winning prints had been disclosed, an enjoyable concert given by some musical members of the society brought a pleasant meeting to a close.

Alas, these idyllic conditions did not last very long. It seemed that the members of the Second Baxter Society took their subject so seriously that they were never far from quarrelling. During these years, mainly from about 1923 to 1926, the prices for Baxter prints rose continuously. Puttick and Simpson held monthly sales sometimes lasting two days, of Baxter and licensee prints. They were eagerly attended, and changes in prices recorded in each month's issue of *The Baxter Times and B.P. Collector* (as it had now become), on the lines of share prices in *The Financial Times*.

The explosion came when Alfred Docker wrote to the *Bazaar, Exchange and Mart*, at that time an important publication in the print and art world. His letter began:

> American and other print collectors may perhaps get somewhat of a shock from what I have to say about Baxter prints—which will quite likely raise a storm of contradiction and protest.
>
> During the past year or so, some of Baxter's productions have reached phenomenal prices in the auction room, and having regard to the facts as they have come to my notice, I am bound to say that in my judgement some of these prices have been entirely unwarranted, and almost absurd. Let us examine the facts.

Then followed a very long and detailed dissertation until he reached the heart of the matter with the devastating statement:

> Many apparently fine prints were very largely hand coloured, and, therefore, to my mind not worth consideration, momentary or otherwise as specimens of Baxter's process.

Docker then went on to specifically name some of the prints: 'Mr and Mrs Chubb' which pair had been sold for £900; 'The Launch of the Trafalgar' sold for £140; 'Edmund Burke' sold for £250, and copies of 'The Coronation' and 'Opening of Parliament' fetched correspondingly high prices. He finished his letter as follows:

> As far as these prints are concerned I say that they were to a large extent coloured by hand "Sic Transit Gloria Mundi" at any rate as far as Baxter prints are concerned.

To realize what these prices meant for Baxter Prints in 1924, one must compare prices paid at auction for works of art at the same period. The following prices were obtained by Christies in May and June 1924:

Canaletto,	The Grand Canal, Venice	£52.0.0
Constable	The Lock	£39.18.0
Guardi,	Island Near Venice	£241.10.0
Gainsborough,	Woodland Stream	£68.5.0
Goya	Peasant Family	£17.17.0

To make things even more pointed the high prices were paid for the Baxter Prints by members of the Baxter Society Committee including Ernest Etheridge and Courtney Lewis who were buying for clients.

Alfred Docker was certainly right about the effect of his letter. Courtney Lewis led the counter-attack:

> It seems to me only fair to the seller, to the buyer, to the dealer, upon whose judgement I believe the latter relied, and to the auctioneers in whose rooms the sale took place, to record that there is, in my belief, no accurate reason for saying that "The Launch of the Trafalgar" recently sold for £140 was in any part hand coloured. I have known it for many years, seen it often and examined it many times. I also know the print of the same subject which was formerly in Mr. Docker's collection. It is an inferior print, it is not darker in colour, it is just faded.

This did not settle the matter. The letters to the *Bazaar and Mart* became so acrimonious that the council of the Baxter Society had to do something about the matter. An expert committee was formed under the chairmanship of Ernest Etheridge consisting of Harold C. Clarke, Joseph H. Rylatt, George E. Lambert and A. E. Wilson Browne, to examine the prints and pronounce a verdict on Docker's charges. After many meetings the expert committee sent a very long and involved letter to the *Bazaar and Mart*, the salient part being:

> The points specifically raised were:
> 1. Was the "Launch of the Trafalgar" recently sold by Messrs. Puttick and Simpson for £140 at all hand coloured?
> 2. Are the Chubb portraits hand coloured?
> 3. Are any 'Coronation' and 'Opening of Parliament' prints touched up by hand?
>
> The reply to each of these questions must undoubtedly be in the affirmative. But the expert committee wish that you had added another question viz:— Are the prints so finished of less value than they would otherwise have been?

Then followed a long treatise on hand-colouring in general, and on Baxter prints in particular, finishing with the very obfuse pronouncement:

> In conclusion the expert committee are strongly of the opinion that such highly finished prints are of more value, and more to be desired by the ardent collector, in contrast to those less highly finished, providing that the prints are as issued by Baxter, and have not subsequently been touched up by others. The value of a rare Baxter print, as is the value of every other collectable article, being enhanced when in original state, it is not of course possible, after such a lapse of time to say how much of this hand-colouring was done by Baxter himself.

I remain, on behalf of the expert committee who have appended their names to this unanimous report,

Ernest Etheridge. Hon Secretary

The report which tried to mollify all parties, really satisfied nobody, and the Baxter Society was never the same again. Many members, particularly those who were dealers, turned to the new field of pot-lid collecting, which was then becoming popular.

The *B.P. Collector and Baxter Times* continued until 1927, when it became more generalized under the title of *Books, Prints and Pictures and B.P. Collector*, but this effort died in 1928. It was then merged with the *Baxter Journal* shrinking to *The Baxter Society Members Circular*, edited by G. H. Gibson and Ernest Etheridge.

On 22 September 1928, a memorial tablet to George Baxter was unveiled at 11 Northampton Square, Finsbury. The tablet, in coloured Doulton ware, bore the following inscription:

GEORGE BAXTER
Artist Craftsman
Born 1804 Died 1867
Lived here from
1844 to 1860
A Central Figure in
Coloured Picture Printing.

C. T. Courtney Lewis died on 23 May 1931. The members' circular for December 1931 contains the following appreciation written by Alfred Docker some years previously.

Mr. Courtney Lewis is a man of many parts and reminds us of a diamond which has a number of facets and radiates light from them all. The Baxter print lay for many years in obscurity, the cinderella, so to speak of art productions, and it rested with Mr. Courtney Lewis, in the role of The Fairy Godmother, to touch it with his wand, and raise it from the ashes of that obscurity and place it before us so that we might appreciate its worth.

The Baxter Society continued until 1938, but with the death of Ernest Etheridge, and with World War II approaching, it was unable to carry on. It had suffered a grievous split in 1936—in that year the London members broke away and formed The National Picture Print Society, the first meeting of which was held at the Garrick Hotel, London, w1 on 20 April 1936, under the presidency of H. G. Clarke, FRSA, with J. H. Rylatt, FRSA, Honorary Secretary. Both of these gentlemen had been members of the committee of the Second Baxter Society.

The National Picture Print Society produced the *Centenary Baxter Book* to mark the centenary of the grant to George Baxter of his patent in 1835. The book was a joint effort by the president and secretary of the society, Clarke being mainly responsible for the biographical matter, and Rylatt for

the cataloguing of the prints. The *Centenary Baxter Book* was published by the Courier Press of Leamington Spa in a limited edition of 125 copies, one of which HM Queen Elizabeth was graciously pleased to accept. After a second meeting held in the students' room of the Department of Prints and Drawings at the British Museum on 30 June 1936, the National Picture Print Society faded away.

Since 1946, there has been no revival of the Baxter societies. There has been one other exhibition, apart from that mentioned in the preceding chapter, in 1967. The Leicester Corporation mounted a commemorative exhibition to mark the anniversary of George Baxter's death. Arranged by a private collector, W. C. Reeve of Leicester, the exhibition was extremely successful.

The exhibition was on display at Leicester for the month of April 1967, and aroused such interest that the curator of the Leicester Art Galleries requested Mr Reeve's permission to send the display around the 'midland circuit' of museums. This was granted and it was shown at Kettering, Newark, Dudley, Warwick and Nottingham.

Letter from G. E. Lambert re criticisms of prints exhibited at London Exhibition, in September Journal, *which C. T. Courtney Lewis had refused to print*

November 2nd 1923
Dear Mr. Courtney Lewis,

I regret it was not possible for me to join you at the last Exhibition Committee Meeting, as I had hoped to do, but I was taken unwell the same morning, and eventually spent a week in bed. I am pleased to say that I am now fairly fit again.

I was disappointed, because I particularly wanted to have a chat with you concerning the remarks contained in your criticism of some of my entries in the recent Exhibition, and published in the September "Journal". Please do not consider anything that I may say to be in any way personally unfriendly, but fair play is a jewel, and I feel so very much hurt that I cannot refrain from speaking fully and plainly, in justice to my efforts, my prints and myself.

Try how I will I cannot banish from my mind the thought that you have allowed the spirit of friendship and co-operation to be entirely over-ruled by that of rivalry. In consequence you have made a deliberate attempt to belittle many of my exhibits by remarks that are unjustified and ungrateful, and have quite overstepped the bounds of common courtesy.

It is not easy for me, or pleasant either, to put into words just how I feel, but I will try to explain. In the first place, it must be remembered that the Exhibition was purely a LOAN one, all entries being lent by Members of the Society, and in no sense did competition enter into the matter. Exhibitors one and all did their level best to help forward the interest in the Works of George Baxter and his Licensees, and, incidentally, it was hoped, the Society also. This being understood I entirely fail to see the necessity of criticism from anyone connected with the Society. If criticism there must be, I feel very strongly that it

should come from outside sources and certainly not from a fellow exhibitor, and, above all, in any case such criticism should be unbiased and fair.

Since I joined the Baxter Society I have done my humble best to help in any possible way and without any thought of praise. I have lent exhibits in other directions which have always been more than appreciated, but not so in this case.

One of the main objects was to obtain the best items we could, and after making various efforts in other directions without much success, we mutually agreed that it would be necessary for you and I to provide the bulk of the exhibits. This was gratifying in one sense, but regretted in another, as I was of the opinion that the more exhibitors there were, the more interesting and better it would be, but the class of Prints required were not offered by others, so there was no help for it. We both disliked the idea of ransacking our collections to such an extent, but it had to be done, and I agreed to save you as much trouble as I could and provided considerably more than half the catalogue. This entailed a great amount of trouble and time, as it is not an easy matter, when dealing with so many items, and I have not yet restored all of the prints into their portfolio positions, many of which, by the way, are not improved. In short, I did my best and my efforts were sincere.

This in itself is surely sufficient to make any uncomplimentary criticism quite out of the question, but it was not so.

I will now refer to some of your remarks to which I take exception.

You say my large "First Impressions" was perhaps the most unsatisfying example of any of the more important subjects in the Exhibition. In view of what I have already said it is truly difficult to understand such a remark. In any case I cannot allow same to remain unchallenged, and I say that this particular copy is undoubtedly a superb one, in fact I have not seen a better. It has been repeatedly admired by many of the Midland Members, and your statement came equally as great a shock to them as to myself. I do not suggest that it is the best copy in existence, but I should very much like to see a better if such there is. Further, if you yourself knew of a more suitable specimen, as a Member of the Selection Committee why did you not mention same? We will suppose for a moment that this item was not first class, but seeing that a finer one was not forthcoming, was it necessary to condemn my print in such a wholesale manner? Of course not.

We will now refer to the "Launch of the Trafalgar." You will recollect that this item with several others was placed before the Committee for comparison, and as in many instances there appeared to be little or nothing to choose between the prints, it was your own suggestion that in the case of the rarer items we should both exhibit. In your criticism you mention two fine copies of the "Trafalgar" and then go on to suggest that mine was faded. With this I totally disagree. Both prints are exceedingly fine ones, but my copy is one of the lighter coloured specimens which we occasionally see; yours is an exceptionally dark one. It is quite a matter of personal taste and not a question as to which is the finest. Many prints by Baxter vary greatly in this respect which, considering their method of production, is not at all to be wondered at. I think it only fair to mention that you ignore the fact that your own print is not full size, being cut down in height rather considerably.

Referring to your comments on the Burke prints, you say that the four lined

copy you exhibited appears to be more rare than the six lined copies. I am sure your readers will not need educating on this point, as I cannot imagine the owners of the latter cutting off a couple of lines of lettering with a view to making the item more rare.

Further, you say my dome-top varieties of the "Coronation" and "Opening of Parliament" are nice prints but cut down to less than half length. Such a statement is surely ridiculous and very misleading. That these smaller prints are a distinct issue is not open to doubt; they are described as such in Baxter's Prospectus and also by yourself in the Picture Printer.

I exhibited many specimens of Kronheim prints from my large collection, and it was quite a special feature of the Exhibition to notice the interest that was taken in these. You say that many of these items "were without any atmosphere," "entirely of the fashion-plate order," and were "gaudy and inartistic." I only exhibited three fashion prints, and for the reason that they were extremely beautiful in colouring, so that your remark is quite erroneous. I am sure your comments will not be appreciated by collectors of Kronheim prints, of which there are many, and I can only hope that they will not allow such words to discourage them. They are Baxter process prints, and, with few exceptions, of considerable merit, and will surely come into their own, in spite of all opposition, and I suggest that it is far better to leave their pleasing effect or otherwise to the individual taste of each collector, and those interested will no doubt judge the statements made from their own standpoint.

I do not think you are interested in or even collect Kronheim productions, or it may be that my entries were used as a medium following a controversy between yourself and others, who are supporters and admirers of these prints; if so, your criticism is to be more than regretted.

It is to be noted that you were in the position of being able to give unstinted praise to your own entries and without any interference by opposite opinions. You have done this to the full, seeing that you devote about two hundred and sixty lines of lettering in support of your own items, and about one hundred lines including deprecatory sentences to my items and less than this number to all other entries. Personally I am not one to seek advertisement or undue commendation, but I submit that my efforts generally in support of the Exhibition and the provision of about six hundred items none of which left any opening for criticism, deserved something more than disparagement. I think I am right in saying that you do not make a single detrimental statement except where my prints are concerned.

Taking the exhibits as a whole, they were really a magnificent show, and in my opinion it was difficult to find reasonable fault anywhere, with the exception of several of the prints that you exhibited with over-mounts, many of which were indifferent copies, and this in spite of the fact that on your own suggestion, prints with over-mounts should on this occasion be strictly omitted. In connection with the Birmingham Exhibition of last year, your subsequent criticism of prints with over-mounts was very strong, yet you were the only one to enter same on this last occasion.

I would like to mention here that in a conversation we had some time ago, I informed you that you offended several good friends and exhibitors by similar unfair and unnecessary criticism in connection with the Birmingham Exhibition, and it was sincerely hoped that there would be no repetition. The

remarks you made have never been forgotten, and it was only with difficulty that we obtained any items from these members for the last Exhibition. I can quite understand their feelings now.

Since I became a Member of the Baxter Society I have been impressed by the lack of that spirit of goodwill and friendly co-operation so necessary to success. There always appears to be something amiss, some bickering or clashing of interests, which I have not met elsewhere. This is a great pity, as nothing should be more pleasing and helpful to collectors than to be able to compare items one with another without enmity, and to give honour where honour is due. I have made many good friends in the Baxter world, and whose friendship I esteem and trust to retain. If they have secured a better copy than I possessed of any subject, I have been the first to offer congratulations. Why not? Friendly competition is all to the good.

I collect Baxter colour prints because I am truly fond of them and solely as a hobby. For this reason from a monetary point of view I shall not suffer from your remarks, as I have nothing to sell or any axe to grind. No one but myself knows what an immense amount of pleasure and recreation I have derived as a busy manufacturer from my prints, and the company of brother collectors.

I hate quibbles almost as much as letter writing, and for this reason I do not wish my enjoyment or my hobby to be marred by unpleasantness or a recurrence of this unfortunate affair.

I was perfectly happy with my prints before I became a member, and I now feel that I can be equally as happy, in view of all that has happened as a non-member, and to make sure that I shall avoid a similar incident I have definitely made up my mind to resign and go my own way.

After all, no one can work without goodwill and some small appreciation sometimes, and I have neither the time nor the inclination to waste good intentions and efforts in any direction.

Speaking as a business man, the Society in its present form or regime does not appeal to me, and I say this with no little amount of regret, and with the earnest hope that my experiences and explanation will save further members at any time having cause to follow me.

I have always expressed gratification in connection with the wonderful work you have done in the interests of Baxter prints and the help you have given to collectors in consequence of your publications, and I wish you every success with your coming issue.

Finally, in view of all the circumstances, and so that my feelings which I have fully expressed can be put before those interested, I ask you to publish this note in its entirety in the next Journal. I shall then at least have had the satisfaction of knowing that both sides have been heard.

G.E.L.

Appendix I

George Baxter's Stamps and Seals

No work on Baxter would be complete without a chapter on his stamps and seals, and no aspect of the subject has led to so much arrant nonsense and controversy. This confusion has arisen because of Baxter's insensate aberration that his rivals were constantly attempting to pass off their inferior work as his own, which led him incessantly to change the wording and form of his stamps and seals in an attempt to frustrate their efforts. Even when he granted licences to other printers to work his process, he still had this obsession, and he changed the embossed seal that he had adopted by this period no less than fifteen times.

During the 1920s, which saw the heyday of the Baxter print, the members of the Baxter Society made an almost Talmudic study of the variations, even going so far as to find different numbers of pearls on the crown which surmounts Baxter's red stamp. J. H. Rylatt, a member of the council of the Baxter Society, and one of the authorities of its expert committee, made an intensive study of the subject and published the results of his researches in a series of articles in the *Baxter Times* during 1924 and 1925. In addition to the fifteen different embossed seals which I have mentioned, he found no less than twenty different varieties of the red seal, some of the variations being so small that one has to study the stamps two or three times before finding them.

I have lettered the designs in order to assist collectors in the identification of the prints, the appropriate letter appearing below the name of the print in the catalogue which follows this Appendix. Before I enumerate them, however, I would like to dispel some of the myths which have arisen, no doubt because of the reasons already given.

1 No print had a stamp or seal before 1847, when Baxter introduced it on 'River in Holland'; so no print before No. 148 in my list ever had a stamp or seal.
2 Any print which should have a stamp or seal naturally has its value considerably enhanced if these are intact, but some collectors will not be deterred from buying an interesting or beautiful print (at a reduced price) if the stamp is missing in the hope that they will find a complete print at a later date when they can then dispose of the inferior variety.
3 Abraham Le Blond never used Baxter's seal on any of his reprints. The Le Blond Baxters are specified in the catalogue so one can usually tell Le Blond's work by both its inferior quality and measurements.
4 The form of stamp or seal is no indication whatsoever of the value of any particular print; the form was used purely at Baxter's whim and he often used different varieties on the same print. For a dealer to claim, therefore, that a print in his possession is made more valuable by a 'certain type' of stamp or seal, I can categorically state is either ignorance or deceit.

Here, then, is the list of stamps and seals which has never before been published complete and fully illustrated. I must pay tribute to the late J. H. Rylatt, without whose research and industry it would have been most difficult and, perhaps at this time, even impossible, to complete.

George Baxter's Red Stamps

A Five pearls each side of orb and cross at top of crown. Two oval lines—one thick, one thin.
Address: 11 Northampton Square
Underneath: Licenses granted to work the process

B Four pearls each side of crown. Two oval lines of same thickness.
Address: XI Northampton Square
Underneath: Licenses granted to work the process

C Four pearls each side of crown. Two oval lines of same thickness.
Address: 11 & 12 Northampton Square
Underneath: Licenses granted to work the process

D Stamp used by an agent of Baxter's, and only found on one print, 'St Ruth's Priory'.

E Six pearls each side of crown. Two oval lines of same thickness.
Address: XI Northampton Square
Underneath: Licenses granted to work the process

F Six pearls each side of crown. Two oval lines—one thick, one thin.
Address: XI Northampton Square
Underneath: licenses granted to work the process

G Five pearls each side of crown. Two oval lines of same thickness.
Address: XI Northampton Square
Underneath: Licenses granted to work the process

H Five pearls each side of crown. Two oval lines—one thick, one thin.
 Address: XI Northampton Square
 Underneath: Licenses granted to work the process

LICENSES GRANTED TO WORK
THE PROCESS

I Six pearls each side of crown. Two oval lines—one thick, one thin.
 Address: XI Northampton Square
 Underneath: licenses granted to work the process

LICENSES GRANTED TO WORK
THE PROCESS

J Five pearls each side of crown. Two oval lines—one thick, one thin.
 Address: XI Northampton Square
 Misprint in line under oval
 Underneath: Licenses granted to work the frocess

LICENSES ORANTED TO WORK
THE FROCESS.

K Six pearls each side of crown. Two oval lines—one thick, one thin.
Address: XI Northampton Square
This is one of two red stamps on which Baxter has printed 'Printed in Oil Colours' in one line.
Underneath: Licenses granted to work the process

L Six pearls each side of crown. Two oval lines—one thick, one thin.
Address: 11 & 12 Northampton Square
The second stamp on which Baxter has printed 'Printed in Oil Colours' in one line.
Underneath: Licenses granted to work the process

M Five pearls each side of crown. Two oval lines—one thick, one thin.
Address: XI Northampton Square
Underneath: Licenses granted to work the process

N Five pearls each side of crown. Two oval lines—one thick, one thin.
 Address: 11 & 12 Northampton Square
 Underneath: Licenses granted to work the process

O Six pearls each side of crown. Two oval lines—one thick, one thin.
 Address: 11 & 12 Northampton Square
 Underneath: Licenses granted to work the process

P Five pearls each side of crown. Two oval lines of same thickness.
 Address: 11 & 12 Northampton Square
 Underneath: Licenses granted to work the process

Q Six pearls each side of crown. Two oval lines of same thickness.
 Address: 11 & 12 Northampton Square
 Underneath: Licenses granted to work above process in Great Britain 200
 guineas each. France, Belgium, Germany, &cc &cc. 1260 Francs. Instructions
 to Licensees 252 Francs.

R Five pearls each side of crown. Two oval lines of same thickness.
 Address: 11 & 12 Northampton Square
 Underneath: Licenses granted to work the process

S Seven pearls each side of crown. Two oval lines of same thickness.
 Address: 11 & 12 Northampton Square
 Underneath: Licenses granted to work the above process in Great Britain,
 France, Belgium, Germany, &c. Instructions given to licensees

T Five pearls each side of crown. Two oval lines—one thick, one thin.
 Address: 11 & 12 Northampton Square
 This is the only stamp on which Baxter has printed 'Printed in Oil Colours By'
 in one line.
 Underneath: licences granted to work the process
 (The last of the red stamps)

Baxter's Embossed Seals

EMA Plain embossed block letters

> G. BAXTER
> INVENTOR & PATENTEE
> 11&12 NORTHAMPTON SQUARE
> LONDON

EMB An oval with embossed block letters surmounted by a crown, and under it
 the title of the print in a plain rectangular frame

> THE UNHAPPY CHILD

EMC An oval with embossed block letters surmounted by a crown, and under it
 the title of the print in a rectangular frame with a double line instead of
 plain as above

> THE
> FAITHFUL MESSENGER

EMD A shield with embossed block letters surmounted by a crown, and under it the title of the print in a plain rectangular frame

EME A shield with embossed block letters surmounted by a crown, and under it the title of the print in a rectangular frame with a double line instead of plain line as above

EMF A garter belt, with embossed block letters, surmounted by a crown and under it the title of the print in a rectangular frame formed with double lines

EMG A garter belt, with embossed block letters, surmounted by a crown and under it the title of the print in a plain rectangular frame

EMH A garter belt, with embossed block letters surmounted by a crown, and under it the title of the print in a rectangular frame formed by a double line, the outer line being wavy

EMI An oval containing a facsimile of George Baxter's autograph, surmounted by a crown of a broader type than previously used so that the cross and orb do not stand out, and under it the title of the print in a plain rectangular frame

EMJ An oval containing a facsimile of George Baxter's autograph surmounted by a crown of the same type as above version, with the title of the print in a rectangle composed of two lines, the outer being wavy and the inner plain

EMK An oval containing a facsimile of George Baxter's autograph surmounted by a crown with the cross and orb standing out prominently, and under it the title of the print in a rectangle composed of one plain line

EML An oval containing a facsimile of George Baxter's autograph surmounted by a crown of the same type as above version and under it the title of the print in a rectangle composed of two plain lines

EMM An oval containing a facsimile of George Baxter's autograph surmounted by a crown of the same type as above version, and under it the title of the print in a rectangle composed of two lines, the outer being wavy and the inner plain

EMN An oval containing a facsimile of George Baxter's autograph, surmounted by a crown similar to above, under it the title of the print in a larger rectangle extending each side of oval composed of two double plain lines, surrounded by a decorated border of small acanthus leaves

EMO A shield with embossed letters surmounted by flags with the title in a plain rectangle underneath. This stamp was only used on the French version of 'Descent From the Cross' with the title either 'La Decente De La Croix' or 'La Descente de la Croix'

Appendix II

Explanation of the Catalogue

In preparing my catalogue of prints, I have not attempted any descriptions of the subjects, nor have I referred to prices. These two matters are fully dealt with in *The Price Guide to Baxter Prints* published in 1974 by The Antique Collectors' Club.

I have numbered my catalogue as far as possible in chronological order. I cannot claim that this is 100 per cent accurate as it has not always been possible to determine dates, but Baxter's changes of address give some information, and on his later work the date of publication was often printed.

What I have attempted to do is to gather as many facts as possible appertaining to each print; therefore, with each print I give the name, date of publication and size. All the prints up to No. 67 were published in books; and, where this is the case, I have given the title and author of the book and the size of the page on which the prints appeared; where the print was first published in a *Ladies' Pocket Book* I have given the name and date of the pocket book.

Some of Baxter's prints were used to illustrate sheet-music, which sold in great numbers in Victorian days. Where appropriate, I have given the name of the musical work and its composer.

I have also indicated on which prints a red stamp or seal was used and have given the index letters to correspond with those given in Appendix I. I have told the history of how the Le Blond Baxters came to be printed, in the chapters on the licensees, and under the names of those prints which were included in this episode I have printed 'Also Le Blond Baxter'.

In 1919 C. T. Courtney Lewis published a small book in which he classified the prints according to their availability at that time. Although some of these facts may be out-of-date now, his classifications do provide a very valuable indication of how many of each print were published and I have therefore included them.

Courtney Lewis numbered the prints in his books in sections according to their subjects, such as 'Missionary Prints', 'Religious Prints', 'Portraits', etc. In order to give a cross reference, Courtney Lewis' number is given in brackets.

I think that in the catalogue which follows, I have collated every fact appertaining to the Baxter prints which it is possible to obtain at this date. I have also given all measurements in inches and fractions of inches, as the prints were published in this scale, and I do not think it would be practical to transfer the sizes to the metric scale.

Catalogue of Prints

1 (1) 1829
'Butterflies'
Print 7×5in; page $11\frac{1}{2}$×9in
Name of book unknown
Class: Extremely rare

2 (2) 1834
'Dippers and Nest'
Print $3\frac{1}{2}$×3in; page $7\frac{3}{4}$×$4\frac{3}{4}$in
Title page of *Feathered Tales* by
Robert Mudie
Class: Rare

3 (3) 1834
'Little Grebes and Nest'
Print $3\frac{1}{2}\times4\frac{3}{4}$in; page $7\frac{3}{4}\times4\frac{3}{4}$in
From *Feathered Tales* by Robert Mudie
Class: Rare

4 (4) 1834
'Eagle and Vulture'
Print $3\frac{1}{2}\times2\frac{1}{2}$in; page $5\frac{7}{8}\times3\frac{3}{4}$in
From *Natural History of Birds* by
Robert Mudie
Class: Moderately rare

5 (5) 1834
'Hindoo and Mohammedan Buildings'
Print $8\frac{5}{8}\times6\frac{1}{4}$in; page 11×8in
From *Fisher's Drawingroom Scrap
Book* and *The Parlour Table Book*
Class: Common

6 (6) 1835
'The Welsh Harper'
Print $4\frac{7}{8}\times3$in; page $6\frac{3}{8}\times4$in
From *Social Tales* by Mrs Sherwood
and *Life as it is* by Mrs Paxton
Class: Moderately rare

7 (7) 1835
'Cattle Drinking'
Print $4\frac{1}{2}\times2\frac{7}{8}$in; page $6\frac{1}{2}\times4$in
A reproduction of Gainsborough's
picture used as frontispiece to *The Artist*
by Gandee
Class: Moderately rare

8 (8) 1835
'Convolvulus Scroll and Wreath'
Print 5×3in; page $6\frac{1}{2}\times4$in
Title page to *The Artist* by Gandee
Class: Moderately rare

9 (9) 1835
'Modifications of the Clouds'
Print $6\frac{3}{4}\times4$in; page $7\frac{1}{4}\times8\frac{1}{2}$in
From *The Book of Science* by
J. M. Moffat; also appeared in *The Boys
Book of Science*
Class: Very rare

10 (10) 1835
'Norfolk Bridge, New Shoreham'
Print $6\frac{1}{4}\times4\frac{5}{8}$in; page $12\frac{1}{2}\times10$in
From *The History of Sussex* by
Horsefield. Only printed in sepia
Class: Very rare

11 (11) 1835
'The End of Time'
Print $3\frac{1}{4}\times2\frac{1}{8}$in; page $4\frac{3}{4}\times3$in
Frontispiece to *The Perennial*, a
collection of religious poetry published
by the editor of *The Evergreen*
Class: Moderately rare

12 (12) 1835
'Polar Sky'
Print $3\frac{3}{4}\times3$in; page $6\frac{5}{8}$in$\times4$in
From *The Heavens* by Robert Mudie
Class: Rare

13 (13) 1835
'The Seasons'
Print 4×3in; page $6\frac{5}{8}\times4\frac{1}{4}$in
Title page of *The Heavens* by Robert
Mudie
Class: Moderately rare

14 (14) 1835
'Tropical Scenery'
Print 4×3in; page $6\frac{5}{8}\times4\frac{1}{4}$in
From *The Earth* by Robert Mudie
Class: Rare

15 (15) 1835
'Temperate'
Print $2\times1\frac{1}{2}$in; page $6\frac{5}{8}\times4\frac{1}{4}$in
From title page of *The Earth* by Robert
Mudie
Class: Moderately rare

16 (16) 1835
'Scene on the Mountain Tops'
Print $3\frac{1}{2}\times3$in; page 6×4in
From *The Air* by Robert Mudie
Class: Common

17 (17) 1835
'Air Bird'
Print $1\frac{1}{2}\times2\frac{1}{2}$in; page $6\frac{5}{8}\times4$in
Vignette on the title page of *The Air* by
Robert Mudie
Class: Common

18 (18) 1835
'Evening on the Sea'
Print 4×3in; page $6\frac{5}{8}\times4$in
Frontispiece of *The Sea* by Robert
Mudie
Class: Common

19 (19) 1835
'The Shore'
Print $1\frac{1}{2}\times2$in; page $6\frac{5}{8}\times4$in
Vignette on title page of *The Sea* by
Robert Mudie
Class: Moderately rare

20 (20) 1835
'Caroline Mordaunt'
Print $2\frac{5}{8}\times4$in; page $6\frac{1}{4}\times4$in
Frontispiece of *Caroline Mordaunt* by
Mrs Sherwood
Class: Rare

21 (21) 1836
'Virginia Water'
Print 5×3in; page $6\frac{1}{4}\times4$in
From *New Year's Token* by
Mrs Sherwood
Class: Rare

22 (319) 1836
'The Welsh Harper'
Print $4\frac{7}{8}\times3$in; page $6\frac{5}{8}\times4$in
A later version of print No 6. Published
after Baxter had patented his process,
and printed with the aid of a metal plate.
The first version was printed with wood
blocks only
Class: Rare

23 (37) 1836
'Cluster of Passion Flowers and Roses'
Print 8×6in; page $12\times9\frac{1}{4}$in
From *Woodlands Nursery Catalogue of
Horticulture* published by Maresfield.
Some versions have names, etc printed
on right-hand corner of print
Class: Both versions extremely rare

24 (67) 1836
'Boy Throwing Stones at Ducks'
Print $4\times2\frac{1}{2}$in; page $5\frac{1}{2}\times3\frac{1}{2}$in
From *Tales for Boys* by Mary Elliot
Class: Extremely rare

25 (68) 1836
'Children Outside Gates of a Mansion'
Print $4\times2\frac{5}{8}$in; page $5\frac{3}{4}\times3\frac{3}{4}$in
From *Tales for Girls* by Mary Elliot
Class: Extremely rare

26 (69) 1836
'Two Lovers Standing Under a Tree'
Print $3\frac{1}{2}\times3$in; page $5\frac{3}{4}\times3\frac{1}{2}$in
From *A Garland of Love Wreathed of
Pleasant Flowers Gathered in the Field
of English Poesy* collected and
published by Chapman and Hall
Class: Moderately rare

27 (22) 1836
'Boy with a Bird's Nest'
Print $2\frac{1}{4}\times2\frac{1}{4}$in; page $6\frac{1}{4}\times4$in
From *New Year's Token* published by
William Darton and Son
Class: Very rare

28 (23) 1836
'Bohemian Peasants of Toplitz Celebrat-
ing the Festival of their Patron Saint'
Print $4\frac{1}{2}\times4$in; page $8\frac{3}{4}\times5\frac{1}{4}$in
From *Sketches of Germany* by Edmund
Spencer
Class: Rare

29 (24) 1836
'Hungarian Peasants Descending the
Drave on a Raft of Barrels'
Print $4\frac{1}{2}\times4$in; page $8\frac{3}{4}\times5\frac{1}{4}$in
From *Sketches of Germany* by Edmund
Spencer
Class: Rare

30 (25) 1836
'Southdown Sheep, from the Flock of
Mr John Ellman of Lewes'
Print $5\frac{1}{2}\times3\frac{1}{2}$in; page $8\times4\frac{3}{4}$in
From *The Agricultural and
Horticultural Gleaner* published by
Baxter and Son, Lewes
Class: Moderately rare

31 (26) 1836
'Convolvulus Leaves, Flower and Bud'
Print $3\times3\frac{3}{4}$in; page $8\times4\frac{3}{4}$in
Title page of *Agricultural and
Horticultural Gleaner* published by
Baxter and Son, Lewes
Class: Moderately rare

32 (26A) 1836
'The Conqueror of Europe' ('The
Auricula')
Print $7\times4\frac{1}{4}$in; page $8\frac{3}{4}\times6\frac{3}{4}$in
From *The Florist's Register* published
by Chapman and Hall
Class: Extremely rare

33 (27) 1836
'The Roman Pavement at Pitney'
Print $7\frac{5}{8}\times5\frac{3}{8}$in; page $11\frac{1}{4}\times8\frac{1}{2}$in
From *History and Antiquities of
Somersetshire* by Rev William Phelps,
AS, FSA
Class: Rare

34 (28) 1836
'Boys with a Kite in a Tree'
Print $4\frac{3}{4}\times2\frac{1}{8}$in; page $6\frac{1}{4}\times3\frac{3}{4}$in
From *Tales of Truth* by Mary Elliot
Class: Very rare

35 (29) 1837
'Turn of the Monsoon'
Print $4\frac{1}{4}\times3\frac{1}{4}$in; page $6\frac{5}{8}\times4$in
From *Spring* by Robert Mudie
Class: Moderately rare

36 (30) 1837
'A Bird of Spring'
Print $1\frac{3}{4}\times2$in; page $6\frac{5}{8}\times4$in
Title page vignette of *Spring* by Robert
Mudie
Class: Moderately rare

37 (31) 1837
'Isola Bella, Lago Maggiore, Italy'
Print 4×3in; page $6\frac{5}{8}\times4\frac{1}{4}$in
From *Summer* by Robert Mudie
Class: Moderately rare

38 (32) 1837
'Summer Fly'
Print $1\frac{3}{4}\times1\frac{1}{2}$in; page $6\frac{5}{8}\times4\frac{1}{4}$in
Title page vignette of *Summer* by
Robert Mudie
Class: Common

39 (33) 1837
'Vineyard Near Mount St. Bernard'
Print $3\frac{1}{2}\times4$in; page $6\frac{5}{8}\times4\frac{1}{4}$in
From *Autumn* by Robert Mudie
Class: Moderately rare

40 (34) 1837
'Autumnal Artist' ('A Spider')
Print 2×2in; page $6\frac{5}{8}\times4\frac{1}{4}$in
Title page vignette of *Autumn* by Robert
Mudie
Class: Common

41 (35) 1837
'Avalanche at Lewes'
Print $4\times3\frac{1}{2}$in; page $6\frac{5}{8}\times4\frac{1}{4}$in
From *Winter* by Robert Mudie
Class: Moderately rare

42 (36) 1837
'Winter Bird'
Print 2×2in; page $6\frac{5}{8}\times4$in
Vignette on title page of *Winter* by
Robert Mudie
Class: Moderately rare

43 (38) 1837
'Advice on the Care of the Teeth'
Page $6\frac{1}{4}\times4$in; print $4\frac{1}{2}\times3\frac{1}{2}$in
This is the frontispiece to the above
named book by Sir Edwin Saunders. It
is the only 'animated' print produced by
Baxter. A female head with an uplifting
flap to show the interior of the jaws.
Class: Rare

The next eleven prints are those
published in *Cabinet of Paintings*
published by Chapman and Hall. The
size of the pages are $9\frac{1}{2}\times7\frac{1}{4}$in. Print
sizes vary slightly.

44 (39) 1837
'Burns and his Highland Mary'
Print $5\times4\frac{3}{4}$in. Title page.
Class: Moderately rare

45 (40) 1837
'Cape Wilberforce, Australia'
Print $5\frac{1}{8}\times3\frac{1}{2}$in
Class: Moderately rare

46 (41) 1837
'The Carrier Pigeon'
Print $5\frac{1}{8}\times4\frac{1}{8}$in
Class: Very rare

47 (42) 1837
'Verona'
Print $5\frac{3}{4}\times4$in
Class: Rare

48 (43) 1837
'Cleopatra'
Print $5\frac{1}{4}\times4$in
Class: Common
This print was published separately and
later called 'Cleopatra, Queen of Egypt'
on a mount (48A).
Class: Very rare

49 (44) 1837
'Lugano'
Print $5\frac{1}{4}\times4$in
Class: Moderately rare

50 (45) 1837
'The Interior of The Lady Chapel
Warwick'
Print $5\frac{3}{4}\times4$in
Class: Rare

51 (46) 1837
'The Boa Ghaut'
Print $5\frac{3}{8}\times4\frac{1}{3}$in
Class: Moderately rare

52 (47) 1837
'Zenobia'
Print $5\frac{3}{8}\times4\frac{1}{4}$in
Class: Moderately rare

53 (48) 1837
'The Destruction of Sodom'
Print $5\frac{3}{8}\times4\frac{1}{4}$in
Class: Common

54 (49) 1837
'Jenny Deans' Interview with the
Queen'
Print $5\frac{3}{4}\times4\frac{1}{4}$in
Class: Rare

The following four prints are from *The
Greenhouse, Hothouse and Stove* by
Charles McIntosh, FLS. Page and print
sizes are all the same: page $7\times4\frac{1}{4}$in;
print $3\frac{1}{2}\times3$in

55 (50) 1838
'Greenhouse Perennials'
Class: Rare

56 (51) 1838
'Greenhouse Shrubs'
Class: Rare

57 (52) 1838
'Orchidae'
Class: Rare

58 (53) 1838
'Annuals'
Class: Rare

59 (54) 1838
'Sunshine and a Cloudy Sky'
Print $2\frac{1}{2} \times 2$in; page 5×3in
Vignette on title page of *Smiles and Tears* by Mary Ann Neale
Class: Extremely rare

60 (56) 1838
'Yes I am Come From High Degree, for I am the Heir of Bold Buccleuch'
Page $4\frac{1}{2} \times 4\frac{1}{4}$in; print $4\frac{1}{2} \times 3\frac{1}{2}$in
From *Lay of the Last Minstrel* by Sir Walter Scott
Class: Very rare

61 (57) 1838
'The Old Water Mill'
Print $4\frac{1}{2} \times 3\frac{1}{2}$in; page $6\frac{1}{4} \times 4$in
From *Melia and other Poems* by Eliza Cook
Class: Rare

62 (58) 1838
'Moonlight at Sea'
Print $3 \times 2\frac{1}{2}$in; page $6\frac{1}{4} \times 4$in
Title page to *Melia and other Poems* by Eliza Cook
Class: Rare

63 (60) 1838
'The Dying Gladiator'
Print $1\frac{1}{2} \times 2$in; page $6\frac{5}{8} \times 4$in
Vignette on title page of *Physical Man* by Robert Mudie
Class: Common

64 (59) 1838
'Milo of Crotona, Rending the Oak'
Print $4 \times 3\frac{1}{2}$in; page $6\frac{5}{8} \times 4$in
Frontispiece to *Physical Man* by Robert Mudie
Class: Common

65 (71) 1838
'The Rev. John Williams'
Print $5\frac{1}{4} \times 4\frac{1}{4}$in; page $8\frac{5}{8} \times 6$in
Baxter's first portrait. Frontispiece to *Missionary Enterprises* by Rev Williams
Class: Moderately rare

66 (79) 1838
'TE PO, Chief of Raratonga'
Print $5\frac{5}{8} \times 3\frac{1}{2}$in; page $8\frac{5}{8} \times 6$in
Illustration to *Missionary Enterprises* by Rev Williams
Class: Common

67 (80) 1838
'The Departure of the Camden'
Mount $14 \times 10\frac{1}{2}$in; print $9\frac{3}{4} \times 5\frac{3}{4}$in
The first print published by Baxter on a mount independently from a book
Class: Extremely rare

68 (81A) 1838
'The John Wesley Missionary Ship'
Print (an oval) $4\frac{1}{2} \times 6\frac{1}{2}$in; page $6\frac{1}{2} \times 4\frac{1}{4}$in
Illustration in publications of the Wesleyan Missionary Society
Class: Rare

69 (98) 1838
'Mr. Medhurst in Conversation with Choo-Tih-Lang'
Print $5 \times 4\frac{3}{8}$in; page $8\frac{3}{4} \times 5\frac{3}{4}$in
Frontispiece of *China—the Spread of the Gospel* by Medhurst
Class: Common

70 (101) 1839
'Rafaralahy. Governor of Foule Point'
Print $5\frac{1}{2} \times 4\frac{1}{4}$in; page $8\frac{5}{8} \times 5\frac{1}{2}$in
From *History of Madagascar . . . and Persecution of the Native Christians* by Rev William Ellis
Class: Moderately rare

71 (70) 1839
'The Parsonage at Ovingham'
Print $4\frac{5}{8} \times 3\frac{1}{2}$in; page $6\frac{1}{4} \times 5$in
A monochrome from *Tales for Young People* by Mary Elliot
Class: Moderately rare

72 (94) 1839
'View from the Mission House, Bangalore'
Print $5\frac{1}{2} \times 4\frac{1}{4}$in; page $8\frac{1}{2} \times 5\frac{1}{4}$in
From *British India. . . . The Progress of Christianity* by Rev William Campbell
Class: Moderately rare

73 (102) 1839
'A Greek Monastery'
Print $5\frac{3}{8} \times 4\frac{1}{2}$in; page $8\frac{3}{4} \times 5\frac{1}{2}$in
From *A Narrative of the Greek Mission*
by Rev S. S. Wilson
Class: Moderately rare

74 (61) 1839
'Lo Studio'
Print 4×4in; page $6\frac{1}{2} \times 4\frac{1}{2}$in
From *Intellectual Man* by Robert
Mudie
Class: Moderately rare

75 (62) 1839
'Michael Angelo's Moses'
Print $2\frac{1}{2} \times 1\frac{3}{4}$in; page $6\frac{1}{2} \times 4\frac{1}{4}$in
Vignette on title page of *Intellectual
Man* by Robert Mudie
Class: Common

76 (63) 1839
'Domestic Happiness'
Print 4×4in; page $6\frac{5}{8} \times 4$in monochrome
From *Social Man* by Robert Mudie
Class: Common

77 (64) 1839
'Child on a Bed'
Print $2\frac{1}{4} \times 1\frac{1}{4}$in; page $6\frac{5}{8} \times 4$in
monochrome
Title page vignette to *Social Man* by
Robert Mudie
Class: Common

78 (65) 1839
'The Judgement of Brutus'
Print $4\frac{1}{2} \times 3\frac{1}{2}$in; page $6\frac{5}{8} \times 4$in
Frontispiece to *Moral Man* by
Robert Mudie
Class: Common

79 (66) 1839
'Socrates'
Print $1\frac{1}{2} \times 1\frac{3}{4}$in; page $6\frac{5}{8} \times 4$in
Vignette on title page of *Moral Man* by
Robert Mudie
Class: Common

80 (73) 1840
'The Rev. John Williams'
Print $2\frac{3}{4} \times 2\frac{1}{4}$in; page $6\frac{3}{4} \times 4\frac{1}{4}$in
Small monochrome version of print 65,
used in a book published at a later date
Class: Rare

81 (100) 1840
'The Six Malagazy Christians'
Print $5\frac{1}{2} \times 3\frac{3}{8}$in; page $7\frac{3}{8} \times 4\frac{1}{4}$in
From *The Narrative of the Persecution
of the Christians in Madagascar* by
Rev J. J. Freeman and O. Johns
Class: Common

82 (104) 1840
'The Landing of Columbus'
Print $5\frac{1}{2} \times 4\frac{1}{8}$in; page $7\frac{1}{4} \times 5$in
From *Maritime Discovery and
Christian Missions* by John Campbell
Class: Rare

83 (129) 1841
'Her Most Gracious Majesty Receiving
the Sacrament at Her Coronation'
In three sizes: With mount 26×21in
Without mount
$21\frac{7}{8} \times 17\frac{3}{8}$in
With domed mount
$17\frac{1}{4} \times 13\frac{1}{2}$in
Class: Very rare

84 (131) 1841
'The Arrival of Her Most Gracious
Majesty Queen Victoria at the House of
Lords to Open Her First Parliament'
Size of print $16\frac{3}{4} \times 21$in
Baxter printed his name on this print in
the left-hand corner. This is the first
print on which he carried out this
experiment which he did not repeat until
1848.
Class: Extremely rare

85 (130) 1841
'Prospectus of Above Two prints with
Royal Arms'
Size of prospectus $12\frac{3}{4} \times 9\frac{7}{8}$in
Class: Extremely rare

86 (370) 1841
'Shells and their Inmates'
Print $3\frac{1}{2} \times 3$in; page $5\frac{1}{4} \times 4$in
Frontispiece used by Religious Tract
Society
Class: Moderately rare

87 (82A) 1841
'The Reception of the Rev. John
Williams at Tanna in the South Seas the
day before he was Massacred'
Mount $16 \times 10\frac{3}{4}$in; print $12\frac{3}{4} \times 8\frac{3}{8}$in
Class: Extremely rare

88 (82B) 1841
'The Massacre of The Rev. John
Williams and Mr. Harris at Erromanga'
Mount $14\frac{1}{4} \times 10\frac{1}{4}$in; print $13\frac{1}{2} \times 8\frac{3}{8}$in
These prints were issued without
mounts, and also in sepia
Class: Extremely rare

89 (83) 1842
'The Rev. J. Williams' First Meeting
with Natives of Erromanga'
Print $4\frac{1}{4} \times 3$in; page $8\frac{1}{4} \times 4\frac{3}{4}$in
From *The Martyr of Erromanga* by
John Campbell
Class: Rare

90 (91) 1842
'The Missionary Premises at Kuruman'
Page and print $8\frac{1}{2} \times 5\frac{1}{2}$in
From *Missionary Labours* by
Rev R. Moffat
Class: Moderately rare

91 (89, 89A, 90) 1842
'The Rev. R. Moffat'
Print $10\frac{1}{2} \times 8\frac{1}{4}$in
Several varieties of this portrait were
also published in sepia
Class: Moderately rare

92 (132) 1842
'The Launch of the Trafalgar'
Print $12\frac{1}{4} \times 8\frac{1}{2}$in
Class: Extremely rare

93 (77) 1842
'The Rev. John Williams'
Print $5\frac{3}{4} \times 4$in; page $8\frac{7}{8} \times 5\frac{3}{4}$in
A monochrome illustration to *Memoirs
of Williams* by Prout
Class: Rare

The next twenty-three prints are plates
from *The History of the Orders of
Knighthood of the British Empire*, four
volumes compiled by Sir Nicolas Harris
Nicolas, KG, MC. All the plates measure
$14\frac{1}{2} \times 10\frac{7}{8}$in and all are rare.

94 (107) 1842
Title page to Vol I. 'A Garter Stall'

95 (201) 1842
Frontispiece to Vol I. 'Queen Victoria in
Garter Stall'

96 (108) 1842
'Order of the Garter' (Sovereign)

97 (109) 1842
'Order of the Garter' (Knights)

98 (110) 1842
'Lesser George and Garter'

99 (111) 1842
'Banner Helmet and Crest of Garter
Stall'

100 (112) 1842
'Collar Badge and Star of Order of
Thistle'

101 (113) 1842
'Riband and Badge of Order of Thistle'

102 (114) 1842
'Order of the Bath' (Knights Grand
Cross)

103 (115) 1842
'Order of the Bath' (Civil Knights)

104 (116) 1842
'Order of the Bath' (Knights
Commanders)

105 (116A) 1842
'Order of the Bath' (Companions of
Order)

106 (117) 1842
'Order of St Patrick' (Collar Badge and Star)

107 (118) 1842
'Order of St Patrick' (Riband and Badge)

108 (119) 1842
'Order of St Michael and St George' (Knights Grand Cross)

109 (120) 1842
'Order of St Michael and St George' (Knights Commanders)

110 (121) 1842
'Order of St Michael and St George' (Companions of the Order)

111 (122) 1842
'Medals and Riband granted for Naval Battles and Medal Riband and Clasp granted for Military Battles'

112 (123) 1842
'Cross and Clasps' (Military Battles)

113 (124) 1842
'Order of the Guelphs' (Grand Cross Knight Military)

114 (125) 1842
'Order of the Guelphs' (Grand Cross Knights Civil)

115 (126) 1842
'Order of the Guelphs' (Military Knight Commander and Civil Knight Commander)

116 (127) 1842
'Order of the Guelphs' (Military Knight and Civil Knight)

117 (106) 1843
'The Wreck of the Reliance'
Size $16\frac{1}{2}\times11\frac{7}{8}$in
Class: Extremely rare
Also Le Blond Baxter

118 (74) 1842
'The Lamented Missionary, The Rev. John Williams'
Size $10\frac{3}{4}\times8\frac{3}{4}$in. There are three versions:
1 Class: Rare (74)
2 The same print an uncoloured mezzotint: Rare (75)
3 The same print with altered background: Rare (76)

119 (77) 1843
'The Rev. John Williams'
Full-length uncoloured portrait.
Class: Rare

120 (96) 1844
'Destruction of the *Tanjore* off Ceylon'
Page 8×5in; print $5\frac{1}{8}\times3\frac{1}{8}$in
From *Madras, Mysore and the South of India* by Elijah Hoole
Class: Rare

121 (231) 1844
'Charles Chubb'
Size $10\frac{3}{4}\times8\frac{3}{4}$in
Class: Extremely rare

122 (231A) 1844
'Maria Chubb'
Size $10\frac{3}{4}\times8\frac{3}{4}$in
Only ten pairs of the above were printed
Class: Extremely rare

123 (355) 1844
'Gathering Apples'
Page $5\frac{1}{4}\times4$in; print $4\times3\frac{1}{2}$in
From *Sights in all Seasons* Religious Tract Society
Class: Moderately rare

124 (84) 1845
'Pomare, Queen of Tahiti'
Size $10\frac{1}{2}\times9$in
Class: Very rare

125 (85) 1845
'George Pritchard, Britannic Consul'
Size $10\frac{1}{2}\times9$in
Class: Very rare

126 (297) 1845
'Surrey Zoological Gardens,
Edinburgh'
Page $5\frac{3}{4}\times3\frac{1}{4}$in; print $3\frac{1}{2}\times2\frac{1}{2}$in
From *The Child's Companion*
published monthly at 1d
Class: Rare

127 (242) 1845
'Jerusalem From the Mount of Olives'
Page $5\frac{3}{8}\times3\frac{1}{4}$in; print 4×3in
From *The Child's Companion*
Class: Common

128 (299) 1845
'View From Richmond Hill: Morning'
Page $7\frac{1}{2}\times5$in; print $5\times3\frac{1}{8}$in
From *Richmond and Other Poems* by
Marie Elliot
Class: Moderately rare

129 (78) 1846
'The Rev. John Williams'
Size $10\frac{3}{4}\times8\frac{3}{4}$in
The same print as print 119 with altered
background. No 1 of 'The Missionary
Portrait Gallery' issued by *The Patriot*
office, London.
Class: Common

130 (374) 1846
Scientific Diagram
Size $10\times8\frac{3}{4}$in

130 (374A) 1846
'Scientific Diagram'
Size $10\times8\frac{3}{4}$in
Two diagrams illustrating *The Course
of Lectures on Natural Philosophy and
the Mechanical Arts* by Thomas Young
Class: Very rare

The next eleven prints are engravings
from *The Two Systems of Astronomy
Etc.* by Isaac Frost
Page $12\frac{1}{4}\times9\frac{1}{2}$in; print $10\frac{3}{4}\times7\frac{1}{2}$in
Class: Extremely rare

131 (374B) 1846
'The Universe According to the
Newtonian System'

132 (374C) 1846
'The Sun in the Centre of Earth,
Mercury and Venus'

133 (374D) 1846
'The Sun in the Centre of Earth, Mars
and Jupiter'

134 (374E) 1846
'The Necessity of Having 2 Suns to
Produce a Penumbra'

135 (374F) 1846
'The Sun in Centre with Earth and Polar
Stars'

136 (374G) 1846
'Proving the Earth Keeps Its Polar Stars
in Same Position'

137 (374H) 1846
'The Earth in Centre of Lightness and
Darkness'

138 (374I) 1846
'The Eclipses of the Sun, and the
Shadow of the Moon'

139 (374J) 1846
'The Complete Year of the Sun's
Situation'

140 (374K) 1846
'The Day and Night Positions of the
Sun, Moon, Stars and Earth'

141 (374L) 1846
'The Complete System of the Universe'

142 (86) 1846
'Wesleyan Missionary Station at
Waingaroa'
Page 6×4in; print 6×4in
From *Wesleyan Juvenile Offering*
Class: Extremely rare

143 (87) 1846
'Rev. Waterhouse Landing at Taranaki'
Print $16\frac{1}{4}\times11\frac{7}{8}$in
Class: Very rare

144 (375) 1846
'Persuasives to Early Piety'
Design for a book cover
Class: Extremely rare

145 (376) 1846
'Female Excellence'
Design for a book cover
Class: Extremely rare

146 (377) 1846
'The Teeth in Age'
Page 7×4in
From *Health Comfort Etc. in Regard to the Teeth* by Edward Miles
Class: Extremely rare

147 (280) 1847
'Her Majesty's Marine Residence, Isle of Wight'
Page $4\frac{3}{4} \times 3\frac{1}{2}$in; print $3\frac{1}{4} \times 2\frac{3}{4}$in
From *The Child's Companion*
Class: Rare

148 (339) 1847
'River Scene, Holland'
Page $4\frac{3}{8} \times 3$in; print $3\frac{3}{4} \times 2\frac{1}{4}$in
From *Le Souvenir* by Suttaby (ladies' pocket book) Also first print separately on mount with red stamps: F.G.
Class: Rare

149 (345) 1847
'View in Madeira'
Page $4\frac{5}{8} \times 3$in; print $3\frac{3}{8} \times 2\frac{3}{8}$in
From *The Scriptural Pocket Book*
Class: Extremely rare

150 (351) 1847
'Crossing the Brook'
Page $4\frac{5}{8} \times 3$in; print $3\frac{3}{8} \times 2\frac{3}{8}$in
From *Le Souvenir* by Suttaby (ladies' pocket book)
Class: Rare

151 (358) 1847
'Little Gardeners'
Page $4\frac{5}{8} \times 3$in; print $3\frac{1}{2} \times 2\frac{1}{4}$in
From *Le Souvenir* (ladies' pocket book)
Class: Rare

152 (371) 1847
'Yggdrasill The Mundane Tree'
Page $7\frac{1}{2} \times 4\frac{1}{2}$in; print $4\frac{1}{2} \times 3\frac{1}{2}$in
From *Northern Antiquities* by Mallet
Class: Common

153 (287) 1847
'Dove Dale'
Page $4\frac{5}{8} \times 3$in; print $3\frac{5}{8} \times 2\frac{1}{4}$in
From *The Ladies Complete Pocket Book 1847*
Class: Very rare

154 (289) 1847
'Near Folkestone: Midday'
Page $4\frac{5}{8} \times 3$in; print $3\frac{5}{8} \times 2\frac{1}{8}$in
From *The Sovereign Pocket Book 1847*
Class: Rare

155 (308) 1847
'Bolton Abbey'
Page $4\frac{5}{8} \times 3$in; print $3\frac{5}{8} \times 2\frac{1}{8}$in
From *Le Souvenir 1847* by Suttaby
Class: Rare

156 (309) 1847
'View Near Ilkley'
Page $4\frac{3}{8} \times 3$in; print $3\frac{5}{8} \times 2\frac{1}{8}$in
From *Marshall's Daily Remembrancer 1847*
Class: Very rare

157 (92) 1847
'The Rev. William Knibb'
$10\frac{1}{2} \times 8\frac{3}{4}$in on mount 14×11in
No 2 of the *Missionary Portrait Gallery* issued by *The Patriot*
Class: Moderately rare
Issued 1855 in sepia
Class: Extremely rare

158 (93) 1847
'The Ordnance of Baptism'
$15\frac{1}{4} \times 11\frac{1}{4}$in
Class: Rare
Issued in 1855 in sepia
Class: Extremely rare

159 (97) 1847
'Hindoo Temple, Gyah Behar'
Page $6\frac{1}{4} \times 4$in; print $4\frac{1}{2} \times 3\frac{1}{2}$in
From *Wesleyan Juvenile Offering 1847*
Class: Common

160 (99) 1847
'Miss Aldersley's School at Ningpo'
Page $7\frac{3}{8} \times 6\frac{3}{8}$in; print $6\frac{1}{4} \times 4\frac{1}{4}$in
Class: Rare

161 (152) 1847
'La Tarantella'
Page $4\frac{1}{2}\times2\frac{3}{4}$in; print $3\frac{5}{8}\times2\frac{1}{8}$in
From *Ladies Elegant Pocket Souvenir 1847* and *Cabinet of Fashion 1847* by Marshall
Class: Rare

162 (156) 1847
'Indian Settlement'
Page $4\frac{1}{2}\times2\frac{3}{4}$in; print $3\frac{1}{4}\times2\frac{3}{4}$in
From *Marshall's Ladies Fashionable Repository 1847*
Class: Moderately rare

163 (323) 1847
'Lake Luggellaw'
Page $4\frac{3}{8}\times3$in; print $3\frac{5}{8}\times2\frac{1}{4}$in
From *Carnan's Ladies Own Memorandum Book 1847*
Class: Rare

164 (325) 1847
'Lake Garda'
Page $4\frac{3}{8}\times3$in; print $2\frac{5}{8}\times2\frac{1}{8}$in
From *Poole's Elegant Pocket Album 1847* and *Sovereign Pocket Book 1847*
Class: Very rare

165 (326) 1847
'La Biondina in Gondoletta'
Page $4\frac{3}{8}\times3$in; on stamped mount $3\frac{3}{8}\times2\frac{1}{4}$in
From *Poole's London Annual Repository*. Red stamp: o
Class: Rare

166 (330) 1847
'Abbeville'
Page $4\frac{5}{8}\times3$in; on stamped mount $2\frac{7}{8}\times2\frac{1}{8}$in
From *Le Souvenir*. Red stamp: o
Class: Very rare

167 (331) 1847
'The King of the French Leaving Eu'
Page $4\frac{5}{8}\times3$in; on stamped mount $3\times2\frac{1}{4}$in
From *Le Souvenir*. Red stamp: o
Class: Very rare

168 (337) 1847
'Nuremberg Bavaria'
Page $4\frac{5}{8}\times3$in; print $3\frac{1}{4}\times2\frac{1}{4}$in
From *Le Souvenir 1847*
Class: Very rare

169 (361) 1847
'Parhelia'
Page $6\frac{3}{4}\times4\frac{1}{8}$in; print $4\frac{1}{2}\times2\frac{3}{4}$in
From *Astronomy and Scripture* by Rev J. Milner
Class: Rare

170 (284) 1848
'Claremont'
Page $4\frac{3}{8}\times3$in; print $3\frac{5}{8}\times2\frac{3}{8}$in
From *Carnan's Ladies' Complete Pocket Book 1848* and *Le Souvenir 1848* by Suttaby
Class: Very rare

171 (291) 1848
'London From Greenwich Observatory'
Page $3\frac{1}{2}\times5\frac{1}{2}$in; print $3\frac{1}{2}\times2\frac{1}{2}$in
From *Child's Companion 1848*
Class: Common

172 (296) 1848
'The Duke of Buccleuch's Residence, Richmond'
Page $4\frac{5}{8}\times3$in; print $3\frac{5}{8}\times2\frac{1}{4}$in
From *Marshall's Daily Remembrancer 1848*
Class: Very rare

173 (341) 1848
'The Andalusians'
Page $4\frac{3}{8}\times3$in; print $3\times2\frac{1}{4}$in
From *Le Souvenir 1848* and *Poole's Pocket Remembrancer 1848*
Class: Very rare

174 (95) 1848
'The Wesleyan Chapel, Pophams Broadway, Madras'
Page $6\frac{1}{2}\times4$in; print 5×3in
From *Wesleyan Juvenile Offering 1848*
Class: Very rare

175 (146) 1848
'The Bride' (small; *see also* print 222)
Page $4\frac{3}{4}\times3$in; print $3\frac{1}{4}\times2\frac{1}{4}$in
From *Le Souvenir 1848* by Suttaby
Class: Very rare

176 (148) 1848
'The Conchologists' (small; *see also* print 223)
Page $4\frac{3}{4}\times3$in; print $3\frac{1}{4}\times2\frac{1}{4}$in
From *Le Souvenir 1848* by Suttaby
Class: Very rare

177 (150) 1848
'Paul and Virginia' (small; *see also* print 224)
Page $4\frac{1}{2}\times2\frac{3}{4}$in; print $2\frac{7}{8}\times2\frac{1}{4}$in
From *Marshall's Ladies' Elegant Pocket Souvenir 1848*
Class: Rare

178 (154) 1848
'The Chalees Satoon' (small; *see also* print 228)
Page $4\frac{3}{4}\times3$in; print $3\frac{1}{4}\times2\frac{1}{4}$in
From *Marshall's Ladies' Fashionable Repository 1848* and *Le Souvenir 1848*
Class: Rare

179 (203) 1848
'Her Most Gracious Majesty The Queen'
On stamped mount 6×4in
First print Baxter-signed (in one of tesselated squares. Second row from bottom; second row from right).
First print Baxter used embossed seal
Red stamps: K, L
Embossed seals: EMJ, EMK, EML
Class: Rare
Also Le Blond Baxter

180 (204) 1848
'His Royal Highness Prince Albert' ('Prince Albert, Blue Breeches')
Print 6×4in
Signed on marble floor, right
Red stamps: K, L, T
Class: Rare
Also Le Blond Baxter

181 (347) 1848
'Temples of Philae, Egypt'
Page $4\frac{5}{8}\times3$in; print $3\frac{3}{8}\times2\frac{3}{8}$in
From *The Scripture Pocket Book 1848*
Class: Very rare

182 (259) 1849
'The Fisherman's Home'
Page $4\frac{3}{8}\times3$in; print $2\frac{1}{4}\times2\frac{1}{4}$in
From *Le Souvenir 1849* by Suttaby
Also on stamped mount with red stamp: O
Class: In book: Very rare
On mount: Rare

183 (286) 1849
'Derwent Water, Cumberland'
Page $5\frac{1}{4}\times4$in; print $3\frac{1}{4}\times2\frac{3}{8}$in
From *Loitering Among the Lakes, and Scripture Book 1849*
Class: Very rare
On mount: Moderately rare

184 (317) 1849
'View From a Deserted Rock Quarry on Wye'
Page $4\frac{3}{8}\times3$in; print $3\frac{1}{2}\times2\frac{1}{4}$in
From *Le Souvenir 1849* by Suttaby
View is Symonds Yat in 1849
Class: Rare
Also on stamped mount with red stamp F: Moderately rare

185 (366) 1849
'Summer' (small)
Page $4\frac{5}{8}\times3$in; print $2\frac{7}{8}\times2\frac{3}{8}$in
From *Marshall's Elegant Ladies' Pocket Book 1849*
Class: Moderately rare

186 (369) 1849
'Winter' (small)
Page $3\frac{5}{8}\times2\frac{7}{8}$in; print $2\frac{1}{4}\times2\frac{1}{4}$in
From *Carnan's Ladies' Pocket Book 1849*
Class: Rare
Also issued separately with and without mount

187 (320) 1850
'Ben Nevis'
Page $4\frac{3}{8} \times 3$in; print $4 \times 2\frac{3}{4}$in
From *The Beauties of Nature* by
Sinclair James
Signed on ground at left
Class: In book: Very rare
Also on stamped mount with red
stamps H, I: Moderately rare

188 (322) 1850
'St Ruth's Priory'
Print $4 \times 2\frac{3}{4}$in
On stamped mount with red
stamps B, C, D
Class: Rare

189 (328) 1850
'Verona Evening Scene'
Print 6×4in
Signed on gondola
Class: on Sheet-music for
'The Mandolino Valse' by Karl Büller,
published by Julien: Moderately rare
On mount with gold border: Moderately
rare
Without mount: Common
Also Le Blond Baxter

190 (344) 1850
'The Circassian Lady at the Bath'
Print $6 \times 4\frac{3}{8}$in
Signed in water on right
Class: on stamped mount with red seal F
On embossed mount with seals EMF, EMI,
EML: Rare
Without mount: Moderately rare
Also Le Blond Baxter

191 (318) 1850
'Water Mill on the Wye'
Page $4\frac{5}{8} \times 3$in; print $3\frac{1}{2} \times 2\frac{1}{4}$in
From *Le Souvenir 1850* by Suttaby
Class: Very rare
On stamped mount with red stamps I, J,
K, L: Rare
Without mount: Moderately rare

192 (338)
'Stolzenfels On The Rhine'
Page $4\frac{5}{8} \times 3$in; print $3\frac{1}{4} \times 2\frac{1}{4}$in
From *Poole's Annual Repository 1850*
Class: Common
On stamped mount with red stamps I, O,
P: Common
With stamp J (the only print with this
stamp): Rare

193 (342) 1850
'The Arctic Expedition in Search of Sir
John Franklyn'
Print 8×6in
Class: on embossed mount with or
without gold border, seals EMD, EMN:
Rare

194 (343) 1850
'Chimborazo'
Page $7\frac{1}{4} \times 4\frac{3}{8}$in; print $5\frac{5}{8} \times 3\frac{1}{4}$in
From *Views of Nature* by Alexander
Von Humboldt
Class: Common

195 (277) 1850
'The Landing of Her Majesty and
H.R.H. Prince Albert in Ireland'
Print $6 \times 4\frac{1}{8}$in
Signed on left
Class: on embossed mount with gold
border seal EMF: Rare
On sheet-music 'Hibernian Quadrille'
and 'The Queenstown Galop' both by
Julien: Rare

196 (278) 1850
'Her Majesty and Prince Albert Leaving
Kingston Harbour'
Print $6\frac{1}{8} \times 4\frac{1}{8}$in
Signed on left. Companion to print 195
Class: On embossed mount with seal
EMA: Very rare
Without mount: Rare

197 (279) 1850
'Balmoral Castle'
Page $4\frac{5}{8}\times3$in; print $2\frac{7}{8}\times2\frac{3}{8}$in
From *Scripture Pocket Book 1850*
Class: Common
On red stamped mount with stamp G:
Common
On embossed mount with seals EMF,
EML: Common

198 (281) 1850
'Windsor Castle' ('Stag Hunting')
Print $3\frac{1}{2}\times2\frac{1}{2}$
Signed in river near centre
Class: On stamped mount with red
stamp I, N, O: Moderately rare
Without mount: Common

199 (282) 1850
'Windsor Castle' (from the Long Walk)
Page $3\frac{1}{2}\times5\frac{5}{8}$; print (oval) $3\frac{1}{2}\times2\frac{5}{8}$in
From *The Child's Companion 1850*
Class: Common

200 (283) 1850
'View from Windsor Forest'
Print 4×3in
Class: On stamped mount with red
stamp T: Rare
Without mount: Moderately rare
Published in *Le Souvenir 1852*: Very
rare

201 (285) 1850
'River Camel, Cornwall'
Print $3\frac{3}{4}\times2\frac{3}{8}$in
Class: On stamped mount with red
stamps F, I: Moderately rare
Without mount: Common
Later published in *The Sovereign
Pocket Book 1859*: Moderately rare

202 (288) 1850
'Netley Abbey'
Print $4\times2\frac{3}{4}$in
Class: On stamped mount with red
stamps I, N: Moderately rare
Without mount: Common
Published in *Marshall's Fashionable
Repository 1851* and *Le Souvenir 1851*:
Very rare

203 (298) 1850
'Richmond Bridge'
Print $3\frac{3}{4}\times2\frac{1}{2}$in
Class: On red stamped mount with
stamp T: Rare
Without mount: Moderately rare
Published in *Le Souvenir 1852*: Very
rare

204 (300) 1850
'View From Richmond Hill'
Print 4×3in
Similar view to print 128 but later in day
Class: On mount: Rare
Without mount: Moderately rare
Published in *Le Souvenir 1852*: Very
rare

205 (304) 1850
'The Lovers' Seat, Hastings'
Print $4\times2\frac{3}{4}$in
Signed on ground at left
Class: On stamped mount with red
stamps, I, O: Moderately rare
Without mount: Common
This same print but unsigned and on a
plain mount: Very rare
Without mount: Rare

206 (207) 1850
'Her Most Gracious Majesty' ('Queen
on Dais')
Print $4\frac{1}{2}\times3$in
Class: Extremely rare

207 (306) 1850
'Warwick Castle'
Print $4\times2\frac{3}{8}$in
Class: On stamped mount with red
stamps G, L, M (the only print with this
stamp), N, O, P: Moderately rare
Without mount: Common
Published in *Le Souvenir 1851*: Rare

208 (307) 1850
'Brougham Castle'
Print $3\frac{5}{8} \times 2\frac{3}{8}$in
Class: On stamped mount with red
stamps, F, I: Moderately rare
Without mount: Common
Published in *Le Souvenir 1850* and later
in *Carnan's Complete Ladies' Pocket
Book, 1858*: Common

209 (310) 1850
'Bala Lake, North Wales'
Page $4\frac{5}{8} \times 3$in; print $3\frac{3}{4} \times 2\frac{3}{8}$in
From *Le Souvenir 1850*
Class: Moderately rare
On stamped mount with red stamps F,
I,O, P: Moderately rare
Without Mount: Common

210 (311) 1850
'Llangollen'
Print $4 \times 2\frac{3}{4}$in
Class: On stamped mount with red
stamps P, R: Moderately rare
Without mount: Common
Published in *Carnan's Ladies' Pocket
Book 1851* and *Marshall's Elegant
Ladies' Pocket Book, 1854*: Rare

211 (312) 1850
'Cader Idris'
Print $4 \times 2\frac{3}{4}$in
Class: On stamped mount with red
stamps G, P, R: Moderately rare
Without mount: Common
Published in *Marshall's Elegant
Ladies' Pocket Souvenir, 1851*: Rare

212 (313) 1850
'River Tiefy, Cardiganshire'
Print $4 \times 2\frac{3}{4}$in
Class: On stamped mount with red
stamps K, L: Moderately rare
Without mount: Common
Published in *Le Souvenir 1851* and
*Marshall's Ladies' Daily
Remembrancer, 1851*: Rare

213 (314) 1850
'Welsh Drovers'
Print $3\frac{3}{4} \times 2\frac{3}{8}$in
Class: On stamped mount with red
stamps E, F, H: Rare
Without mount: Moderately rare
Published in *Marshall's Daily
Remembrancer, 1850* and *The
Sovereign Pocket Book, 1860*: Rare

214 (315) 1850
'Tintern Abbey'
Page size $4\frac{5}{8} \times 3$in; Print $3\frac{3}{4}$in $\times 2\frac{3}{8}$in
From *Le Souvenir 1850* and
*Marshall's Ladies Daily
Remembrancer 1850*
Class: Moderately Rare
Also on stamped mount with red stamps
E, H, I, O, P:
Class: Rare
Without mount: Common

215 (316) 1850
'Crucis Abbey'
Print $3\frac{7}{8} \times 2\frac{3}{8}$in
On mount with red stamp L:
Class: Very Rare
Without mount: Moderately Rare
Published in *Scripture Pocket Book
1851*:
Class: Moderately Rare

216 (133) 1850
'The Regal Needle-box Set'
Issued first in strip of 12, size $12\frac{1}{2} \times 2\frac{1}{4}$in;
each print $1\frac{7}{8} \times 1$in
Class: Rare
Prints:
 1 'Windsor Castle'
 2 'H.R.H. Prince Albert'
 3 'Queen Victoria on Horseback'
 4 'Queen Victoria on Balcony'
 5 'Her Majesty leaving the Isle of
 Wight'
 6 'Balmoral'
 7 'The Coronation'
 8 'The Duchess of Sutherland'
 9 'Her Majesty Delivering Her
 Speech'
10 'Buckingham Palace'

11 'Deer Stalking'
12 'The Royal Fleet in Kilkenny Bay'
Issued later on card with prints 11 and
12 omitted. Size of card $4\frac{1}{4} \times 5\frac{1}{3}$in
Class: Very Rare

217 (134) 1850
'The Queen's Floral Needle Box Set'
On card size $5\frac{1}{8} \times 3\frac{1}{2}$in; each print
$1\frac{7}{8} \times 1$in
Each print is a group of flowers and is
individually signed. The prints were
issued with 7 different colour
backgrounds: blue, light or dark:
Common
Light Green: Moderately Rare
White: Moderately Rare
Mauve, Green, Orange: Very Rare

218 (136) 1850
'One Group of Flowers' (signed)
Print for outside of needle boxes, 6×4in
Printed in 3 colours:
Blue; Common
White: Moderately Rare
Orange: Rare

219 (137) 1850
'Three Groups of Flowers'
Print for outside of needle boxes,
$5\frac{1}{4} \times 3\frac{3}{4}$in
3 Prints on card. 2 small side by side
with larger print beneath. Signed.
In various colours
Class: Rare

220 (137) 1850 'La Tarantella' (needle-
box set)
On card $5 \times 3\frac{3}{8}$in; each print $1\frac{7}{8} \times 1$in
10 prints in 2 rows of 5, Nos 1, 5, 6 and
10 printed sideways:
1 'La Tarantella'
2 'The Escaped Bird'
3 'Madeira'
4 'Figures at a Window'
5 'The Wreck'
6 'Fortune Telling'
7 'The Torrent'
8 'Girl by Side of Stream'
9 'Chinese Scene'
10 'Eastern Temples'
Class: Moderately rare

221 (138) 1850
'The Greek Dance and Harem Set'
2 strips of 5 prints each marked to be cut
for needle boxes. Size of each strip
$5 \times 1\frac{7}{8}$in; print $1\frac{7}{8} \times 1$in
'The Greek Dance' (top strip)
1 'Jealousy'
2 'The Wreath Dance'
3 'The Greek Dance'
4 'The Guitar'
5 'The Playful Child'
'Harem Set' (lower strip)
1 'The Harem Dance'
2 'Ladies of the Harem'
3 'The Circassian Slave'
4 'The Captive Slaves'
5 'The Captive Jewels'
Class: Moderately rare
Also on stamped mount with gold
border with red stamp P: Very rare
Each strip with red stamp P: Very rare

222 (147) 1850
'The Bride' (large)
Print $5 \times 3\frac{7}{8}$in
An enlargement of print 175
Signed on right of balcony
Class: On mount with gold border: Rare
Without mount: Moderately rare
On sheet-music 'The Prima Donna
Valse' by Julien: Rare
Also Le Blond Baxter

223 (149) 1850
'The Conchologists' (large)
Size 5×3in
Signed on the shore
Enlarged version of print 176
Class: On stamped mount with red
stamps I, N: Rare
On embossed mount with seal EML: rare

224 (151) 1850
'Paul and Virginia'
Print 5×3in
Enlarged version of print 177
Class: On mount with gold border: Rare
Without mount: Common
Used as oval print on 'The Paul et
Virginia Valse' by Julien, and 'Julien's
Cadeau for 1853': Rare

225 (301) 1850
'The Dripping Well, Hastings'
Print $4 \times 2\frac{3}{4}$in
Signed on left
Class: On stamped mount with red
stamp H: Moderately rare
On embossed mount with seal EMF:
Moderately rare
Without mount: Common

226 (302) 1850
'The Dripping Well, Hastings'
Print $4 \times 2\frac{3}{4}$in
The same print as 225, but all the people
on the left of the stream are missing, and
the print is unsigned
Class: On embossed mount with seals,
EMK, EML: Very rare
Without mount: Rare

227 (153) 1850
'La Tarantella'
Size 4×4in
An enlargement of print 161
The picture is the same but this version
is signed on left
Class: On stamped mount with red
stamps I, O, P: Rare
On embossed mount with seals, EMF,
EML: Rare

228 (155) 1850
'The Chalees Satoon'
Size $4\frac{3}{4} \times 3\frac{3}{8}$in
An enlargement of print 178 except this
print has broken columns in foreground,
and is signed on one of these
Class: On stamped mount with red
stamp, P: Rare

229 (157) 1850
'Indian Settlement'
Size $4 \times 2\frac{1}{2}$in
An enlargement of print 162 to which it
is similar, but this print is signed in water
on the left
Class: On stamped mount with red
stamps, H, O: Moderately rare
Without mount: Common

230 (158) 1850
'First Impressions'
Page $4\frac{1}{2} \times 2\frac{3}{4}$in; print $3\frac{3}{4} \times 2\frac{3}{4}$in
From *Le Souvenir, 1851* by Suttaby
Class: Very rare
On stamped mount with gold border
and red stamps, G, R: Very rare
Without mount: Rare

231 (205) 1850
'His Royal Highness Prince Albert'
Print 6×4in
Signed on floor at left
Similar to print 180, but in this print the
prince is wearing cream breeches and
top boots
Class: On mount with gold border and
embossed seals EMF, EMH, EMI, EMJ and
EMK (sometimes found without gold
border) either category: Rare
Without mount: Moderately Rare
On stamped mount with red stamp T:
Rare

232 (206) 1850
'Her Majesty Queen Victoria'
Print $3\frac{3}{4} \times 2\frac{3}{4}$in
A smaller version of print 179, printed
for Messrs De La Rue for use on outside
cover of playing cards. Signed as 179,
but in addition the next square on
pavement has 'Pub. by De La Rue &
Co.'
Class: Rare

233 (217) 1850
'Jetty Treffz, Madelle'
Print $6\frac{1}{8} \times 4\frac{1}{8}$in
Signed on right
Class: On mount with gold border and
red stamps N, P, or embossed seal EML:
Very rare
Without gold border and embossed
seals, EMG, EMH: Rare
Without mount: Rare
On sheet-music 'Julien's Album for
1851', and 'Book II of Deutsche Lieder'
arranged by W. H. Calcott, published
by Julien: Rare

234 (218) 1850
'Jenny Lind, Madelle'
Print $6\frac{1}{8} \times 4\frac{1}{8}$in
Signed on left
Companion print to 233
Class: On mount with gold border and
red stamps A, F, G, H, P, and embossed
seals, EMK, EML: Very rare
On embossed mount with seal, EMF, and
without gold border: Rare
Without mount: Rare
On sheet-music 'Julien's Album for
1851' and 'Book I of Deutsche Lieder'
arranged by W. H. Callcott, published
by Julien: Rare

235 (234, 234A) 1850
'The Holy Family' ('The Madonna')
Print 6×4in
Signed on floor near centre
Class: Square print with embossed seals
EMF, EMJ, EMK, EML: Common
On dome-topped print with gold border:
Moderately rare
On stamped mount with red stamp F:
Common
On sheet-music 'The Holy Family
Admired Sacred Melodies' arranged by
W. H. Callcot, published by Julien:
Common

236 (270) 1850
'Shall I Succeed' ('The Coquette')
Page $4\frac{3}{8} \times 3$in; print $3\frac{1}{2} \times 2\frac{1}{4}$in
From *Marshall's Elegant Ladies'
Pocket Book, 1850*
Class: Rare
On embossed mount with seal EMK:
Rare
On stamped mount with red stamp I:
Rare

237 (295) 1850
'Harrow-on-the-Hill'
Page $4\frac{5}{8} \times 3$in; print $2\frac{7}{8} \times 2\frac{3}{4}$in
Class: From *Marshall's Ladies'
Elegant Pocket Souvenir, 1852* and *Le
Souvenir, 1852*: Very rare
On stamped mount with red stamp s:
Moderately rare
Without mount: Common

238 (305) 1850
'Brighton Chain Pier'
Print $2\frac{1}{4} \times 3\frac{1}{2}$in
Obviously print 154 which has added
the pier and a different title
Class: On mount with embossed seals
EMD, EMN: Very rare
Without mount: Rare

239 (140) 1851
'The Fairies' Needle-box Set'
Set of 10 needle-box prints in 2
strips of 5
'Pas des Trois' (top strip):
1 'The Dance of the Cupids'
2 'Mdlle Cerito'
3 'Mdlle Taglioni'
4 'Mdlle Lucille Gran'
5 'Cupids Bathing'
'The Fairies' (lower strip):
1 'The Surprise'
2 'Love Sleeping'
3 'The Fairy Tempter'
4 'The Enchantress'
5 'The Fairy Flight'
Class: On embossed mount with gold
border 5×4in with embossed seal EMD:
Extremely rare
In 2 strips $5 \times 1\frac{7}{8}$in with or without gold
border: Very rare
Each needle-box print $1\frac{7}{8} \times 1$in: Very
rare

240 (161) 1851
'Opening of the Great Exhibition. Her
Majesty's Carriage'
Print 4×3in
This print was issued in two versions:
1 The coach is drawn by four pairs of
horses wearing plumes
Class: On stamped mount with red
stamp Q: Extremely rare
2 With one pair of horses without
plumes and the coachman holding a
whip
Class: On stamped mount with red
stamp Q: Very rare

241 (294) 1851
'The Royal Exchange'
Print 4×3in
Class: On stamped mount with red
stamp Q: Very rare
Without mount: Rare

242 (162) 1851
'The Great Exhibition: Exterior'
Print $12\frac{3}{4}$×6in
Print has domed top and gold border
Class: On stamped mount with red
stamp P: Common
On embossed mount with seals EMA,
EMB: Common

243 (163) 1851
'The Great Exhibition: Interior'
Print $12\frac{3}{4}$×6in
Companion to print 242
Domed print with gold border
Class: On stamped mount with red
stamp P, S: Common
On embossed mount with seals EMA,
EMB: Common

244 (164) 1851
'The Great Exhibition: Exterior'
Page 8×$6\frac{1}{4}$in; print 6×4in
Domed top with gold border.
Illustration to *Baxter's Pictorial Key to
the Great Exhibition*
Class: On stamped mount with red
stamp Q: Moderately rare

245 (165) 1851
'The New Houses of Parliament'
Page 8×$6\frac{1}{4}$in; print $4\frac{3}{4}$×$3\frac{1}{2}$in
Illustration to Baxter's *Pictorial Key to
the Great Exhibition* (as 244)
Class: On stamped mount with red
stamp, Q: Moderately rare

246 (211) 1851
'His Royal Highness The Prince of
Wales' ('The Prince 8 years old')
Print $3\frac{1}{2}$×$2\frac{1}{2}$in
Print signed on ground
Class: On stamped mount with red
stamps F, O: Rare
Without mount: Moderately rare

247 (240) 1851
'Bethlehem'
Page $5\frac{1}{2}$×$3\frac{1}{2}$in; print $2\frac{1}{2}$×$3\frac{5}{8}$in
From *The Child's Companion 1851*
Class: Common

Gems of the Great Exhibition
This book which was in preparation
from 1851, was not ready for
publication until three years later.
Prints 248, 249, 250 and 251 which
follow were Gems 1, 2, 3 and 4, and
were published separately in 1852.
Prints 278, 279 and 280 were ready in
1854 when the book was published.
Prints 242 and 243 (the exterior and
interior) were used as Gems 8 and 9.

All the Gems except Gem 7 (Print
280) have domed tops with gold borders
with an embossed stamp in the centre of
mount beneath the print.

The first 5 gems have 3 groups of
statuary, and were designed to be cut
into 3 prints each, a development from
the needle-box strips. Baxter carried out
this plan in 1854 and issued 16 single
statue gems (prints 284 to 299). These
prints have domed tops with gold
borders and an embossed seal beneath.
For names of groups of statuary see
entries 284 to 299.

248 (166) 1852
Gem 1. 'The French Department'
Print $9\frac{3}{8}$×$4\frac{7}{8}$in
Class: On mount with gold border and
embossed seals EMA, EMB: Common

249 (167) 1852
Gem 2. 'The Belgian Department'
Print $9\frac{1}{2}$×$4\frac{3}{4}$in
Class: On mount with gold border, and
embossed seals EMA, EMB: Common

250 (168) 1852
Gem 3. 'The Russian Department'
Print $9\frac{5}{8}$×$4\frac{7}{8}$in
Class: On mount with gold border and
embossed seals EMA, EMB: Common

251 (169) 1852
Gem 4. 'The Foreign Department'
Class: On mount with gold border and
embossed seals EMA, EMG: Moderately
rare
Without mount: Common

252 (139) 1852
'The Religious Events (Scriptural) Set'
(Needle-box prints)
2 strips with 5 needle-box prints in each
Each strip $5 \times 1\frac{3}{4}$in; each print $1 \times 1\frac{7}{8}$in
Religious Subjects 1:
1 'Boaz and Ruth'
2 'Joseph Sold'
3 'Caleb and his Daughter'
4 'The Finding of Moses'
5 'Ishmael'
Class: On embossed mount with seals
EMF, EMJ, EMI: Very rare
Without mount: Rare
'Scriptural Set' Religious Subjects 2:
1 'The Salvation'
2 'Christ Blessing the Bread'
3 'The Saviour'
4 'David'
5 'King Saul'
Class: On embossed mount with seals
EMF, EMJ, EMI: Very rare
Without mount: Rare
Also issued on a card $16 \times 9\frac{1}{2}$in, each
print being separately mounted in a gold
scroll, with the title of the picture, and
'G. Baxter Patentee London' beneath
printed in gold. These were designed to
be used as Sunday-school prizes
Class: Very rare

253 (267) 1852
'So Nice'
Print $6\frac{1}{4} \times 4$in
The first of Baxter's illustrations of
contemporary Victorian life
Class: On embossed mount with seals
EMF, EMK, with gold border: Rare
Without border: Moderately rare
Without mount: Common
Also Le Blond Baxter

254 (332) 1852
'The Reconciliation'
Print $8\frac{1}{2} \times 6\frac{3}{4}$in
Sometimes domed with gold border
Class: On embossed mount with seals
EMD, EML: Very rare
Without mount: Rare
Sheet-music with domes top or oval print
on 'Julien's Album for 1852': Very rare
Also Le Blond Baxter

255 (354) 1852
'Flora the Gypsy Girl'
Oval print $8 \times 6\frac{3}{8}$in
One of Baxter's 'young ladies'
Class: On embossed mount with seal
EML, with or without gold border: Very
rare
Without mount: Rare

256 (189) 1853
'The Crystal Palace New York'
Domed print $12\frac{3}{4} \times 5\frac{3}{4}$in
Signed on sandwich board
Class: On embossed mount with seal
EMB: Rare
Without mount: Moderately rare

257 (195) 1853
'Australia: News from Home'
Print $5\frac{7}{8} \times 4\frac{3}{8}$in
Class: On embossed mount with seals
EMO, EMI, EMK, EML: Moderately rare
Without mount: Common
On sheet-music: 'News from Home
Quadrille' by Julien, published Julien &
Co: Rare
Also Le Blond Baxter

258 (220) 1853
'Sir Robert Peel'
Print $4\frac{3}{8} \times 3\frac{1}{8}$in
Signed on right under left elbow
Class: On embossed mount with seals
EMF, EMG, EMI, EMK: Rare
Without mount: Moderately rare
With 'Published by Permission of
Colnaghy & Co. From the Picture by
Sir Thomas Lawrence' beneath print:
Very rare
Also Le Blond Baxter

259 (221) 1853
'Sir Robert Peel'
The same print as 259 with index finger of left hand extended
Class: On mount as above: Extremely rare
Without mount: Very rare
With lettering as above: Extremely rare

260 (222) 1853
'Lord Nelson'
Print $4\frac{3}{8} \times 3\frac{1}{8}$in
Signed on right under left arm
Class: On embossed mount with seals EMF, EMK, with or without mount: Rare
Also Le Blond Baxter

261 (224) 1853
'Emperor Napoleon I'
Print $4\frac{1}{4} \times 3$in
Class: On embossed mount with seals, EMK, EML, EMM: Very rare
Without mount: Rare

262 (225) 1853
'The Late Duke of Wellington'
Print $4 \times 2\frac{3}{4}$in
Class: On embossed mount with seals, EMD, EMF, EMK: Rare
Without mount: Moderately rare

263 (226) 1853
'The Late Duke of Wellington'
Print $4\frac{3}{4} \times 3\frac{1}{4}$in
Similar to 262 but slightly larger, and in this print the Duke's right hand with gold encrusted cuff extends from his cloak, hence: 'Wellington With Arm'
Class: On embossed mount with seal, EMD: Moderately rare
Without mount: Common
Also Le Blond Baxter

264 (232) 1853
'The Saviour Blessing the Bread'
Print $8 \times 6\frac{3}{4}$in
Class: On embossed mount with seals, EMD, EME, EMK: Moderately rare
Without Mount: Common
Also Le Blond Baxter

265 (233) 1853
'The Saviour Blessing the Bread'
Print $8 \times 6\frac{3}{4}$in
Same print as 264 except this variety has no nimbus around the head of the Saviour
Class: With or without seals as above: Rare

266 (236) 1853
'The Descent from the Cross'
Print $8 \times 6\frac{1}{2}$in
Class: On embossed mount with seals, EMD, EME, EML, EMN, with or without mount: Common
Also Le Blond Baxter

267 (237) 1853
'La Descente de la Croix'
Print $8 \times 6\frac{1}{2}$in
The same print as 266 except that the man half-way up the ladder has a star-like mark on his left shoulder, and this is the only print with embossed seal, EMO
Class: With or without mount: Rare

268 (239) 1853
'The Birth of the Saviour'
Print $6 \times 4\frac{1}{2}$in
Sometimes a square print on mount without any seal
Class: Moderately rare
Without mount: Common
On sheet-music 'The Adoration' by W. H. Callcot, published by Robert Cocks & Co, 1859
Domed print with gold border: Moderately rare
Also Le Blond Baxter

269 (243) 1853
'The Crucifixion'
Print $14 \times 12\frac{1}{2}$in
Signed in left-hand corner
The first of the 'baxterotypes'. In sepia with marginal frame
Class: On embossed mount with seal, EMN: Moderately rare
Without mount: Common
Also Le Blond Baxter

269 (243A) 1853
'The Crucifixion'
Print $14 \times 12\frac{1}{2}$in
The same print as 269 except that in addition it has the words 'Justin M' in right-hand corner
Class: With or without mount: Very rare

270 (244) 1853
'The Holy Family'
Print 14×12in
Baxterotype in sepia with marginal frame
Not to be confused with print 238
Class: On embossed mount with seal, EMO: Rare
Without mount: Moderately rare

271 (265) 1853
'Me Warm Now'
Print $6\frac{1}{4} \times 4\frac{3}{8}$in
Class: On embossed mount with seals EMK, EML, EMN: Rare
Without mount: Common

272 (271) 1853
'So Tired'
Print $6 \times 4\frac{1}{4}$in
Said to be portrait of Princess Royal
Class: On embossed mount with seal, EMF: Rare
Without mount: Common
Also Le Blond Baxter

273 (292) 1853
'The Funeral of the Late Duke of Wellington'
Print $6\frac{1}{8} \times 4\frac{3}{8}$in
Class: On embossed mount with seals EMD, EMJ, EMN: Rare
Without mount: Moderately rare

274 (350) 1853
'Copper Your Honour'
Print $6\frac{1}{8} \times 4\frac{3}{8}$in
Signed on ground at right
Class: On embossed mount with seals EMF, EMH, EMJ, EMK: Rare
Without mount: Common

275 (353) 1853
'The Day before Marriage'
Print $14\frac{7}{8} \times 10\frac{7}{8}$in
Signed on stone at bottom right
Published and dated 12 June 1853, 30 July 1853 and 1 March 1854
Class: On embossed mount with seal EMN, 1853 editions: Rare
1854 edition with or without mount: Moderately rare
Also Le Blond Baxter

276 (360) 1853
'Morning Call'
Print $6\frac{1}{8} \times 4\frac{1}{8}$in
Signed on bottom step, right
Class: On embossed mount with seals EMF, EMG, EMK, EML: Moderately rare
Without mount: Moderately rare

277 (196) 1854
'News from Australia'
Print $6 \times 4\frac{3}{8}$in
Companion to print 257, published 1853
Class: On embossed mount with seals EMJ, EMK, EMM, EMN: Moderately rare
Without mount: Common
Also Le Blond Baxter

In 1854 Baxter completed his *Gems of the Great Exhibition*. It was dedicated to 'His Imperial Majesty The Emperor of Austria, by His Most Obedient and Obliged Servant, George Baxter'. The book contains 9 gems:

1 Print 248
2 Print 249
3 Print 250
4 Print 251
5 Print 278
6 Print 279
7 Print 280
8 Print 242
9 Print 243

It also contained Baxter's Preface which stated:

'In issuing the complete volume of the Gems of the Great Exhibition 1851, Mr. Baxter takes this opportunity of saying that induced by many patrons of the fine arts to produce, by his patented invention of picture printing in oil colours, some of the finest objects contained in the Exhibition as memorials to posterity of this truly remarkable event, he has to congratulate himself upon the perfect success which has attended the execution of this project, in the very extensive patronage and appreciation of the numerous admirers of his art, which he enjoyed in the progress of the work.'

He continues with a description of Paxton's Building and finishes his Preface similarly to the *Key to the Great Exhibition* published 1851. There is also a picture of both sides of 'The Great Gold Medal of the Empire of Austria' which was presented to him by the Emperor.

278 (170) 1854
Gem 5. 'The Austrian Department'
Print $9\frac{5}{8} \times 4\frac{7}{8}$in
Class: On embossed mount with gold border and seals EMA, EMB: Extremely rare
Without mount: Rare

279 (171) 1854
Gem 6. 'The Amazon on Horseback'
Print $8\frac{3}{4} \times 6\frac{1}{4}$in
Class: On embossed mount with gold border and seals EMA, EMB: Moderately rare
Without mount: Moderately rare

280 (172) 1854
Gem 7. 'The Veiled Vestal'
Page $13 \times 8\frac{3}{4}$in; print $5\frac{1}{8} \times 3\frac{7}{8}$in
Title page of *Gems of Great Exhibition*
On mount with domed top and blue background: Extremely rare
On embossed mount with seals EMB, EML: Rare
Without mount: Moderately rare
Page complete: Rare
With square top and red background: Moderately rare

The Single Statue Gems
Gems 1 to 5 were designed with the intention of being each divided later into 3 parts, and issued as the 'Single Statue Gems'. The prints are all $4\frac{3}{4} \times 3$in on embossed mounts with gold borders.

From Gem 1
281 (173) 1854
'Sabrina' by W. C. Marshall
Seals EMB, EMC
Class: Moderately rare

282 (174) 1854
'Cupid and Psyche' by Benzoni
Seals EMB, EMC
Class: Moderately rare

283 (175) 1854
'A Nymph' by R. T. Wyatt
Seals EMB, EMC
Class: Moderately rare

From Gem 2
284 (176) 1854
'The Lion in Love' by G. Geefs
Seals EMB, EMC
Class: Rare

285 (177) 1854
'The Faithful Messenger' by J. Geefs
Seal EMC
Class: Rare

286 (178) 1854
'The Unhappy Child' by Sims of Brussels
Seals EMB, EMC, EML
Class: Rare

From Gem 3
287 (179) 1854
'The Greek Slave' by Hiram Powers
This was considered a most daring
statue for Victorian days. At the top of
the plinth there were ingenious slots in
which the Victorian gentlemen could
insert the ferrule of their sticks or
umbrellas and rotate the statue to obtain
an all round view of its beauty
Seal EML
Class: Very rare

288 (180) 1854
'Rinaldi and Armida' by Benzoni
Seal EML
Class: Very rare

289 (181) 1854
'Mother Presenting her Son With a
Bible' by Mark Thornicroft. Also
known as 'Alfred the Great, Receiving
From His Mother The Book Of Saxon
Poetry'
Seals EMB, EML
Class: Very rare

From Gem 4
290 (182) 1854
'The Dog and the Serpent—The
Attack' by M. Lechesne
Seal EML
Class: Very rare

291 (183) 1854
'The Dog and the Serpent—The
Defense' by M. Lechesne
Seal EML
Class: Very rare

292 (184) 1854
'The Dead Mother on the Prairie with
the Living Babe at Her Breast' by
M. Lechesne
Also known as 'The Attack of the Eagle'
Seal EML
Class: Very rare

From Gem 5
293 (185) 1854
'Girls Fishing' by Monti
Seal EML
Class: Very rare

294 (186) 1854
'Mazzeppa Group' by Pierotti Seals
EMJ, EML
Class: Very rare

295 (187) 1854
'Hagar and Ishmael' by P. Max
Seal EML
Class: Very rare

From Gem 6
296 (188) 1854
'The Veiled Vestal' by Monti
Seals EMB, EML
Class: Very rare

When the Crystal Palace was moved to
Sydenham in 1854 Baxter embarked on
a further book *Gems of the Crystal
Palace at Sydenham*. This project did
not get very far as he only produced the
following four prints: 297, 298, 299 and
300 in the series

297 (191) 1854
'The Exterior of the Crystal Palace,
Sydenham'
Print $11\frac{3}{4} \times 5\frac{1}{2}$in
Signed on road at left
Class: On embossed mount with seal
EMN: Moderately rare
Without mount: Common

298 (192) 1854
'The Pompeian Court at the Crystal
Palace'
Print $11\frac{1}{2} \times 7\frac{3}{4}$in
Class: On embossed mount with seal
EMN with or without mount: Very rare

299 (193) 1854
'The Crystal Palace and Gardens'
Print $6\frac{1}{2} \times 4\frac{1}{2}$in
Signed low in centre
Class: On embossed mount with seal
EMK: Common
Also Le Blond Baxter

300 (194) 1854
'The Assyrian Court of the Crystal
Palace'
Print $6\frac{1}{2} \times 4\frac{1}{2}$in
The print of this court, designed by
Digby Wyatt Esq, the architect of the
Pompeian Court in the last title, was
advertised as being included in Baxter's
Gems of the Crystal Palace Sydenham
but no coloured variety has been seen
Class: Extremely rare

The following four prints (301, 302, 303
and 304) were published during the
Crimean War. As three of the prints
depict scenes in England, we can
assume that news from the Crimea was
scarce, and had to be manufactured

301 (197) 1854
'Review of the British Fleet at
Portsmouth'
Print $9\frac{7}{8} \times 5$in
Signed on one of the stones of battery at
right
Class: On embossed mount with seal
EMN: Rare
Without mount: Moderately rare

302 (198) 1854
'Charge of the British Troops on the
Road to Windlesham'
Print $9\frac{1}{2} \times 4\frac{7}{8}$in
Companion to print 301
Class: On embossed mount with seal
EMN: Rare
Without mount: Moderately rare
Signed on foreground: Extremely rare

303 (199) 1854
'The Seige of Sebastopol'
Print $6\frac{1}{4} \times 4\frac{1}{4}$in
Class: On embossed mount with seal
EMN: Very rare
Without mount: Rare
This is the only print of an actual event
of the Crimean War

304 (200) 1854
'The Soldier's Farewell' ('The Parents'
Gift')
Print $6 \times 4\frac{3}{8}$in
Signed in bottom left-hand corner on
snow next to broom
Class: On embossed mount with seal
EMK: Moderately rare
Without mount: Common
Also Le Blond Baxter

305 (227) 1854
'Vive L'Empereur' ('Napoleon, Long
Moustache')
Print $4\frac{1}{4} \times 3$in
Class: On embossed mount with seals
EMK, EML: Moderately rare
Without mount: Common
On sheet-music 'Vive L'Empereur
Galop' by Julien: Rare
Also Le Blond Baxter

306 (229) 1854
'Vive L'Empereur'
Print $4\frac{1}{4} \times 3$in
Almost the same print as the previous
one except that the Emperor's
moustaches do not have the long
pointed ends, and his beard is shorter.
This is the rarer version
Class: On embossed mount with seals
EMK and EMN, with or without mount:
Rare
On sheet-music 'Vive L'Empereur
Galop': Rare

307 (228) 1854
'Eugénie Empress of the French'
Print $4\frac{1}{4} \times 3$in
Companion to print 305
Class: On embossed mount with seals
EMK, EMM: Rare
Without mount: Moderately rare
On sheet-music 'Julien's Album for
1853': Rare
Also Le Blond Baxter

308 (235) 1854
'The Ninth Hour. And Jesus Cried with a Loud Voice and Gave Up the Ghost'
Print $8\frac{1}{4} \times 6\frac{1}{2}$in
Class: On embossed mount with seal
EMN: Moderately rare
Without mount: Moderately rare
Also Le Blond Baxter

309 (238) 1854
'The Third Day He Rose Again'
Print $8 \times 6\frac{1}{2}$in
Companion to print 266
Class: On embossed mount with seal
EMN: Moderately rare
Without mount: Common
Also Le Blond Baxter

310 (241) 1854
'Proposed Communist Settlement of British Commonwealth'
Page $11\frac{1}{8} \times 7\frac{3}{4}$in; print 9×6in
From *British and Foreign Institute Transactions*, published by Fisher and Son, and *The Christian Commonwealth* by John Minter Morgan, published by Chapman and Hall
Class: Rare

311 (263) 1854
'So Nasty — I don't like it'
Size $8\frac{1}{2} \times 6\frac{1}{2}$in
Companion print to 253
Signed on floor at left
Class: On embossed mount with seals
EMJ, EMM: Rare
Without mount: Moderately rare
Also Le Blond Baxter

312 (348) 1854
'The Belle of the Village'
Print $8\frac{5}{8} \times 6\frac{1}{2}$in
Signed on ground at right
Class: On embossed mount with seal
EMN: Very rare
Without mount: Moderately rare
On sheet-music 'The Belle of the Village Valse' by Julien, and also on 'Julien's Album for 1855': Very rare
Also Le Blond Baxter

The following thirteen prints are by the baxterotype process, with which Baxter had experimented in 1853 when he published prints 269 and 270. All are religious subjects except the last two:

313 (256) 1854
'Prayer', ('The Infant Samuel')
Baxterotype in sepia, $6 \times 4\frac{1}{4}$in
Class: On embossed mount with seal
EMN: Rare
Without mount: Moderately rare

314 (257) 1854
'Ecce Homo'
Oval baxterotype in sepia, $6 \times 4\frac{1}{4}$in with square border
Class: On embossed mount with seal
EMN: Rare
Without mount: Moderately rare
Also Le Blond Baxter (can be recognized by the different colour sepia)

315 (245) 1855
'The Crucifixion'
Baxterotype in sepia, $5\frac{3}{4} \times 5$in
Small version of print 269
Class: On embossed mount with seal
EMN: Moderately rare
Without mount: Common

316 (255) 1855
'It Is Finished'
Baxterotype in sepia, $6 \times 4\frac{1}{4}$in
Class: On embossed mount with seal
EMN: Moderately rare
Without mount: Common
Also Le Blond Baxter (can be recognized by different colour sepia)

The following seven prints are baxterotype reproductions of the Raphael cartoons which were the most copied pictures in England at that time. Prince Albert was an enthusiastic admirer of Raphael, and when photography was introduced, collected every photograph of Raphael's works, which he displayed in the 'Raphael Room' at Windsor Castle

The prints are all $8\frac{1}{2} \times 6\frac{1}{2}$in on embossed mounts with seal EMN

317 (247) 1855
'St Paul Preaching at Athens'
Class: On embossed mount: Moderately rare
Without mount: Common

318 (248) 1855
'Ely The Sorcerer Struck Blind'
Class: On embossed mount: Rare
Without mount: Moderately rare

319 (249)
'St Peter and St John Healing the Sick'
Class: On embossed mount: Moderately rare
Without mount: Common

320 (250) 1855
'Christ Charge to Peter "Feed My Sheep" '
Class: On embossed mount: Very rare
Without mount: Rare

321 (251) 1855
'The Death of Ananias'
Class: Onn embossed mount: Very rare
Without mount: Rare

322 (252) 1855
'The Miraculous Draught of Fishes'
Class: On embossed mount: Very rare
Without mount: Rare

323 (253) 1855
'St Paul and Barnabas at Lystra'
Class: On embossed mount: Extremely rare
Without mount: Rare

324 (258) 1855
'The Slaves'
Oval baxterotype in sepia, $14\frac{1}{2} \times 12$in with square mount
Class: On embossed mount with seal
EMN: Very rare
Without mount: Rare
Also Le Blond Baxter

325 (254) 1855
'Dover Coast'
Baxterotype in sepia, $10\frac{7}{8} \times 8$in
Class: On embossed mount with seal
EMN: Very rare
Without mount: Moderately rare

326 (141) 1855
'The Allied Sovereigns and Commanders of Their Forces'
Needle-box set souvenir of the Crimean War
On card $4 \times 5\frac{1}{2}$in with ten small oval prints $1\frac{1}{8} \times 1\frac{7}{8}$in, each a perfect miniature
Top row:
1 'Lord Raglan'
2 'Queen Victoria'
3 'The Sultan'
4 'Napoleon III'
5 'General Canrobert'
Bottom row;
1 'Sir Charles Napier'
2 'Duke of Cambridge'
3 'Marshall St Arnaud'
4 'Prince Napoleon'
5 'Omar Pasha'
Class: On complete uncut card: Rare

327 (142) 1855
'The Allied Sovereigns and Commanders of Their Force'
The same needle-box set as print 326, the only alteration being that the Empress Eugenie has been substituted for Marshall St Arnaud (No 3 bottom row)
Class: Complete card: Very rare

328 (260) 1855
'The Bridesmaid'
Print 15 × 10½in
This is the second of the large prints of
Baxter's young ladies which are
probably his most popular works. The
other four are:
275 'Day Before Marriage'
349 'The Lovers' Letter Box'
374 'Fruit Girl of the Alps'
365 'The Parting Look'
Class: On embossed mount with seal
EMN, with or without mount:
Moderately rare
Also Le Blond Baxter

329 (262) 1855
'The First Lesson'
Print 8½ × 6½in
Signed in right corner
Class: On embossed mount with seal
EMN: Rare
Without mount: Rare
Also Le Blond Baxter

330 (340) 1855
'Returning From Prayers'
Print 3⅝ × 4¼in
Signed on left
Class: On embossed mount with seal
EMK, EMM: Very rare
Without mount or on sheet-music
'Julien's Album for 1856': Moderately
rare
Also Le Blond Baxter

331 (356) 1856
'The Gleaners'
Print 6 × 4in
Signed on ground at left
Class: On embossed mount with seals
EMJ, EMK, EMM: Rare
Without mount: Moderately rare

332 (357) 1856
'Little Red Riding Hood'
Print 6¼ × 4⅜in
Said to be a portrait by Landseer of
Lady Eveline Russell, daughter of the
Duke of Bedford
Class: On embossed mount with seals
EMJ, EMK, EMM: Rare
Without mount: Moderately rare
Also Le Blond Baxter

333 (208) 1856
'Victoria, Queen of Great Britain'
('Queen Hand on Table')
Print 4⅜ × 3in
Class: On embossed mount with seals
EMK and EMM: Extremely rare
Without mount: Rare
Also Le Blond Baxter

334 (209) 1856
'Victoria Queen of Great Britain'
('Queen With Head-dress')
Print 4⅜ × 3in
Same print as 333 except that the queen
is wearing an Egyptian style head-dress
instead of the crown, which is on the
table
Class: On embossed mount with seals
EMJ, EMK, EMM, with or without mount:
Very rare

335 (210) 1856
'His Royal Highness Prince Albert'
(in 11th Hussars uniform)
Print 4⅜ × 3in
Companion to print 334
Class: On embossed mount with seals
EMJ, EMK, EMM: Very rare
Without mount: Rare

336 (219) 1856
'The Daughter of the Regiment'
Print 6⅛ × 4⅛in
Jenny Lind in the red dress and green
jacket she made famous in this role
Class: On embossed mount with seals
EMJ, EMK, EMM: Very rare
Without mount: Rare
Also Le Blond Baxter

337 (223) 1856
'Edmund Burke'
Print $2\frac{1}{2} \times 3\frac{1}{2}$in
Portrait of the orator as a young boy
from a sketch by Sir Joshua Reynolds
Never on the usual Baxter mount, but
sometimes on a mount with gold border
and engraved lettering
Class: Extremely rare
Without mount: Very rare

338 (230) 1856
'The Rev. John Wesley'
Oval print $4\frac{1}{4} \times 3\frac{3}{8}$in
Class: On embossed mount with seal
EMJ
With or without mount: Very rare

339 (266) 1856
'Puss Napping'
Print $6\frac{1}{4} \times 4\frac{3}{8}$in
Signed on right
Class: On embossed mount with seals
EMK, EMM: Rare
Without mount: Moderately rare
Also Le Blond Baxter

340 (269) 1856
'Short Change'
Print $6 \times 4\frac{3}{8}$in
Class: On embossed mount with seals
EMI, EMJ: Very rare
Without mount: Rare

341 (273) 1856
'Fruit No 1' (after Lance)
Print $6\frac{1}{4} \times 5\frac{1}{2}$in
This and the companion print which
follows are Baxter's only still-life fruit
studies
Class: On embossed mount with seal
EMJ: Very rare
Without mount: Common
Also Le Blond Baxter

342 (274) 1856
'Fruit No 2' (after Lance)
Print $6\frac{1}{4} \times 5\frac{1}{8}$in
Class: On embossed mount with seal
EMJ: Very rare
Without mount: Common
Also Le Blond Baxter

343 (275) 1856
'The Gardener's Shed'
Print 15×11in
Signed on left
Class: On embossed mount with seal
EMN: Rare
Without mount: Moderately rare
Also Le Blond Baxter

The following four prints are from *The
Ascent of Mont Blanc* which Baxter
published in association with
J. MacGregor Esq, MD. The size of each
print is $6 \times 4\frac{1}{2}$in and when on embossed
mounts, all four have the same seal, EMN
Class: On embossed mount: Rare
Without mounts: Moderately rare
The four prints were all republished by
Le Blond

344 (336) 1856
1 'The Glacier Du Tacconnay'

345 (336A) 1856
2 'Leaving The Grand Mullets'

346 (336B) 1856
3 'Le Mur De La Côte'

347 (336C) 1856
4 The Summit

348 (346) 1856
'The Mountain Stream' ('Indians
Reposing')
Print $14\frac{3}{4} \times 11$in
Signed on extreme left
Class: On embossed mount with seal
EMN, with or without mount:
Moderately rare
Also Le Blond Baxter

349 (359) 1856
'The Lovers' Letter Box'
Print $15 \times 10\frac{7}{8}$in
Signed at left on wall
The third of Baxter's five young ladies
Class: On embossed mount with seal
EMN, with or without mount:
Moderately rare
Also Le Blond Baxter

350 (367) 1856
'Summer Time' ('Gathering Roses')
Print $6 \times 4\frac{1}{4}$in
Signed on left under roses
Class: On embossed mount with seal
EMN: Very rare
Without mount: Rare
Also Le Blond Baxter

351 (290) 1857
'The Hop Garden'
Print $6 \times 4\frac{1}{8}$in
Signed on ground centre
Class: On embossed mount with seals
EMJ, EMK, EML, EMM: Rare
Without mount: Moderately rare

352 (88) 1857
'Vah-Ta-Ah. The Fijian Princess'
Page $5\frac{7}{8} \times 3\frac{5}{8}$in; print $3\frac{3}{8} \times 2\frac{5}{8}$in
Oval portrait of a Fijian princess whom
the Rev Joseph Waterhouse converted
to Christianity
From his book *Vah-Ta-Ah. The
Feejeean Princess, with occasional
allusions to Feejeean customs, and
illustrations of Feejeean life*
Class: Common

353 (143) 1857
'The Queen and the Heroes of India'
(needle-box set)
Card $4\frac{1}{2} \times 5\frac{1}{2}$in; print $1\frac{1}{8} \times 1\frac{7}{8}$in
Obviously another version of the 'Allied
Commanders' set print 326. This set
also consists of 2 rows of 5 oval prints
Top row:
1 'General Havelock'
2 'Queen Victoria'
3 'General Sir G. Campbell'
4 'Napoleon III'
5 'General Sir J. Outram'
Bottom row:
1 'Sir J. Inglis of Lucknow'
2 'Duke of Cambridge'
3 'Empress Eugénie'
4 'Prince Napoleon'
5 'Colonel Greathed'
Each portrays a prominent person in the
Indian Mutiny; Class: Rare

354 (334) 1857
'Lake Lucerne'
Print $15 \times 10\frac{1}{2}$in
Signed on road in centre
Class: On embossed mount with seal
EMN: Very rare
Without mount: Common
Also Le Blond Baxter

355 (276) 1857
'Hollyhocks'
Print 15×11in
Companion to print 343
Class: On embossed mount with seal
EMN: Rare
Without mount: Moderately rare
Also Le Blond Baxter

356 (349) 1857
'Come Pretty Robin'
Print $6 \times 4\frac{1}{4}$in
Signed on wall below window
Class: On embossed mount with seals
EMJ, EMK, EMM: Rare
Without mount: Moderately rare
Also Le Blond Baxter

357 (264) 1857
'Infantine Jealousy'
Print $6 \times 4\frac{1}{4}$in
Signed under chair, right
Class: On embossed mount with seals
EMJ, EMK: Very rare
Without mount: Rare
Also Le Blond Baxter

358 (352) 1857
'The Corn Field'
Print $6 \times 3\frac{3}{4}$in
Signed on ground, right corner
Class: On embossed mount with seal
EMJ: Very rare
Without mount: Rare
Also Le Blond Baxter

In 1858 Baxter issued his last three sets of needle-box prints

359 (144) 1858
'The May Queen Set'
Card $4\frac{1}{2} \times 5\frac{1}{2}$in; Prints $1\frac{1}{8} \times 1\frac{7}{8}$in
This set consists of two rows of prints in each of which oblong and oval prints alternate
Top row:
1 'The May Queen' (oblong)
2 'The Greek Bride' (oval)
3 'Sunset' (oblong)
4 'Affection' (oval)
5 'The Albanian Lovers' (oblong)
Bottom row:
1 'The Persian Lovers' (oblong)
2 'The Princess Royal' (Princess Frederick William of Prussia) (oval)
3 'View of the Rhine' (oblong)
4 'Prince Frederick William of Prussia' (oval)
5 'Rustic Felicity' (oblong)
Class: Very rare

360 (144A) 1858
Second Version of the 'May Queen Set'
Card $4\frac{1}{2} \times 5\frac{1}{2}$in; Prints $1\frac{1}{8} \times 1\frac{7}{8}$in
This set is identical to the previous set except that prints 2 and 4 in the bottom row ('The Crown Prince' and 'Princess of Prussia') have been replaced by two oval prints: 2 'Attention'
4 'Contemplation'
Class: Extremely rare

361 (145) 1858
'Figures and Landscapes Set'
Card $6 \times 4\frac{3}{4}$in; Prints 2×1in
Set of 10 prints in 2 rows of 5 in each, all oval, in which figures and landscapes alternate
Top row:
1 'Cupid and His Victim'
2 'Drinking Fountain'
3 'Lady With A Bird'
4 'Landscape'
5 'Lady With A Guitar'
Bottom row:
1 'Landscape'
2 'Lady With A Rose'
3 'Mountain Scene'
4 'Two Ladies'
5 'Castle Scene'
Class: Very rare

362 (213) 1858
'The Princess Royal'
Print $6\frac{1}{4} \times 4\frac{1}{8}$in
This full-length portrait of the Princess Royal at the time of her marriage to Prince Frederick William of Prussia is undoubtedly print 233 ('Jetty Trefetz Madelle') altered
Class: On stamped mount with seals
EMJ, EMK: Very rare
Without mount: Moderately rare
On sheet-music 'Ring Out Old England's Bells' composed by Walter Maynard, published by Cramer, Beale & Chappell: Very rare
On sheet-music 'The Royal Bridal March' composed by Walter Maynard, arranged by E. F. Rimbault, published by Cramer, Beale & Chappell: Very rare

363 (214) 1858
'The Princess Royal, Princess of Prussia'
Print $4\frac{3}{8} \times 3\frac{1}{8}$in
Three-quarter-length portrait of the princess after her marriage when she became the Crown Princess of Prussia. Said to be taken from a miniature of the princess painted prior to her leaving England
Class: On embossed mount with seals
EMJ, EMK: Very rare
Without mount: Rare
Also Le Blond Baxter

364 (215) 1858
'Prince Frederick William of Prussia'
Print $4\frac{3}{8} \times 3\frac{1}{8}$in
Companion to print 363
Published at the time of his marriage
which took place at the Chapel Royal,
St James. Also reproduced from a
miniature painted at the time
Class: On embossed mount with seal
EMJ: Very rare
Without mount: Rare

365 (362) 1858
'The Parting Look' (1)
Print $25\frac{1}{2} \times 18\frac{1}{2}$in
Signed on right
This shares with Baxter's final print
(379) the distinction of being his largest
work. The print was issued in three
versions which have an interesting
history. The picture is a reproduction of
a painting by E. H. Corbauld, 'The
Parting Glance' depicting the moment
when Olivia from the *Vicar of
Wakefield* leaves her parents' house
Class: On embossed mount with seal
EMN: Very rare
Without mount: Rare

366 (363) 1858
'The Parting Look' (2)
Print $25\frac{1}{2} \times 18\frac{1}{2}$in
Signed on right
It is said that Prince Albert, the Prince
Consort, took a personal interest in this
print, but thought that the young lady
should be shown on her own. Baxter
therefore issued the second version on
which he replaced the man and box with
foliage. Some versions have the porter
without the box, probably issued in an
incomplete state
Class: On embossed mount with seal
EMN: Very rare
Without mount: Rare

366A (364) 1858
'The Parting Look' (3)
Print $25\frac{1}{2} \times 18\frac{1}{2}$in
Signed on right
Exactly the same prints as 365 and 366
except extra lace has been added round
the young lady's neck. Olivia is the
fourth of Baxter's young ladies
Class: On embossed mount with seal
EMJ: Very rare
Without mount: Rare

367 (268) 1858
'See Saw Margery Daw' ('Little Miss
Mischief')
Print $6 \times 4\frac{1}{4}$in
Signed on right
Class: On embossed mount with seal
EMJ: Extremely rare
Without mount: Common
Also Le Blond Baxter

368 (261) 1859
'Christmas Time'
Print $6 \times 4\frac{1}{2}$in
Class: On embossed mount with seal
EMJ: Very rare
Without mount: Rare
Also Le Blond Baxter

369 (272) 1859
'Stolen Pleasures'
Print $6 \times 4\frac{3}{8}$in
Class: On embossed mount with seal
EMJ: Very rare
Without mount: Rare
Also Le Blond Baxter

By 1859 Baxter was once again in deep
financial straits. Remembering his
successes with his early prints of Queen
Victoria and Prince Albert on balconies,
he issued the following two prints of
royal subjects in an attempt to recoup
his fortunes. Unfortunately matters had
gone too far to be saved

370 (216) 1859
'Victoria, Queen of Great Britain' ('The Large Queen')
Print $15\frac{3}{4} \times 11\frac{1}{2}$in
Class: On embossed mount with seal
EMJ: Extremely rare
Without mount: Very rare

371 (212) 1859
'His Royal Highness, The Prince of Wales'
Print $4\frac{1}{2} \times 3\frac{1}{2}$in
Sometimes signed in bottom right-hand corner
Class: Signed or unsigned: Rare
On sheet-music 'The Prince of Wales Galop' by Charles D'Albert, published by Chappell & Co: Rare

372 (327) 1859
'Italy'
Print $7\frac{3}{4} \times 6$in
Signed in right-hand corner
Class: Very rare
Also Le Blond Baxter

373 (333) 1859
'The Fruit Girl of the Alps'
Print $15\frac{1}{4} \times 11$in
The fifth and last of Baxter's young ladies
Class: On embossed mount with seal
MN: Very rare
Without mount: Rare
Also Le Blond Baxter

The following two prints, 'Winter' and 'Summer', both after paintings by W. E. Jones, were issued as a pair at Christmas 1859. They both measure $15 \times 10\frac{1}{2}$in, and when on embossed mounts have the same seal, EMN

374 (365) 1859
'Summer' ('The Large Summer')
Print $15 \times 10\frac{1}{2}$in
Class: On embossed mount with seal
EMN: Extremely rare
Without mount: Moderately rare
Also Le Blond Baxter

375 (368) 1859
'Winter' ('The Large Winter')
Print $15 \times 10\frac{1}{2}$in
Class: On embossed mount with seal
EMN: Extremely rare
Without mount: Moderately rare
Also Le Blond Baxter

376 (159) 1860
'The First Impressions'
Print $13\frac{7}{8} \times 11\frac{1}{2}$in
An enlargement of print 230
Class: Published in colour: Very rare
Published in black and white: Moderately rare
Also Le Blond Baxter

377 (335) 1860
'Dogs of St. Bernard'
Print $25\frac{1}{2} \times 18\frac{1}{2}$
After Sir E. Landseer, Baxter's last print and (except for print 339, 'Puss Napping') his only animal study
Class: On embossed mount with seal
EMN: Very rare
Without mount: Common

The Le Blond Baxter Prints

117 (106)
'The Wreck of the Reliance'

179 (203)
'Queen on Balcony'

180 (204)
'His Royal Highness Prince Albert'

189 (328)
'Verona Evening Star'

190 (344)
'Circassian Lady at the Bath'

222 (147)
'The Bride'

254 (332)
'The Reconciliation'

258 (220)
'Sir Robert Peel'

260 (222)
'Lord Nelson'

263 (226)
'Wellington With Arm'

265 (233)
'The Saviour Blessing the Bread'

267 (236)
'La Descente De La Croix'

268 (239)
'The Birth of the Saviour'

269 (243)
'The Crucifixion'

272 (271)
'So Tired'

275 (353)
'The Day Before Marriage'

257 (195)
'Australia News From Home'

277 (196)
'News From Australia'

299 (193)
'The Crystal Palace and Gardens'

304 (200)
'The Soldier's Farewell'

305 (227)
'Vive L'Empereur'

306 (228)
'Eugénie Empress of the French'

308 (235)
'The Ninth Hour'

309 (238)
'The Third Day He Rose Again'

321 (257)
'Ecce Homo'

322 (258)
'The Slaves'

311 (263)
'I Don't Like It'

312 (348)
'Belle of the Village'

328 (260)
'The Bridesmaid'

330 (340)
'Returning from Prayer'

332 (357)
'Little Red Riding Hood'

329 (262)
'The First Lesson'

336 (219)
'The Daughter of the Regiment'

339 (267)
'Puss Napping'

340 (266)
'Short Change'

341 (273)
'Fruit No. 1' (after Lance)

342 (274)
'Fruit No. 2' (after Lance)

343 (275)
'The Gardener's Shed'

344 (336/1)
'Glacier Du Tacconay'

345 (336/2)
'Leaving the Grand Mullets'

346 (336/3)
'Le Mur de la Côte'

347 (336/4)
'The Summit'

348 (346)
'The Mountain Stream'

349 (359)
'The Lovers' Letter Box'

350 (367)
'Summer Time' ('Gathering Roses')

351 (290)
'Hop Garden'

354 (276)
'Holly Hocks'

355 (334)
'Lake Lucerne, Switzerland'

356 (349)
'Come Pretty Robin'

357 (264)
'Infantine Jealousy'

363 (213)
'The Princess Royal, Empress of Prussia'

367 (268)
'See Saw, Margery Daw'

370 (261)
'Christmas Time'

371 (272)
'Stolen Pleasures'

374 (327)
'Italy'

375 (333)
'The Fruit Girl of the Alps'

376 (365)
'Large Summer' (after W. E. Jones)

377 (368)
'Large Winter' (after W. E. Jones)

378 (159)
'The Large First Impressions'

The Le Blond Ovals

As the Le Blond ovals have become collectors' items (a complete set was sold by Richardson & Smith of Whitby on 27 May 1976 for £2,500) I give their titles and numbers. The title is embossed on the right and number on the left of the mount.

49
'The Image Boy'

50
'Please Remember the Grotto'

72
'Good News'

73
'The Burning Glass'

74
'Blowing Bubbles'

75
'The Pet Rabbits'

76
'The Blackberry Gatherers'

77
'The Soldier's Return'

78
'The Sailor's Departure'

79
'The Gleaners'

80
'The Mill Stream'

81
'The Cherry Seller'

82
'The Pedlar'

83
'The Snowman'

84
'The Young Angler'

85
'May Day'

86
'The Fifth of November'

87
'Crossing the Brook'

88
'The Village Spring'

89
'Snowballing'

90
'The Fisherman's Hut'

91
'Waiting at the Ferry'

92
'The Swing'

93
'The Bird's Nest'

99
'Grandfather's Pipe'

100
'Grandmother's Snuff Box'

101
'Sunday Morning' (one of two upright ovals)

102
'The Wedding Day' (the second upright oval)

103
'The Dancing Dogs'

104
'Learning to Ride'

111
'Moonlight'

112
'The Leisure Hour'

Appendix III

Fakes and Forgeries

Knowing of my interest in Baxter prints, a friend, Stephen Belloni, told me about a set which his father had bought around 1920, and which his family had owned ever since. He described them to me, but what aroused my interest was that he said that on the back of each was pasted a description in 'Old English' of the method of making the prints. This sounded rather unusual and I asked permission to see them.

The prints were more interesting than I had expected, being perfect examples of a type of fake which was quite abundant in the twenties. The prints were actually the Le Blond 'Regal' needle-box set, placed in pairs in six frames. Each pair was on a white mount, the lower portion of the mount being taken up with a forged Baxter seal. This was an embossed oval with the words 'Printed in Oil Colours' in the centre of the oval, and G. Baxter, 11, Northampton Square' in the margin. This seal would not deceive any collector who knew a little about Baxters as there is no seal which conforms to it, but it had deceived the purchaser and his family for over fifty years.

Each pair of needle-box prints, with the forged seal beneath, was nicely presented in a black Hogarth frame, on the back of which was pasted a piece of parchment in antiquated English, describing a process which had nothing at all to do with the prints. This was quite an elaborate fraud and the perpetrators must have been well paid for the time and energy expended. The trade in fakes and forgeries flourished in the 1920s when the prices of Baxter prints reached their peak.

To explain the tricks of the forgers, and how to detect them, I cannot do better than give an extract from *Guide to the Collection of Baxter Prints* (published by S. Martin & Co, London, 1926) by Ernest Etheridge, an acknowledged expert on the subject.

As articles of vertu become more valuable, the manufacture of imitations tends to increase. This applies to Baxter prints as it does to antique furniture, china, glass, etc. Many of the imitations are crude, some are passably fair, and a few quite likely to deceive any but the experienced collector or expert.

It has been frequently said that the production of imitations of Baxter prints will be likely to cause the demand for the genuine article to flag, but experience goes to prove that this is not the case. It is safe to say that just as is the case with other collectable articles, knowledge of the genuine will outrun the ingenuity of the makers of the spurious. Fine antique pieces of furniture command very high prices, in spite of the numerous reproductions. Beautiful china is extensively imitated. Old Masters are skilfully copied, but in neither case does the fact tend to reduce the prices paid for the genuine specimens.

A better or more concrete instance in support of the same argument could not be given than to mention the countless reproductions of some of the famous Morland prints, or Wheatley's "Cries of London," in each case the reproductions outnumbering the genuine by hundreds to one, and yet whenever the original prints are offered for sale in the auction room the prices paid are astounding.

It is unlikely that any printer of the present day will produce anything as good as the Baxter print. The printers of Baxter's own time, with the instructions they received with the licenses he issued, and in some cases with the help of Baxter's apprentices and work-people, were unable to produce prints which cannot be distinguished from Baxter's own productions. In most cases they are easily distinguishable.

The true collector is always a student, and there is in connection with the Baxter print much knowledge at hand, but still much to learn. The better the various characteristics of the prints are known, the less likelihood there is of being 'had'.

The writer is convinced that nothing is likely to be produced which will deceive the expert, or even the average collector who had taken pains to learn his subject.

Most of the reproductions have been produced by one or other of the following methods:

1 By colouring by hand pulls from Baxter's plates.
2 By reproducing his subjects by the three-colour process.
3 By printing Baxter's name on Le Blond, Kronheim, or other prints.
4 By placing Le Blond or licensee prints on fraudulent Baxter mounts.

The difference in the prices realised for prints on stamped mounts to those on plain mounts has induced a new and more difficult-to-detect kind of fraud—the placing of a genuine Baxter print on a fraudulent mount.

Several dies have been struck, one reproducing the Crown and Oval, containing Baxter's name and address, and several others for the name tablets under the oval.

The former is quite well done, although the impressions from it are far too sharp, and the latter are easily detected, being likewise too sharp, but also incorrect.

Not only is the die-stamping obviously new, but the mounts are not of the right colour or texture, and if one has an undoubtedly genuine mount to compare them with, the difference is so apparent that a mistake is unlikely.

The matter is entirely in the hands of collectors themselves.

If all are united to frustrate the activities of the faker, and those possessed of the necessary knowledge are prepared to impart it to others, and if every fraud not already mentioned is reported to the Baxter Society (whose address is to be found in an advertisement at the end of this book) immediately on discovery, there is little doubt that the results obtained by the producer of fakes will not justify the trouble and expense of producing them.

Many, if not most, of the frauds on the market have at various times made their appearance in the auction room, and where such things are regularly offered it is only reasonable to assume that the auctioneer connives with the faker to dispose of his spurious wares, but it is easy to give such places a wide berth.

If one has a bent for acquiring things under the hammer, he should attend only sales of auctioneers of repute, and there are plenty of them today who cater for the true collector, and who would not knowingly sell any print about which they had a doubt.

Unfortunately also a word of warning is necessary to those collectors who at holiday and other times spend their leisure in looking round all the antique and second-hand shops at seaside resorts and elsewhere.

Many of these, too, are above suspicion, but unfortunately only too many are only dealers in fakes. One or two resorts on the South Coast have a particularly bad reputation in this respect, and it is to be hoped that this warning will have the necessary result, and that collectors will beware.

We propose to deal with each of the before-mentioned methods separately, and to give at the end of this article a list of the prints known to be in existence.

Of the hand-coloured pulls from original plates, in most instances it is only necessary to try the colours with a wet handkerchief; but since we published this 'tip' in the first number of the Baxter Society Quarterly Journal, the unscruplous but nevertheless ingenious producer of this class of fake now mixes his colours with gum, or some such substance; therefore it is now also necessary to examine the print under a strong magnifying-glass, with the aid of which it is easy to detect that the colours are not printed, the task being rendered much easier if a genuine print is at hand for comparison.

The three-colour process prints, which are most prolific, and which are very presentable to the untrained eye, are fortunately very easy to distinguish if once the method of production is grasped and what to look for understood.

If one of these prints is examined under a magnifying glass the whole of the picture will be seen to be covered with a minute pattern, something like a fine trellis pattern, which can be seen in every part of the picture. This pattern is caused by the screen through which the original print was photographed, and although not the same pattern in every print, it is (whatever the pattern) to be found over the whole surface of the print.

A Baxter print not having any screen, if examined under a strong glass, is seen to be different in every part. The dark colours are solid, and the shading is produced by fine lines, and that of the faces by dots, very minute but varying in size, called stippling, and the most of Baxter's plates are particularly fine in this respect.

The third method mentioned, that of putting Baxter's name on Le Blond-Baxter's or other prints, has been rather extensively used, but is not very likely to deceive if certain points are remembered.

Le Blond-Baxter prints are, if signed with Baxter's name, always shorter than the sizes given in the list in this book, it having been necessary to cut a small strip off the bottom of the print in order to get rid of Le Blond's name, which was in most cases printed at the extreme bottom of the print.

Then, again, Le Blond's prints are invariably unfinished, not having colour on cheeks or lips, although in a number of instances this has been added, as well as the signature; but the fact can be detected with the magnifying-glass.

The signature also is very suspicious, being composed of letters of one size, whereas Baxter's signature invariably consists of letters of different sizes and styles, and most of the fakes of this kind in existence have the following signature:

Published Oct. 7, 1854,
By G. Baxter,
Proprietor and Patentee,
London.

All the letters being of the same size, and having the appearance of having been put on with a rubber stamp, frequently run in a slanting direction, and in many cases are put on prints which Baxter himself did not sign.

In connection with this fraud, and mainly because we have exposed the same in the article published in the Baxter Journal, improved methods have been adopted, and occasionally prints can be found with forged signatures which have undoubtedly been printed from a copper-plate. But these, too, if examined with a magnifying-glass, can be seen to be printed on the print, and not to be an integral part of the plate; and if the additional fact, which should never be forgotten, that the print is shorter, is remembered, it helps one to decide the issue.

In a few cases Le Blond printed his name too high up in the body of the print to allow of it being cut off, and in these cases the signature is usually erased and colour applied to conceal the erasure, but the magnifying-glass will disclose the fraud.

With regard to the printing of Baxter's name on subjects which he did not even produce, little need be said, for the collector who does not take the trouble to learn what prints were produced is not worth consideration or pity.

Remains now only the fourth frequently adopted method, that of putting genuine or spurious prints on faked mounts.

Invariably the three-colour prints are found on spurious mounts.

Some of the Le Blond-Baxters and some of the small Kronheims, too, and, as already stated, sometimes genuine Baxter prints (more dangerous on account of their very genuineness, particularly if fine, as was the case with "Stolen Pleasures" recently inspected) have been detected on spurious mounts, but if the texture and quality of genuine mounts is thoroughly grasped the detection is easy.

Under this heading it will be as well to mention two clever frauds brought to us for verification, both being exceedingly fine, full-size photographs of "Copper, your Honour", on stamped mounts, the print and mount being photographed, and the prints being also very cleverly coloured, but neither would bear close examination when once suspicion was aroused.

HAND-COLOURED PRINTS (Baxter's)

Boy throwing stones at	Coronation
Ducks	First Parliament
Children outside Gates of	First Impressions (Large)
Mansion	Lady Chapel, Warwick

BAXTER PRINTS

Large Queen	Me Warm Now
Launch of the Trafalgar	Parting Look
Madeira	Queen on Dais

THREE-COLOUR PROCESS PRINTS

Burke, Edmund (No mount)	Morning Call (Stamped
Christmas Time (Stamped	mount)
mount)	Napoleon I (Stamped mount)
Copper, your Honour	Nelson (Stamped mount)
(Stamped mount)	Prince Consort (Hussars)
Duke of Wellington (Stamped	(Stamped mount)
mount)	

BAXTER'S NAME PRINTED ON

Any of the Le Blond-Baxters, a list of which is given in the list of plates Le Blond printed from [pages 153–6] may be found with Baxter's name printed on, but if measurements are taken the print will be found to be shorter, except in "Third Day He Arose," where signature will have been erased from the left-hand bottom about one inch from margin, and "Red Riding Hood", where signature should be on the covering of the basket. Several Kronheim small prints have been so printed.

PRINTS WITH FORGED PLATE SIGNATURES

The Cornfield (Le Blond)	See Saw (Ditto)
(Baxter's signature in centre	Daughter of the Regiment
printed from plate)	(Ditto)
So Nasty! (Ditto, on level	
with leg of chair)	

In addition to the above-mentioned frauds, one occasionally meets with a three-colour illustration from one of the Baxter books, which are of no account if the smallest amount of discretion is used. Just a few words of advice:

Do not lock the stable door when the horse has gone. In other words, if you are offered a print of which you are in doubt, ask to be allowed to take it away for advice, leaving payment for it if necessary; and where this request is refused it is quite a probable thing that the vendor knows what the result would be.

If you have no friend who is able to tell you what you want to know, send the print or prints to either the author or to the Baxter Society for verification.

Two other points I would urge all prospective collectors to observe:

Buy only good copies of any subject. Poor, faded, or mutilated prints are a drug on the market. They never give any pleasure to either their owner or friends he may show

them to. They are of no value and never will be.

The other point I would stress is that you keep your prints away from sunny walls or any wall which gets a strong light, as some of the colours are fugitive and fade easily. If you must frame them, hang them in shady spots, but for preference keep them in albums for the benefit of future generations.

In conclusion, learn all you can about the prints you wish to collect. Buy only from persons who have a reputation to keep up and whose word you can rely on. Buy with your eyes and not your ears.

I have been unable to contact the Publisher or any member of Mr Etheridge's family to request permission to quote the above. I trust if any member reads this, they will accept my apologies.

Obituary notice of Mr Ernest Etheridge taken from the *Birmingham Mail*, 9 December 1939:

The death took place yesterday of Mr. Ernest Etheridge, Oreston, Cremorne Road, Four Oaks. He had been in business as an antique dealer at Queen's Hotel Buildings, Birmingham, for many years.

Mr. Etheridge was the founder of the Baxter Society of which he was the honorary secretary. The society was formed to further the interests of collectors of Baxter and licensee prints, and picture pot lids and "to counteract the efforts of the numerous forgers of those very desirable prints." Mr. Etheridge was one of the largest dealers in Baxter prints in the country and had an international reputation. He assisted in the formation of about three-quarters of the most famous Baxter collections. Some of the collections are privately owned in Birmingham and district. He was a member of the Council of the Antique Dealers' Society. Mr. Etheridge was a well-known Freemason.

Fake Baxter Prints which are found nowadays

Since the above chapter was written, and through my association with the British and the Victoria & Albert Museums, I have seen many letters from excited collectors who think that they have found unknown Baxter prints. These letters come from all over the country, and always enclose photocopies of some of the same group of five prints: 'Boy throwing stones at ducks' (incorrect address); a cornfield scene with two figures; a circular version of 'The Little Gardeners' with the figures reversed; 'The Moorish Bride'; and 'Going to Church'. All these prints have one feature in common; beneath the print on the right in very small letters are printed the words in two lines, 'Baxter's Patent Oil Printing, 11, Northampton Square'. This shows that they came from the same hand.

The last print (Plate 18) gives the key to the mystery. It was printed posthumously from a set of Baxter plates and blocks by the secretary of the first Baxter Society in 1895. After Frederick Mockler's disastrous exhibition, his entire collection was auctioned and sold at knockdown prices in Birmingham (then the centre of the Baxter world) in 1896.

It seems reasonable to assume that the purchaser produced prints from them in the 1920s when the Baxter boom was at its height, and like other collectors' items, they come on the market when the original owner dies or disposes of his collection.

MEM

Appendix IV

Preface to Cabinet of Paintings, published by Chapman & Hall, 1836

So little is known to the Public generally of the Art by which the imitative Paintings in the present volume are produced, that it seems necessary to give here a preliminary sketch of its origin and progress, with a brief notice of the manner in which it is practically applied.

The earliest examples which we have of the art of representing an object in two or more colours, by means of engraved wood-blocks and a printing-press, are to be found in the Psalter, printed by Faust and Scheffer, at Mentz, in 1457—the first printed book which contains the printers' names and a precise date. The large capital letters contained in that truly admirable work of art are printed in red and blue ink, in imitation of the large ornamental letters which are to be found in old manuscripts; and the manner in which they are executed affords a simple exemplification of the art of printing in colours from wood-blocks.

The largest ornamental letter in the Psalter of 1457, is the letter B, at the commencement of the first Psalm—"Beatus vir." The form, or shape, of the letter is printed in red, from a wood-block, on which a dog chasing a bird, together with heads of corn and flowers, have been cut in outline and in intaglio. The lines which are thus cut into the block not receiving any ink or colour, when it is beat with a printer's ball, the figures which they represent are preserved colourless on the vellum on which the book is printed, and thus appear like white tracings on a red ground. From a second block, engraved with a kind of fillagree tracery, the spaces between the stem and the curved parts of the letter, together with a border surrounding it, are printed in blue ink. As each colour is communicated by means of a separate impression, the difficulty in this kind of printing is to cause the coloured lines of the second block to fall in their proper places, without overlaying the lines which have been previously impressed. In two later editions of the Psalter, which appeared in 1459 and 1490, the large capital letters are also printed in two colours in the same manner. In the edition of 1490, however, the colours are red and green, instead of red and blue.

Though the invention of printing in colours from two separate blocks is unquestionably due to Germany, yet the first application of the art to the imitation of drawings in chiaro-scuro has been claimed for Italy by Vasari, who, in his "Lives of the Painters," asserts that Ugo da Carpi was the first who invented the art of producing fac-similes of such drawings, by means of impressions from two or more wood-blocks. As there is no direct evidence, however, to show at what period Da Carpi first began to engrave in chiaro-scuro, the claim which has been put forward on his behalf has been questioned by Bartsch and other German writers, who endeavour to show that the art was practised in Germany before it was known in Italy. The earliest date which has been discovered on Ugo da Carpi's chiaro-scuro wood-engravings is 1518, and it scarcely can be supposed that he began to engrave in this style earlier than 1515; for previous to that period we have no trace of him as an engraver. The claims of Germany to the honour of having first applied the art of printing in colours, from two or more blocks, to the imitation of drawings in chiaro-scuro, rest on better grounds than mere assertion. An engraving on wood in this style, "A Repose in Egypt," after Lucas Cranach, is dated 1509; two others by

Hans Baldung Grün, are dated 1509 and 1510; and a portrait by Hans Burgmair bears the date of 1512; all earlier than any known work of the same kind by Ugo da Carpi. In a folio edition of Ptolemy, printed at Strasburg by I. Schott in 1513, a map of Lorraine is printed in three different colours from wood-blocks; and a shield of arms on the border is executed in its proper heraldic colours in the same manner.

Although it seems probable that the art of printing in colours from two or more blocks was first applied by the Germans to the imitation of chiaro-scuro drawings, yet it must be admitted that its improvement between 1518 and 1540, when it attained its greatest perfection, is owing to Ugo da Carpi and other Italian artists. Though it may be said that Ugo da Carpi's best chiaro-scuro engravings—which were executed from drawings by Raphael—owe much of their excellence to the excellence of the original designs, yet it must at the same time be remembered, that to preserve in his copy the spirit and character of a good original, is an engraver's highest praise.

The chiaro-scuro engravings, executed by Da Carpi and other artists of the sixteenth century, may be divided into two classes: the one being an imitation of a pen-and-ink drawing, on tinted paper, in which the lights are introduced with a crayon; the other an imitation of a drawing made in bistre or sepia, or of a drawing or a painting executed with three, four, or more tints of the same general colour, but of different degrees of strength. The first mode requires only two blocks. On one block the outline of the drawing with its hatched shades is copied, and printed in the usual manner of a wood engraving. The colour in imitation of the tinted paper is next communicated from the second block, in which the lines intended to be left white in the impression, in imitation of the touches of the crayon, are cut in intaglio. An engraving by Ugo da Carpi, of a sybil reading, with a boy holding a torch, after a design by Raphael, is executed in this manner from two blocks; and Vasari says, that it is his first attempt in this style.

In the second, or more complicated manner of engraving in chiaro-scuro, in imitation of a drawing or painting of three or more tints of the same general colour, three or more blocks are required; and with the number of blocks, the difficulty of making the tints harmonize and the lines fall correctly, is increased. Da Carpi and the earlier engravers in this style seldom used more than four blocks; on one was engraved, in the usual manner, the outline and the strongest shades; from a second the lighter shades, and other parts of the same tint, were impressed; from a third the half-tints; and from a fourth, the ground or colour of the paper, with the lights preserved by being cut in intaglio.

About 1530, Antonio Fantuzzi, called also Antonio de Trente, executed several chiaro-scuros from designs by Parmegiano. It is said that Fantuzzi being expressly employed by Parmegiano to engrave chiaro-scuros from his drawings, took an opportunity, when residing with his master at Bologna, to rob him of all his blocks, impressions, and designs. Between 1530 and 1540, Joseph Nicholas Vincentini de Trente, a contemporary of Fantuzzi's, and probably a fellow-townsman, executed several chiaro-scuro engravings, chiefly from the designs of Parmegiano.

Andrea Andreani, who was born at Mantua in 1540, and who died about 1623, engraved more chiaro-scuros than any other artist, either of that or of any subsequent period. He copied several of Ugo da Carpi's chiaro-scuro engravings, and executed many others from drawings and paintings by the most eminent Italian masters. His largest works are Abraham's Sacrifice, from the pavement of the cathedral of Sienna, executed in 1586; and the Triumphs of Julius Caesar, from a celebrated painting by Andrea Mantegna, published in a volume dedicated to

Vincentius Gonzaga, Duke of Mantua, in 1598.

Henry Goltzius, a Flemish painter, born in 1558, executed several chiaro-scuro engravings, from his own designs; the most remarkable of which are Hercules killing Cacus, and four subjects emblematic of the four elements. About 1623, Louis Businck, a French engraver, executed several chiaro-scuros, chiefly from designs by Bloemart and Lalleman; and between 1630 and 1647, the same art was practised at Bologna by Bartolomeo Coriolauo. Towards the latter end of the seventeenth century, chiaro-scuro engraving was practised by Vincent le Sueur, a French artist; who was, however, greatly excelled in this branch of art by his nephew, Vincent le Sueur, who was born in 1691, and died in 1764.

Between 1721 and 1724, Edward Kirkall, an English engraver, executed several chiaro-scuros, after drawings by some of the most eminent Italian painters, in which he attempted an improvement of the art by printing the outlines and other parts of the subject from etched and aqua-tinted copper-plates. Though he deserves great credit for the attempt, yet it cannot be said that he improved the art; for his more delicate and laboured productions are flat and spiritless, compared with the works of Da Carpi and the early Italian engravers in chiaro-scuro. About 1724, Kirkall published a series of marine views, after the designs of W. Vandevelde, executed entirely on copper, and printed in a kind of greenish-blue ink. These he also called "prints in chiaro-scuro": and they have been sometimes confounded with his other proper chiaro-scuros, where the tints and ground are impressed from wood-blocks.

In chiaro-scuro engraving, Kirkall was far surpassed by his countryman, John Baptist Jackson, who executed several pieces in this style at Venice between 1738 and 1745, chiefly from designs by Titian, Tintoret, and Paulo Veronese. Seventeen of those engravings were published in one volume, folio, at Venice, in 1745. Mr Jackson subsequently returned to England, and commenced the manufacture of paper-hangings at Battersea. In 1754, he published a small quarto volume, entitled "An Essay on the Invention of Engraving and Printing in Chiaro-oscuro, as practised by Albert Durer, Hugo da Carpi, & c., and the application of it to the making Paper Hangings of Taste and Elegance. Illustrated with Prints in proper colours." There are eight of those prints; four chiaro-scuros, and four in "proper" colours, in imitation of drawings. The colours having been badly compounded with oil, the paper now appears much stained. The letter-press of the volume proves the writer to have known little of what had been previously done in the art; and the "prints," both coloured and in chiaro-scuro, are likely to impress persons who are unacquainted with his earlier and greater works, with but a mean opinion of his abilities.

In several of the engravings executed between 1730 and 1740, by Arthur Pond and George Knapton, in imitation of sketches by eminent painters, the tinted ground, draperies, and other parts of the subjects, are impressed from wood-blocks over the copper-plate outlines. In 1749, Count Antonio M. Zanetti published a collection of chiaro-scuros, executed by himself between 1722 and 1747, chiefly after Parmegiano, whose drawings professors of this art have always been most fond of copying. About 1738, a few chiaro-scuros were executed by an English amateur of the name of Skippe.

Mr. W. Savage, in his "Hints on Decorative Printing," the first part of which appeared in 1819, and the second in 1822, gave several specimens of chiaro-scuro engraving executed on wood by Branston and others; and he also attempted to produce imitations of coloured drawings, in a similar manner, by repeated impres-

sions from engraved wood-blocks. In this bolder attempt, however, the artists employed by him have not succeeded so well as in simple chiaro-scuro. Though it is impossible to speak of the imitative coloured drawings in Mr. Savage's work in terms of commendation, yet it would be unjust to withhold from him the credit of having been the first person since the time of Skippe who recalled the attention of the public to chiaro-scuro engraving; and the only one since the time of J. B. Jackson, who attempted to extend the boundaries of the art by employing it to produce copies of coloured drawings.

Having now given a brief outline of the progress of chiaro-scuro engraving, with the names of the principal artists by whom it has been cultivated, it remains to notice its improvement and extension by Mr. Baxter, as displayed in the pictorial illustrations of the present volume. Through his own unaided talent and his indefatigable perseverance—for he is both the engraver and printer its boundaries have been so far extended, that the name, "chiaro-scuro engraving" cannot with propriety be applied to his copies in colours of paintings and drawings. To the art, as improved by Mr. Baxter,—which he almost may be said to have invented, and which he certainly has been the first to practise with success—a distinctive name is wanting; and none appears to be more appropriate than that of PICTURE-PRINTING; for to the skilful use of the PRESS, in communicating the colour from the engraved block to the paper, we are chiefly indebted for the admirable fac-simile paintings which ornament the PICTORIAL ALBUM.

In the execution of those imitative paintings, Mr. Baxter has availed himself of advantages, which are to be obtained by having certain parts of each subject engraved on steel. The first faint impression, forming a ground, is from a steel-plate; and above this ground, which is usually a neutral tint, the positive colours are impressed from as many wood-blocks as there are distinct tints in the picture. Some idea of the difficulty of Picture-Printing may be conceived, when the reader is informed, that, as each tint has to be communicated by a separate impression, some of the subjects have required not less than twenty blocks; and that even the most simple in point of colour, have required not less than ten. The very tint of the paper upon which each imitative painting appears to be mounted, is communicated from a smooth plate of copper, which receives the colour, and is printed, in the same manner as a wood-block.

Of the practicability of copying all kinds of paintings by means of Picture-Printing, the various specimens contained in the present volume afford ample proof. In the subject marked "Verona," by Prout, Mr. Baxter has produced so perfect a fac-simile, that it is questionable if even the painter himself could with his pencils produce a more exact copy. It is highly characteristic of the manner of the original designer; and those who are acquainted with his style, at the first glance declare it to be, "From a View in Italy, by Prout." The walls of the houses, which many other artists find so very stony and difficult to manage, appear, indeed, to be seen beneath an Italian sky; while a light and cheerful effect is communicated to the whole subject from the blue and white colour of the blind which forms a verandah to a picturesque window, and from the touch of bright red on the drapery which hangs from the balcony. The light blue sky, in part veiled, but scarcely hidden, by thin white clouds, forms a delightful relief to the architectural parts of the subject.

In "Jeannie Deans's Interview with the Queen," from a design by Mrs. Seyffarth, formerly Miss Sharpe, we have an excellent copy of a beautiful picture, illustrative of a scene which the genius of Sir Walter Scott has described with all the minuteness

and invested with all the interest of reality. In this difficult subject Mr. Baxter has happily preserved the expression of the faces, while in the costume and the foliage he has produced a perfect miniature copy of the large original. We perceive, as in the original picture, that his Grace of Argyle wears a coat of mulberry-coloured velvet; and may almost fancy that we hear the Queen's brocade petticoat rustle. From the folds of Jeannie Deans's petticoat, as she kneels before the Queen, we may be sure that it is a comfortable woollen garment, ample and lengthy, as befitting the prudent daughter of "Douce Davie," and probably home-spun. Her red jacket seems to be of the same material; and the manner in which it is relieved by a border of snowy white, and connected, in point of colour, with the blue petticoat, by means of the tartan scarf, is an admirable specimen of Mrs. Seyffarth's skill in the effective combination of striking colours. In fact, the attitude, figure, and dress of Jeannie are above all praise.

In the "Interior of the Lady-Chapel, Warwick," from a painting by Holland, we perceive how capable the Art of Picture-Printing is of representing such subjects with effect. Here minuteness and accuracy of architectural detail are combined with rich, mellow, and harmonious colouring, representing, with a truth and a feeling which are instantly acknowledged,

> 'the high embowed roof,
> With antique pillars, massy proof,
> And storied windows, richly dight,
> Casting a dim religious light.'

In the "Carrier Pigeon," from a painting by Miss F. Corbaux, Mr. Baxter has taxed his ability to the utmost, to give a faithful copy of the beautiful colours and charming expression which are to be found in the original; and, notwithstanding the difficulty of the attempt, he has succeeded. The subject is, indeed, of itself inspiring. A Persian girl, lovely as a Houri in Mahomet's Paradise, is about to despatch a message to her lover—to the youth whose image is impressed on her heart, and on whom her mind dwells. She writes not her thoughts upon paper, after the manner of European maidens; but addresses the loved one in the symbolical language of flowers, which speak at once to the heart; and her messenger is a dove! A subject more fraught with the very poetry of love was never painted; and a lady only was capable of conceiving and expressing the idea in all its tenderness and beauty. A passion-flower, emblem of her feelings, hangs from the wall of her kiosk; and the sky, tinged towards the horizon with a rosy hue, lends an additional warmth to her cheek. She seems as if musing on the manner in which her communication will be received; and, half hesitating whether to send it or no, she still holds to her breast her winged messenger, to whose neck the flowers—truly a billet-doux—are already bound.

It is unnecessary to adduce more instances of the successful manner in which Mr. Baxter has copied the colours of the originals and at the same time preserved the expression of the characters. The applicability of the art, as has been already observed, to copy in their proper colours historical, architectural, and imaginative subjects, as well as landscape, is sufficiently established by the pictorial illustrations of the present volume; and should they be favourably received by the Public, with whom the decision respecting their merit must finally rest, it will be the endeavour of the engraver, and of the publishers, to produce another series, at a future opportunity, no less worthy of approbation.

1st Nov. 1836 C.

Bibliography

Baxter Society Quarterly Manual, The (1923–36)
Baxter Times, The (Courier Press, Leamington, 1923–38)
Bullock, C. F. *Life of George Baxter* (published at 21 Bright St, Birmingham, 1901)
Clarke, H. G. *Baxter Colour Prints* (Maggs Bros, London, 1919)
Baxter Colour Prints Pictorially presented (Maggs Bros, London, 1920)
Clarke, H. G. and Rylatt. *Centenary Baxter Book* (1936)
Docker, A. *Baxter Prints* (Courier Press, Leamington, 1929)
The Colour Prints of William Dickes (Courier Press, Leamington, 1924)
Etheridge, E. *Baxter Prints* (S. Martin, Birmingham, 1929)
Courtney Lewis, C. T. *George Baxter—His Life and Work* (Sampson, Low,
 Marston & Co, 1908)
The Picture Printer (Sampson, Low, Marston & Co, 1911)
George Baxter, The Picture Printer (Sampson, Low, Marston & Co, 1924)
Supplement to *George Baxter* (Sampson, Low, Marston & Co, 1924)
Story of Picture Printing in England (Sampson, Low Marston & Co, 1928)
The Le Blond Book (Sampson, Low, Marston & Co, 1925)

Acknowledgements

I would like to express my thanks to

Mr Lionel Lambourne for his Preface;
Mr Allen Grove, former Curator of the Maidstone Museums and Art Gallery for
permission to print the letter in Chapter 5, and to Mr Hunter, present curator for
endorsing that permission;
Mr Michael J. Martin for supplying the prints for the Plates; The staff of the
British Library, and the British Museum Print Room for their consideration and
help when this book was being researched and written;
The staff of the Birmingham Reference Library, who stayed behind after closing
time on a Saturday afternoon to photocopy and collate for me material from the
Baxter Journal.
Degrees of rarity etc, and details from C. T. Courtney Lewis, by kind permission
of Sampson, Low, Marston & Co.
A Glance at William Dickes and His Process by R. W. Baxter reprinted by kind
permission of Courier Press, Leamington Spa.

Index to the Catalogue

The numbers in this Index refer to Catalogue numbers, not page numbers.

Index

Plate pages are indicated by italic type